# WHERE MOUNTAINS LIVE

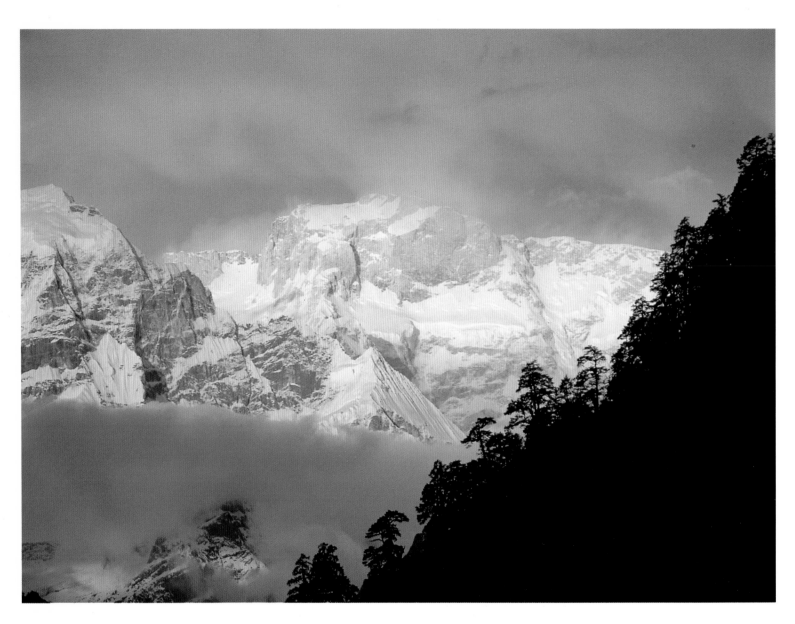

*Then the miracle happened. Folded in light mist hill*

*after hill rolled away into the distance from beneath my*

*feet, and over this green ocean sparkled the vast ice-bergs*

*of the Himalayas. Never in my remotest dreams had I*

*imagined such beauty could exist on earth.*

*—Lionel Terray*

# WHERE MOUNTAINS LIVE

## Twelve Great Treks of the World

*By* Leo Le Bon

*Foreword by* Sir Edmund Hillary

*An APERTURE Book*

*To Alexander, my young son, with the*
*fervent hope that he, too, may one day have*
*the privilege to travel to remote parts of the*
*world where mountains live and to enjoy*
*their bounty.*

Composition by David E. Seham Assoc., Inc., Metuchen, New Jersey. Printed and bound in Hong Kong by South China Printing Company.

Library of Congress Catalog Number: 87-70203; ISBN: 0-89381-242-0.

The staff at Aperture for *Where Mountains Live* is Michael E. Hoffman, Executive Director; Donald Young, Editor; Ina Schell, Director of Sales and Marketing; Stevan Baron, Production Director; Barbara Sadick, Production Manager; Dean Brown and Diana Mignatti, Editorial Assistants.

Book Design by John White; Jacket Design by Robert Aulicino.

Aperture Foundation, Inc. publishes a periodical, books, and portfolios of fine photography to communicate with serious photographers everywhere. A complete catalog is available upon request. Address: 20 East 23 Street, New York, New York 10010.

*Frontispiece: Manaslu, world's seventh highest peak, central Himalayas, Nepal.*

The quotations used in this book are reprinted through the kind permission of their publishers: p. 2 Terray, Lionel. *The Borders of the Impossible*. Paris: Editions Gallimard; p. 36 Burdsall, Richard L., Arthur B. Emmons, Terris Moore, and Jack Theodore Young. *Men Against the Clouds*. Seattle: The Mountaineers, rev. ed., 1980; p. 57 Herzog, Maurice. *Annapurna*. New York: Dutton 1953; p. 61 Frost, Robert. "The Road Not Taken" from *The Poetry of Robert Frost* (ed. Edward Connery Lathem). New York: Henry Holt and Company 1969; p. 75 Harrer, Heinrich. *Ladakh*. Innsbruck: Pinguin-Verlag 1978; p. 83 Douglas, William O. *Beyond the High Himalayas*. Garden City, N.Y.: Doubleday & Company, Inc., 1952.

# *Foreword*

TREKKING is one of the most agreeable pastimes that I know. It is a healthy, vigorous, and challenging activity that brings you close to nature and lets you share the beauty of the environment. You don't have to be a tough and hardy person to enjoy trekking. You can choose whatever you may wish to do, from a relaxed stroll through the valleys and forests, a vigorous hike along a high mountain ridge, to the major effort involved in crossing a high alpine pass.

Nature can be very peaceful, but it is rarely quiet. There may be the soft moaning of the wind over a ridge, the roaring of a foaming mountain stream, the sweet music of the birds in the forest, or the dull thunder of an ice avalanche tumbling down the high cliffs above. You have an astonishing sense of freedom—you are dependent only on your own two feet . . . no buses, trains, or planes to catch; no concrete jungles to traverse or gasoline fumes to breathe. The air is clean and fresh, and you feel the stimulation of going wherever your own wishes lead you.

Leo Le Bon has been a pioneer trekker for several decades. There are indeed few remote parts of the world where he hasn't left his footprints. Most of us would not have the time and energy to undertake such great journeys, or to do so many of them. The world is beautiful. Almost everywhere there are spectacular sights to be seen, unusual cultures to experience, and ancient relics of past civilizations that leave us mystified.

In his book, Leo Le Bon introduces us to twelve great treks covering much of the world. With his descriptive maps, lively stories, and magnificent illustrations, we are able to enjoy these adventures for ourselves.

Sir Edmund Hillary

# Table of Contents

# Introduction

THERE is no better way to put oneself in touch with the remote world of nature and its native mountain people than to pay a visit, on foot, alone or in a small party. The highlands of Peru, the mountains and plains of East Africa, the Himalayan foothills crisscrossed with footpaths below stately Buddhist monasteries: these varied terrains offer more challenges and exotic cultural experiences than can be had by anyone during a short lifetime. Once one has been exposed to the immense pleasures of walking the untouched places, one is forever addicted.

Walking was once a way of life for all of us—we have simply forgotten. As George Steiner tells us in *The Mountain Spirit*:

> We forget what space and time signified, felt, "tasted" like to one who reckoned the map and the hour in terms of walking from point to point, from town to town, across borders. A walked world is radically different from one traveled in a train, automobile, or airplane.

*Where Mountains Live* describes twelve of the world's most enchanting mountain walks. All these trips are "treks." A trek can be defined as an extended journey on foot to a remote area where one must be self-sufficient—carrying all food, equipment, and shelter by porter or animal.

In selecting only a dozen treks from the infinite variety of adventure journeys that are possible in the world today, I have chosen those that have given me a particular sense of satisfaction during my twenty-five years of trekking. I am often asked, "What is your favorite place or trek in the world?" I can only reply that each country, each journey, is different; that each destination has its own inimitable attractions and unique character.

Nepal, for instance, is unequaled as a trekking destination because of its blend of mountains, landscapes, and people. Tibet, the "Roof of the World," provides a unique feeling of space and silence. China greatly appeals to me for its newness (to us) and the great contrasts to our Western way of doing things. India's Ladakh Province and Bhutan, the "Dragon Kingdom," retain the full spirit and traditions of Buddhism, the most human of all religions. In South America no trekking country quite equals Peru, with its diverse landscapes of desert, exotic jungle, windswept altiplano, and ice-clad peaks. My favorites here are high-altitude trekking in the Cordillera Blanca, the highest and most scenic tropical mountains in the world, and the Cordillera Vilcabamba, near Cuzco, where the mystery of the Incas lingers among the crumbling strongholds that line the ancient trails to Machu Picchu. In Patagonia, a tempestuous

and invigorating environment creates an experience of nature's extremes, where wild crags, gigantic rivers of ice, and wind-whipped lakes studded with icebergs provide a sense of untamable land.

Mountains have fascinated me since childhood, but because I grew up in Belgium, a flat country, it was not until I moved to California that I was able to become acquainted with them. I began by walking and climbing in the High Sierra; later I visited the Andes, Alps, Himalayas, and points between. Whatever the locale, the high trails of the mountains have taught me a great deal: to see the simple beauty of a delicate wildflower growing out of a white granite crack; to sit quietly by a soft, babbling mountain brook flowing through an alpine meadow; to endure hardship with a smile; and to value true friendship when the chips are down. As I traveled I learned to become aware of my individual senses, my strengths, and my weaknesses. The mountains helped shape my character and have given me a way of seeing everyday life from a different vantage point.

This different angle, this other perspective, is what I would like to offer the reader of this book. My attempt is to show, in word and picture, what vast treasures of beauty, enjoyment, and satisfaction can be discovered in the mountains of the world and what they can contribute to our life in the urban environment—how they might help us come to more harmonious terms with ourselves, our fellow citizens, and the natural environment that supports us.

The treks herein represent many good times, but a few tough moments also: snowstorms, dusty rides on backbreaking dirt roads across seventeen-thousand-foot passes, cold and windy nights, and even hunger. Why does anyone give up the comforts of civilization for such travels? Perhaps we respond to that spiritual drive in all of us, that quest for ultimate meaning or challenge.

Perhaps in the end the challenge is not the mountain, or the arduous trek, or the treacherous river crossing, but ourselves. The mountains attempt to cut us down to size, inflicting fatigue, cold, and fear, and perhaps sapping our self-confidence. Yet the adventurer learns to accept these discomforts of his own volition while struggling to maintain fortitude. That is meeting the real challenge—the adventure within.

Leo Le Bon
Berkeley, California

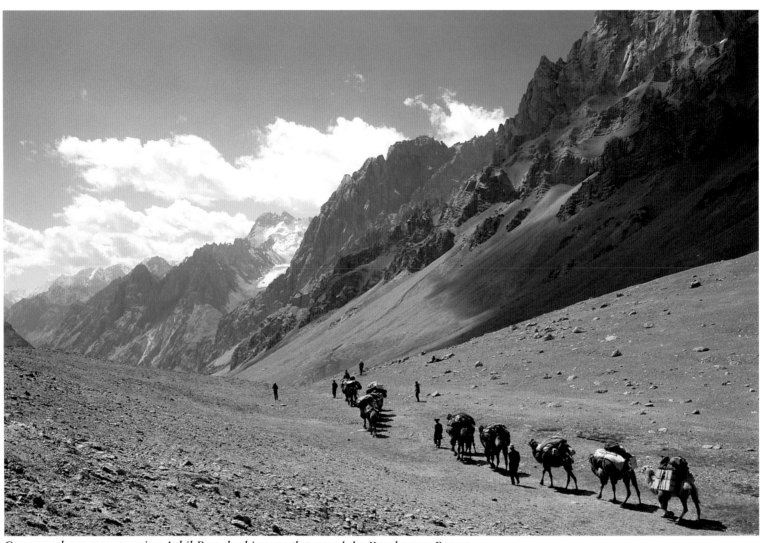

*Our camel caravan crossing Aghil Pass, looking south toward the Karakoram Range.*

# CHINA
# *The Karakoram Trek to K2*

*The most interesting parts of a map are the blank*

*places. They are the spots I might explore some*

*day. . . . I make imaginary use of them. . . .*

*—Aldo Leopold*

TAKLA Makan, K2, Shaksgam, Sarpo Laggo—these names have fascinated me ever since I met Eric Shipton at a lecture in San Francisco in 1966. Although Shipton talked of his recent adventures in the Patagonian icecap, the conversation afterward turned to other epic treks he had made, including one of his greatest adventures, a trip to the Karakoram Range in 1937. Later he sent me a copy of his book *Blank on the Map,* an account of his exploration of the northern solitudes of the Karakoram Range and K2, the second highest mountain in the world. That five-month-long expedition began in Rawalpindi (now in Pakistan). Shipton then crossed the Karakoram Range by the 18,650-foot Sarpo Laggo Pass and surveyed eighteen hundred square miles of what the explorer Tom Longstaff called "one of the most difficult mountain fastnesses in the world," a region that included two major rivers, the Shaksgam and the Zug Shaksgam. He also climbed up into the great amphitheater under the forbidding north wall of K2 and produced an accurate map of southern Chinese Turkestan.

Even though I became involved in the adventure-travel business around the time I met Shipton, I never dreamed I would visit such an exotic place. No matter how well connected one might be with certain aspects of exploration and adventure tourism, certain locales forever recede from one's grasp for one reason or another. The northern Karakoram was to me an even more elusive goal than Tibet. China was hermetically sealed off to all tourism for nearly thirty years; then, in the late 1970s, the political climate suddenly changed. First the eastern and southern parts of the country were opened; then, in 1979, I became one of the first Westerners to visit Urumchi, the capital of the westernmost province of Sinkiang. On returning to Beijing I heard about the Chinese Mountaineering Association (CMA) and the opening of eight major peaks to foreign climbers: Everest, Shishapangma, Minya Konka, Muztagata, Kongur, Kongur Tiube, Anyemachin, and Bogda. This led to Mountain Travel's first expedition to China (Minya Konka—see Chapter three) and subsequent visits to other remote parts of China and Tibet.

As I expected, the Karakoram Range was not on the list of opened areas, and the "blanks" on Shipton's map remained as elusive and forbidding as ever. Then, on a visit to Beijing in January 1982, I was told that the northern Karakoram *had* been opened. Suddenly those old magical names—K2, Takla Makan, Sarpo Laggo—acquired a new meaning, and I knew I would finally be going there.

The CMA suggested I take out a sixty-day reconnaissance permit to explore the entire area, including K2, Broad Peak, and the two Gasherbrums—the four eight-thousand-meter

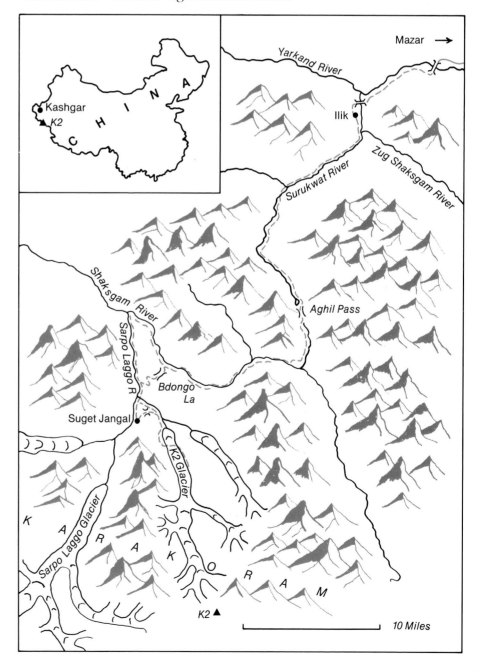

(approximately 26,250 feet) peaks of the Karakoram. I was ecstatic, but not for long. It soon became apparent that the expenses of traveling in Sinkiang under the CMA's auspices were extremely high, and I had to postpone the trip until the fall of 1983, when I found a small party of trekkers who were willing to share the cost.

On our way to Urumchi aboard a Chinese CAAC jetliner, I read *The Heart of a Continent*, Sir Francis Younghusband's classic 1887 account of his seven-month journey from Beijing to Delhi via Chinese Turkestan and the icy Karakoram. Shipton's predecessor, then Lieutenant Younghusband, was the first European to see K2 from the north and to cross the Karakoram from north to south. We would be retracing his footsteps from the roadhead at Mazar, which we planned to reach in six days, traveling by air and bus via Urumchi and Kashgar, then on foot to the base of K2. From there we would attempt to ascend the glacier leading to the great amphitheater at the foot of the north face.

We stopped briefly in Urumchi, the capital of what is officially known as the Uigur Autonomous Province. This city has become a boom town in recent years, the industrial hub of an area covering one sixth of China's land surface.

We continued by air to Kashgar, where we were met by the CMA representative. Kashgar, a Muslim city of 160,000, is inhabited mostly by Uigurs, ancient descendants of the Turks. It is more than two thousand years old and had been closed for decades to the outside world. Though the Uigurs form the ethnic majority, there are also Kazak, Kirghiz, Tajik, Uzbek, and other minority groups. In the bazaar, perhaps the last large open-air market in Central Asia, various nationalities could be identified by their traditional headgear and clothing. We visited the Id-al-Kah Mosque—the largest in Kashgar—as well as the shrine of the imperial concubine Hsiang. In the ancient city of Hanoi, twenty-five miles west of Kashgar, we found pottery shards amid a few crumbling earthen walls. My most vivid memory of Kashgar—aside from the ever present mosques, bazaars, and donkey carts—was the huge statue of Chairman Mao Tse-tung looming over the People's Park, his arm outstretched in a paternal gesture.

We stayed at the former Russian consulate, now converted to a guest house for tourists, with a group of foreign journalists, the first such group to visit Kashgar. We were told by the hotel manager to keep a low profile and not to walk alone outside the compound. Our liaison officer had a more benevolent attitude and confided privately that if we did not ask for permission, he would not have to say no. With that hint our group took off. Tourists had just been allowed into Kashgar, and we enjoyed the city as much as the journalists, full of awe and wonder for the ethnic diversity of a city more akin to Rawalpindi or Peshawar than to the drab-looking cities of western China. Kashgar is the westernmost city of China, and to the journalists it was the end of the road, the ultimate goal. To us, the town was the beginning, the start of our journey into Central Asia.

The first day on the road, we drove from Kashgar along the southwestern fringe of the Takla Makan Desert, an inhospitable wasteland

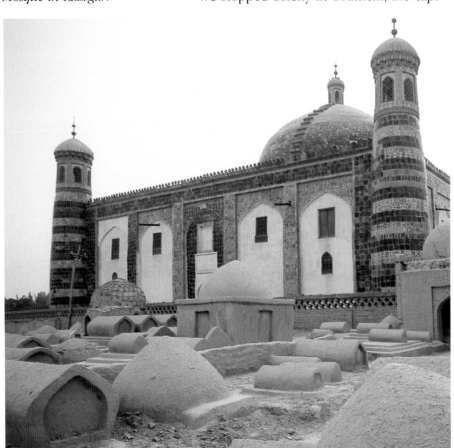

*Cemetery and Id–al–Kah Mosque in Kashgar.*

of 125,000 square miles. Mosques, donkey carts, melon stands, and an occasional open-air Muslim bakery, where we bought delicious freshly baked bagels, were the roadside attractions. Takla Makan ("The Place of No Return") is fringed only by the caravan paths of the Silk Road of ancient times. It is the setting for much of Peter Hopkirk's excellent *Foreign Devils on the Silk Road*, a book describing the turn-of-the-century adventures of Sven Hedin, Sir Aurel Stein, Albert von Le Coq, and other explorers who sought the buried Buddhist treasures of Chinese Turkestan. These treasures can be seen and admired today in the museums of Paris, London, and New Delhi. Le Coq, who carted three hundred crates (weighing one hundred seventy pounds each) of pre-tenth-century Buddhist murals to the ethnographic museum of Berlin, did not live to see their destruction during World War II. Of this rich past, little visual evidence remains; we saw only gray sandy wastes punctuated by oasis after oasis.

I had been told by the CMA planners in Beijing that we would travel by bus to the trailhead in three stages, with stops in Yarkand and Khotan. This turned out to be untrue, as we stopped first at Kargalik, some distance past Yarkand, and then along the road in the foothills, away from any habitation. To add to our frustration, we were not allowed to drive through Yarkand but made a wide detour to avoid the town altogether. When, after a seven-hour ride, we finally pulled into Kargalik, the driver headed straight for the Chinese guest house, a low structure surrounded by ten-foot walls and a huge iron gate. No sooner had the bus entered the courtyard than the gates were closed with a bang, and we were admonished not to attempt to leave the grounds.

A clear explanation of this rule was never given by our liaison officer; he only made vague excuses such as "This is to protect you from the crowds" or "Sorry, not allowed." To our persistent inquiries—"Why can't we go into town? What have we done?"—always came the inevitable blank stares. The officers could not comprehend our questioning their authority. They had their instructions and that was it. I was finally told by the chief of the local Security Bureau (the equivalent of our

FBI), "The foreigners are not allowed to visit the area—only to drive as quickly as possible to the mountains." But our group would not have it, and finally, after persistent negotiations, we managed to extract a major concession, a short walk through town. The conditions: We must all walk together, only on the main road, and with Security Bureau plain-clothsmen as escorts.

Our walk turned out to be a thrilling event, the highlight of our journey thus far. A huge crowd gathered soon after we left the compound—in fact they had already gathered there in considerable numbers, peering at us through the iron gate—and before long it nearly became a mob scene. What a strange feeling to be stared at and followed by a huge, silent crowd! The Uigur people were friendly and uninhibited, showing us inside their sidewalk stalls, offering slices of melon, posing for pictures. They were as curious about us as we were about them. We smiled, took photos, patted kids on the head, and bought trinkets. Two women in our group bought garish green bellydancing pantaloons; holding them up to their bodies, they executed a few swings

*Pond with poplar trees in Kashgar.*

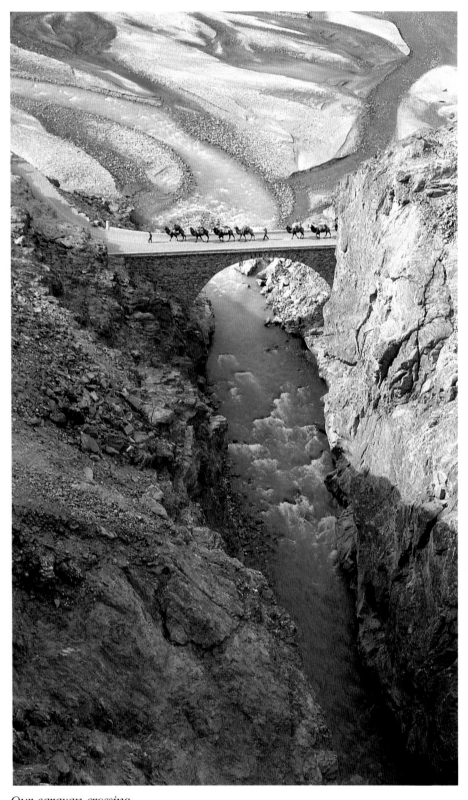

*Our caravan crossing the Roman arch bridge built in 1962 during the war between China and India.*

of the hip, much to the amusement of the crowd.

From what little I was allowed to see, Kargalik was similar to, but slightly larger than, the other desert towns we had driven through. Its streets were lined with dusty, flimsy poplars and small shops. Each mud-walled structure contained a set of wooden panels facing the street. After closing shop, the store owners hook up these boards, secure them with a padlock, and go home.

In Kargalik we met up with our legendary predecessor, Lieutenant Younghusband, who here made final preparations for his great leap into the unknown Karakoram. The name "Karakoram" apparently comes from one of the highest passes to the east and means, in Urdu, "Black Gravel," a misnomer for one of the most brilliant snowy ranges in Asia.

We ate our last restaurant meal at the Kargalik guest house, and on the next day we drove off early, enjoying sunrise over the Takla Makan from our dust-covered bus. A cook had joined us with an army truck full of provisions and fresh foodstuffs from the Kargalik market. We drove east along the Yarkand–Khotan road for a few miles, then turned sharply south onto the highway that leads across the Tibetan plateau to Lhasa. Soon the monotonous expanse of featureless desert gave way to high sand dunes, then to cliffs of sandstone and foothill peaks that reached upward to ten thousand feet.

From the Takla Makan Desert (elevation 3,900 feet) we ascended nearly seven thousand feet that day and crossed the Tupu Dawan Pass (10,800 feet) over an intermediate range of foothills. Along the way we visited the village of Kugiar, where at one of the few remaining camel-breeding stations in Sinkiang we picked up a couple of camel drivers who would come on our trek. (The camel contingent was to come later from Kugiar.) The Tupu Dawan Pass is truly a test of nerves. The road was almost too narrow for our large bus; it was, in fact, designed for army trucks, not buses. Often we would compete with a Chinese truck driver to see who could reach the next hairpin turn first. The pass, no more than a narrow cleft in a rocky ridge, offered our first mountain view, a distant glimpse of

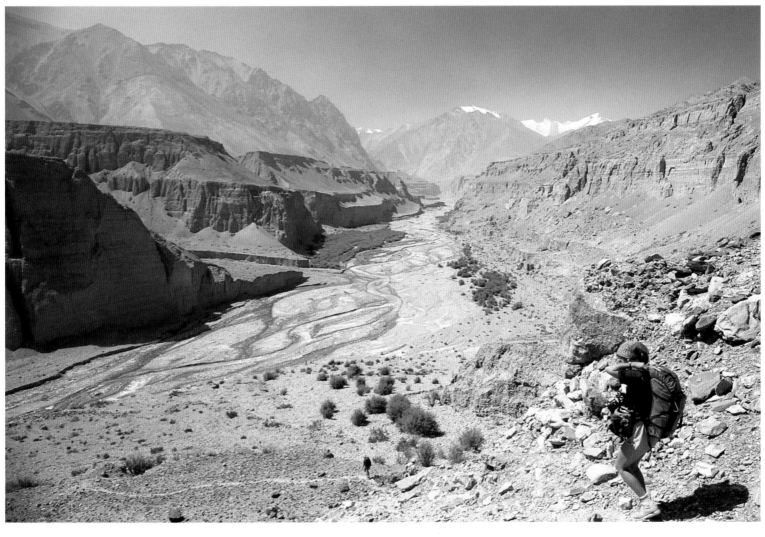

the snowy ranges to the south.

As we gazed at this vast sea of peaks, I concluded that one would be hard-pressed to find more isolated country anywhere in the world. Those intrepid explorers—Younghusband, Shipton, and the others—indeed showed courage and determination when they penetrated these wilds at a time when no road or motorized transport of any kind existed and no maps or guides showed the way.

That night we camped on a grassy meadow around nine thousand feet, just beyond Khudi, the last permanent habitation. We were now in the foothills of the westernmost spur of the Kun Lun Range, one of the largest in Asia. It divides Sinkiang from Tibet, and contained one of the highest unclimbed peaks in the world, Ulugh Muztag. (Ulugh Muztag was since climbed in 1985 by a joint Chinese–American expedition and surveyed at 22,923

feet.) Ahead of us lay the formidable Kun Lun and the Chiragsaldi Pass (16,300 feet), which the bus conquered the next morning. From the top we looked south toward the great Yarkand River Valley, or Yarkand Darya (drainage), the first of three that we would traverse before reaching K2. Descending to the river, we stopped briefly at a Chinese-army fuel depot and had lunch by the stream, at 12,100 feet. Vegetation is sparse in the hot and arid valley of the Yarkand; only grasses and small willows grow among the boulders. Yet the river is a turbid torrent of Himalayan proportions, its source the glaciers of the eastern Karakoram some eighty miles away.

The Sinkiang–Tibet Highway continues upstream along the Yarkand, but now we headed west, downstream, following the turbulent waters along the worst stretch of road imaginable, to Mazar Dara, twenty miles away.

*View looking up the Surukwat River canyon. The Aghil Range appears in the distance.*

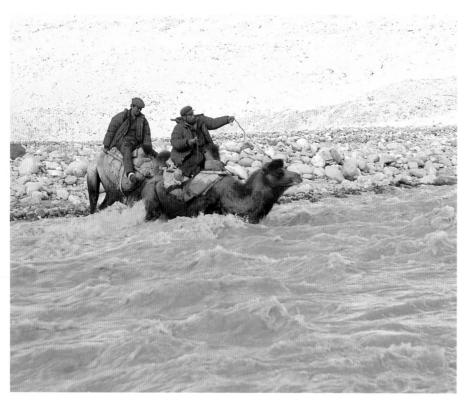

*Ilitude, our most
experienced camel
driver, testing the swift
waters of the K2 River,
the most perilous
moment on the trek.*

notation after his name in my diary: "Looks at girls." These five men made our journey a rich and human experience, for without them we would have been dependent on our CMA staff, who, though friendly and well-educated young Chinese from Urumchi, were not familiar with mountains and knew nothing of the area.

Except for a few Kirghiz nomads, we were to encounter no inhabitants, and no permanent settlements, along the Yarkand Darya. Later, after crossing the Aghil Pass into the Shaksgam River Valley, we would see not a trace of human activity. Younghusband mentions seeing a few remains of stone huts and some evidence of cultivation in the Yarkand Valley, but we saw none.

Ready to start the trek, we set out the next morning from Mazar Dara, waved off by a stalwart group of Australians who had preceded us by several weeks but had been unable to cross the Shaksgam River and reach the base of K2. They wished us luck and warned us about certain river fords. As it turned out, we had no problems. Some of us even crossed without using a camel where the Australians had turned back. Earlier—at the Kashgar airport—we had met the Italian team that had just completed the second ascent of the north ridge of K2. They too had had a rough time crossing the rivers, even losing a camel to the torrent; two of their climbers had to swim for their lives. We were three weeks behind the Italians and two behind the Australians, and we knew the water level dropped rapidly after the middle of September. So, with some apprehension but with confidence that we would succeed, we were off, the camels following, on a six-day trek toward our base camp below K2.

Climbing over the collapsed bridge by the Mazar stream, we followed the right bank of the Yarkand for about a mile. At a bend in the river we came across a large stone bridge built in 1962 by the Chinese army during the war with India. Without this bridge it would have been impossible to cross the Yarkand because the water level was too high.

Crossing the bridge, we were soon overtaken by our camel caravan. The area was quite hot, with little vegetation except for

We were stopped at dusk where a small bridge over the Mazar stream had collapsed. By prearrangement with the CMA I had requested camel drivers to meet us here with their beasts. At first we refused to go near the camels, as they smelled absolutely foul. (Toward the end of the trip no one seemed to notice the smell any longer.) The men and their animals had come a long way—eight days from Kugiar, the "camel commune," across deserts and high passes. The camels were here not for us to ride but to carry our supplies and baggage and to help us ford the rivers of the Karakoram, still at a fairly high level toward the end of summer.

In addition to our sixteen Bactrian camels (a two-humped, larger and stronger version of its African cousin) we had five Uigur camel drivers, all from the village of Kugiar. They ranged in age from twenty-two to sixty-five and were named Kharaja (twenty-two), Ilitude (fifty), Riaz (sixty-five), Ushur (twenty-three), and Eniva (twenty-five). Riaz, whom we called Grandpa, told me that when he was young he had crossed the mountains with camel caravans and visited Pakistan. Kharaja was a smiling young man who loved to dance at night by the campfire. I remember Ushur best by my

sparse growth of willows and tamarisks that flourished by the river. Huge slopes of fine brown gravel, which we estimated to be four thousand feet high, reflected the rays of the sun and dwarfed man and beast. Above this gravel slope craggy peaks of shale and slate thrust upward for an equal distance. After a trail lunch of cheese and salami, we found the old road collapsed in several places along the river; the going was often rough, forcing us to descend to river's edge.

Farther downstream we passed a steep gorge where, according to Younghusband, infidels were thrown into the foaming Yarkand hundreds of feet below. A few miles farther a narrow valley opened onto a vast plain ringed with high peaks, some covered with snow. This was the valley of the Surukwat River, which drains the Aghil Range, mountains we would cross later during the trek. To my right the Surukwat cut through a broad volcanic-rock band several hundred feet high and joined the Yarkand in its mad rush for the Takla Makan Desert, where it disappears into the Tarim Basin. Younghusband had somehow managed to drive his donkeys up this gorge; the ice-covered boulders cut the knees of his animals. Alongside these cliffs we found a small, hand-made Roman arch of solid stone construction. There was another bridge, also dating from the 1962 war. Our liaison officer told me that thirty-four soldiers had died when the bridge's scaffolding collapsed.

After we crossed the bridge the terrain quickly leveled out. Here, on a small sandbar known as Ilik, we set up our first trek camp. The weather was clear and warm, so we did not use tents. Around us and to the south were snow-clad peaks. To the west we saw the distant Aghil Range, but of the mighty Karakoram nothing was yet to be seen—and nothing of it would be seen until we reached Aghil Pass. Shipton had come as far north as Ilik, then retraced his steps and returned over the mountains to India.

On the second day our camel drivers, some of whom had worked for the Italian expedition, showed us a shortcut, a narrow track high up on an ancient alluvial terrace that paralleled the valley. Made of conglomerate (small boulders and pebbles hardened to-

gether with clay and sand), the terrace was sparsely covered with various plants and shrubs, some of which were in bloom. Large boulders offered shade and a modicum of coolness in the dry heat of this high-altitude desert. Turning a large bend in the Surukwat, we could see in the distance, across the river, the confluence with the rather small Zug Shaksgam, ("zug" means "false" in Urdu), a river that Shipton explored. Huge terraces were visible above the Zug Shaksgam, and high-water marks betrayed an astonishing volume of runoff during the recent past. Shortly after noon our terrace narrowed and vanished into a rocky wall, forcing us to descend to the water's edge past hanging vegetation.

The walls of the Surukwat now began to close in, while the vegetation near the river became dense. Eventually the valley devolved into a canyon, with walls consisting mainly of brown and ocher slate. Closer to the river, vertical walls of conglomerate stood as if cut by a sharp knife. We camped near a clear stream coming in from the west.

By dawn the Surukwat had shrunk enough so that we could wade across. (Snow-fed streams shrink in volume during the late night and early morning due to lowering temperatures.) We were now at the entrance of a very narrow gorge, where an old trail led first steeply up and over the gorge, then down again to a small rocky clearing. Later, after crossing a ravine, we finally emerged on a narrow but long gravelly plain that ran headlong into a sheer wall of steep snow-and-ice peaks—the northern escarpment of the Aghil.

We ate lunch in the center of the flat, barren plain under lowering clouds and snow flurries. The temperature had dropped sharply during the night, and now, as we approached the high peaks of the Aghil, an icy wind swept the valley. It was here that Younghusband's guide, after looking desperately at the impenetrable wall ahead, told him he was lost. Indeed, the route was impossible to detect from below; only after we approached the mountain wall did a passage to the east reveal itself. The Surukwat had by now become a small stream that we could ford easily by jumping from boulder to boulder. On the slope that led to the pass we encountered a small summer set-

*Muslim shepherd along the Sinkiang–Tibet highway.*

tlement of Kirghiz yak herders sheltered in crudely made stone huts. We spent some time with them. I bought a multicolored piece of hand-loomed cloth from one of the girls, and they offered us fresh yak yogurt. Later, after several more hours of steep uphill walking, we reached a campsite at fifteen thousand feet, a grassy slope near another small settlement of Kirghiz—the last that we would see.

Next morning the weather cleared, and in less than two hours of walking over gently rising terrain I reached a small tarn and soon stood on the Aghil Dawan (15,680 feet). A sea of peaks unfolded to the south and east, while close by along the ridge rose the ice-clad limestone Aghil peaks, their sharp summits cresting at more than twenty thousand feet. Younghusband had stood on this pass almost a hundred years ago, the first European to do so; Shipton had followed him fifty years later. Both men had felt and described their excitement at reaching this divide, and, as we huddled together sharing a few snacks, we too shared the magical grandeur of this lonely and wild spot.

After lingering on the pass for nearly three hours awaiting our camel caravan—one of our trekkers, affected by the altitude at our last camp, was riding the lead camel—I started to descend toward the Shaksgam Valley, which was visible from just below the pass as a small, shiny ribbon winding its way between towering peaks and rocky walls. The descent to the river proved straightforward, but the trail was virtually nonexistent and the terrain fairly difficult, especially for the tender-footed camels. Toward the bottom the wide ravine by which we were descending narrowed into a gully offering a spot of shade and then opened onto a broad alluvial fan.

A great view of the Shaksgam River (12,900 feet) awaited us. The river's course sprawled for miles, with innumerable small streams lacing a mile-wide channel of gray gravel. On both sides steep walls rose to alluvial terraces; in places these walls were several hundred feet high and impossible to climb up or descend. Beyond, the rock-and-ice peaks we had seen from the pass now thrust up in straight gigantic sweeps I had never seen before. So outscale was the terrain that what I

perceived as a thirty-foot terrace wall turned out to be nearly three hundred feet high. Standing near the edge of one of these crumbling walls of sand, pebbles, and boulders, we wondered how we would get down. I remembered Younghusband's similar predicament, and how he found wild-ass tracks that led down a small gully—not more than three feet wide—and to the water three hundred feet below. Our heavily burdened camels could not descend this chute and had to be detoured several miles to the east. (Younghusband had unloaded his donkeys before forcing them down the chute). It is amazing that nearly a hundred years after an explorer discovered such a key passage the same spot could not only be located but still be used in the same fashion.

The CMA staff had made an exploratory trip to K2 in 1979 and had forded the river about a mile below the chute. Shipton, nearly fifty years ago, had also figured that this was the correct spot, and so did our camel drivers. They took off with the animals and crossed without mishap while we remained on the north bank. Having unloaded at a wooded spot, they came back across the river to pick us up. This was the first major crossing, and I was apprehensive as we rode the huge camels across the swift, wide river. We climbed aboard as best we could (no easy task!), two to a camel and three camels to a string. A camel driver took charge, and without much ado we reached the opposite shore. Camp was set up and hot tea was ready when we pulled in, and the exciting experience was soon dismissed as a minor affair.

Continuing downstream along the easy left bank, we came to a section where one of the river channels churned against the steep and unstable limestone talus. We managed to ford, on foot, to a gravel bar, but then a larger channel, deep and swift, forced us to await rescue by our camel caravan. This happened several times that day and the next. We were once again on the right bank, and foot travel was easy once more: pleasant hours along the sandy, endless river flats, the towering limestone peaks surrounding us. Above these sandy flats rose huge walls of conglomerate— even bigger than those we had seen in the Su-

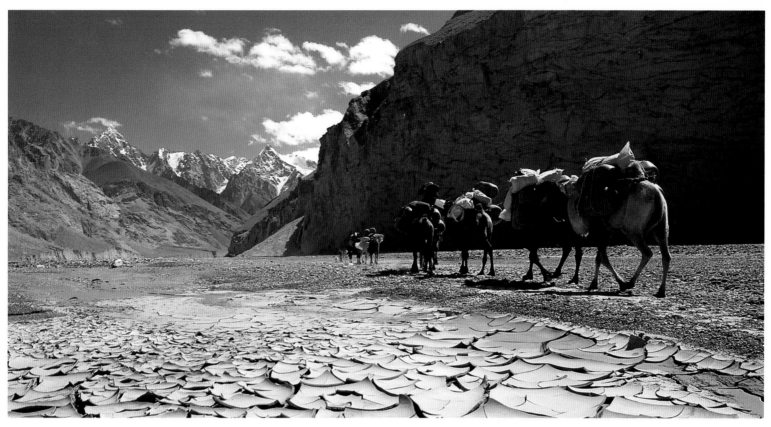

rukwat Valley—slashed here and there by steep ravines descending from the craggy peaks. Our fifth camp, similar to previous ones, was set up along this bank in a sandy clearing among red willows, tamarisks, and dwarf birches. We found a patch of dead willow wood and had a campfire replete with Uigur song and dance—an event in which our cameleers joined in wholeheartedly.

On the final day traveling toward base camp we crossed the Shaksgam once more; then, after walking most of the morning, we spotted in the distance the junction with the Sarpo Laggo River. Our route lay around a rock peak to the south of this confluence. But before reaching this junction we began a shortcut over the Bdongo La (*la* means "pass"), a 14,200-foot pass to the left. This pass requires third-class scrambling—we had to use our hands—and it is more of a mountaineering passage than a trekking route. Although we crossed and made it safely down the far side, this route is definitely not recommended.

While we descended the steep sandy slopes of the Bdongo La, our diminutive camel caravan slowly made its way around the rock peak two thousand feet below. Suddenly someone yelled "K2, K2," and for an instant, in a glint of blue sky, high above all other peaks, I saw a gigantic mountain of sweeping

proportions. Before my camera could grasp the image it was gone, not to be seen again for several days. This was exactly where Younghusband had first seen K2, and he later wrote:

I chanced to look up rather suddenly, and a sight met my eyes which fairly staggered me. We had just turned the corner which brought into view, on the left hand, a peak of appalling height, which could be none other than K2, 28,278 feet in height [officially now 28,250 feet], second only to Mount Everest. Viewed from this distance, it appeared to rise in an almost perfect cone, but to an inconceivable height. We were quite close under it—perhaps not a dozen miles from its summit—and here on the northern side, where it is literally clothed in glacier there must have been from fourteen to sixteen thousand feet of solid ice. It was one of those sights which impress man forever and produce a permanent effect upon the mind—a lasting sense of the greatness and grandeur of Nature's work—which he can never lose or forget.

Younghusband did not see K2 up close again, for he marched past Suget Jangal and continued his journey toward the Muztagh Pass and India.

A heavy cloud cover had by now crept

*The broad, flat Shaksgam Valley with the rocky ramparts of the mighty Karakoram Range coming into view.*

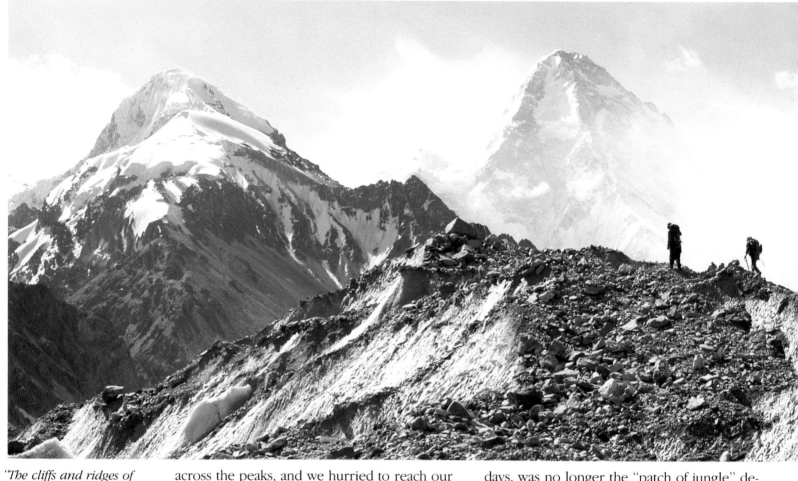

*"The cliffs and ridges of K2 rose out of the glacier in one stupendous sweep to the summit of the mountain, 12,000 feet above. The sight was beyond my comprehension, and I sat gazing at it, with a kind of timid fascination...."*
—*Eric Shipton.*

across the peaks, and we hurried to reach our base camp at Suget Jangal before dark. But two miles short of camp we were stopped by the raging waters of the K2 River, a greater obstacle by far than anything we had seen previously. Although the volume was less, the river channel was narrow and deep, and the water was a mountain torrent. I watched with concern while our experienced cameleers walked up and down along the bank studying the wave action, discussing among themselves what would be the best place to cross. Eventually Ilitude—the man with the biggest camel—led his reluctant beast into the torrent. He made it, but just barely. The Bactrian camel, it turns out, is adept at fording rivers providing the water does not reach the belly, for if it does, not only does he become buoyant but the water pressure on his upstream flank causes him to lose his footing. The underbelly of Ilitude's camel was wet, but the other drivers now felt confident and, after tossing off all loads, invited us to mount for the ride—perhaps the most frightening part of the trip. Once we were safely across, the poor creatures were again driven into the frigid waters to retrieve the loads and the remaining staff.

Suget Jangal, our home for the next five

days, was no longer the "patch of jungle" described by Younghusband, but rather a sadly denuded and trampled-over climbing base camp. Three expeditions had been here recently—the Chinese in 1979, the Japanese in 1982, and the Italians whom we had met. Several large army tents had been left behind by previous occupants, and we found some small plots of vegetables that had been started by the Japanese and the Italians. Mourning doves, hoopoes, and finches were the new permanent residents, living off the scraps of these expeditions. Aside from these birds no wildlife was seen during the entire trek, which was rather disappointing, especially as this entire basin is permanently uninhabited by people.

I had allocated five days to explore K2 Glacier and the great amphitheater below the north ridge—to see what Shipton had described as "a sight beyond my comprehension." Six days are in fact needed to reach the advance base camp and return. There are two possible routes of access on the first day, depending on the amount of water in the K2 River. If the river is low—early spring or late fall—it is possible to enter the gorge with camels and ferry loads to the snout of the glacier. If the river is not passable, one must

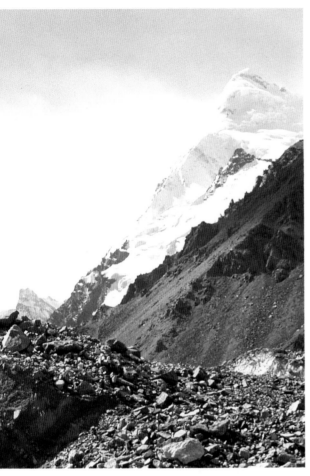

climb a high ridge east of Suget Jangal, traverse a thousand feet above the stream, then descend via third-class scree slopes to the snout of the glacier. A campsite can be found among the boulders near the snout.

On day two, one proceeds as follows: Ascend to the right of the glacier, following a narrow gully between the ice and the rock; half an hour later the tip of K2 appears above the glacier. Continue on a narrow climbers' footpath for several miles, until the level surface of the glacier is reached. Traverse here over easy but broken terrain (rubble over ice) to the true right bank, a distance of about one mile. Continue along this side for several hours. Cross a tributary glacier, the only one coming in from the east. Camp as far up as possible. On day three veer toward the center of the glacier and locate a moraine-covered trough—or ramp—that leads onto the smooth surface ice at the head of the glacier. Camp just before reaching that upper portion, near a rocky spur, on rubble-covered ice. Under good conditions, and with the route marked with willow wands, this trip can be made in mountain boots without the use of rope or ice ax. It is prudent, however, to have these tools available should conditions dictate.

All this information was not known to me when we arrived at Suget Jangal. The camel drivers said they would not take their animals into the gorge because the water was too high. They suggested that we reconnoiter to determine if we could enter the gorge on foot. Our first day was taken up with checking the gorge and making alternative arrangements (a visit with camels to the Sarpo Laggo Glacier) for trekkers who would not be backpacking up the glacier. Our second day was a much-needed rest day. On day three we left with tents, sleeping bags, and three days' worth of food, and, after contouring the high ridge east of camp—we had decided not to use the gorge after all—we descended to the snout of the glacier, where we camped. On day four we reached the top of the glacier and traversed it diagonally to a point where our view of K2 was about to be blocked by an intervening ridge. Not having time or a reason to continue—we would not see K2 again that day if we had—we spent the noon hours marveling at the huge ice-clad peak for which we had come so far. It was a sight beyond our comprehension, and although we were still a fair distance from the base of the mountain, its sheer size was overwhelming. A tempest was blowing around the peak and we had only occasional clear views, but each one of those moments was so precious that we could not keep our eyes away from that enormous precipice. Reluctantly, and only after waiting the last half hour without seeing K2—the storm was now in full force—we returned to our snout camp. On the fifth day we bypassed the gorge by climbing back up the ridge; there was still too much water to round a corner of rock in the river.

Our return journey to civilization was uneventful. We arrived at Mazar six days after leaving Suget Jangal, just as our bus driver pulled in. It snowed heavily on the Kun Lun Mountains that last night while we camped at Mazar, and we had a hard time getting over the frozen 16,500-foot Chiragsaldi Pass with bald tires and no chains. We drove back to Kashgar in two days, instead of three on the way out. The extra day was well spent in Kashgar among the mosques, bazaars, and donkey carts of this once important city on the Silk Road.

*Breaking camp on the Tibetan Plateau in view of the Himalayas while yaks graze nearby.*

# *Everest: The Kangshung Trek*

*As the Sun dries the morning dew, so are the sins of man*

*dissipated at the sight of the Himalaya.*

*—From the Puranas*

IN the spring of 1981 I received a telex from the Chinese Mountaineering Association in Beijing with the exciting news that Mountain Travel had been granted a permit to trek to Mount Everest from the Tibetan side. I immediately started preparations, looked at numerous maps, and read the accounts of the early explorers. Six months later, after assembling a group of fourteen trekkers and completing the complex negotiations with the CMA, I walked into the Chinese Consulate in San Francisco with fifteen passports in hand for the coveted and rare visas that would allow entry into Tibet. While a clerk stamped our passports with a big red star and Chinese characters, I recalled some of the elaborate and flowery language of the historic permit issued in 1920 by the Dalai Lama to the British for their reconnaissance expedition to Everest. The permit reads partially as follows:

> ... a group of white men will be traveling to the west of the Five Treasures of the Great Snow [the Kanchenjunga massif] in the jurisdiction of the Fort of the Shining Glass [Shegar] near the Monastery of the Valley of Deep Ravines [Rongbuk] in the Southern Land of Birds [Southern Tibet].

We flew to Beijing, then to Chengdu, in Sichuan, then to Lhasa. Shortly after the takeoff from Chengdu I tried to catch a glimpse of Minya Konka (24,790 feet), the great peak of western Sichuan, where I had spent six weeks the previous year (see Chapter Three). My efforts were in vain: large altocumulus clouds covered the region. Later the Himalayas came into view from the south. With the help of several maps I managed to identify Namche Barwa (25,446 feet), the last high peak of the Himalayan uplift at the eastern end of the chain; it is the world's highest unclimbed mountain. Below the mountains I saw the Tibetan headlands that give birth to the greatest rivers of Asia, nurturing the civilizations of a continent and its two billion people. I marveled at the deep, dark canyons and shimmering ribbons of water of the Yangtze, the Mekong, the Yarlung Tsangpo (the Brahmaputra in India), the Salween, and the Irrawaddy. Within miles of each other these great rivers carve their paths off the Tibetan Plateau, falling toward the plains of Asia, to destinations as far apart as Shanghai, Saigon, and Calcutta.

Four hours after we took off from Chengdu our ancient Russian propjet landed

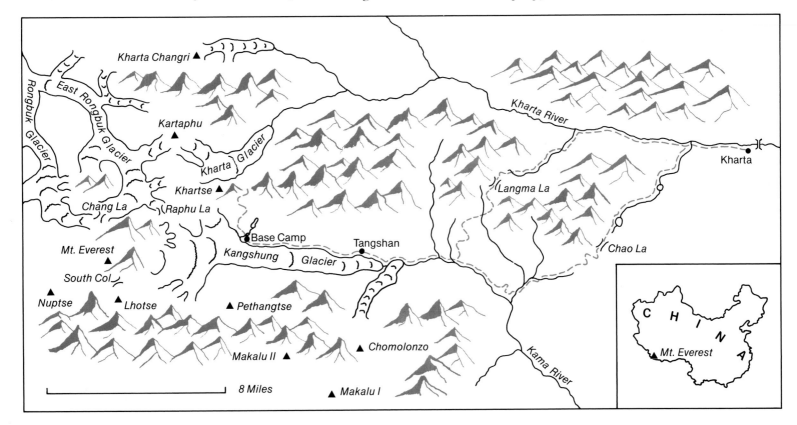

uneventfully at Lhasa airport on the Yarlung Tsangpo River, about eighty miles downstream from the city.

Stepping off the plane and setting foot in Tibet, I felt indescribable thrills. A waft of pure, aromatic air immediately intoxicated me, though no doubt the altitude (11,500 feet) had a hand in this. The fierce, blinding light set off everything in a highly contrasting manner, with the stark hills of the Tsangpo Valley rising majestically above. Landing at Lhasa I felt that I was coming home to something unknown yet familiar, as if my soul belonged here, among those mountains.

From the primitive but adequate airport a two-lane dirt road—now being paved—led west along the Yarlung Tsangpo for about twenty miles to where the Kiychu River debouches into the Yarlung Tsangpo from the north. We followed the Kiychu for several hours until, suddenly, we saw the gilded turrets of the legendary Potala Palace, the former residence of the god-kings of Tibet, atop a steep cliff strategically located in the center of the Lhasa Valley.

Reaching the holy city of Tibetan Buddhism was an anticlimax. In my romantic fantasies I had imagined a magical city, its golden roofs sparkling in the far distance with an ever growing crowd of Tibetans approaching from all sides: lamas, pilgrims, traders on foot, caravans of donkeys and yaks laden with wool and salt—all making their way toward the fabled city. I had imagined somehow being part of this crowd, entering Lhasa on foot as a turn-of-the-century explorer. Instead, I arrived by Japanese minibus.

We drove along the outskirts of the city on a well-paved road, then turned off onto a poplar-lined lane that led to the principal Chinese-government guest house, well sealed from all outside interference by a twelve-foot-high stone wall.

Once the great capital of Tibet and the repository of Tantric Buddhism, Lhasa was a forbidden city to the West until recently, when the Chinese government decided to allow foreign tourists to enter the city. During the nineteenth century Westerners raced to reach Lhasa, but most of those bold enough to try either perished on the way, were arrested and turned back, or gave up. It was not until 1904 that Francis Younghusband became the first European to enter Lhasa, at the head of the British Army during its Tibetan campaign. The Chinese annexed Tibet in 1950 and later es-

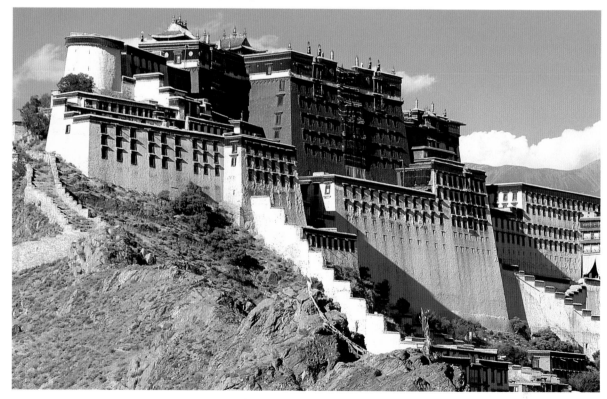

*The Potala, in Lhasa, largest edifice in Tibet, and traditional seat of the Dalai Lama, the "God-King" of Tibet.*

tablished control; the Dalai Lama fled to India.

During our four-day stay in Lhasa we visited those important cultural edifices that the Chinese allowed us to see. These included the Jokhang, the "cathedral" of Lhasa; the Drepung Monastery, at one time the largest Buddhist monastic center in the world, also housing the first Tibetan printing press; and the palace and gardens of Norbulinka, the summer residence of the most recent Dalai Lamas.

We climbed to the rooftops of the Potala—the palace is now a museum—and enjoyed a panoramic view of the city and the valley below us. The Potala, the largest edifice in Tibet, was begun in the seventh century during the reign of Songsten Gampo, the first Tibetan king. Thirteen stories tall, the Potala sprawls over more than four hundred thousand square feet. Its total height exceeds three hundred fifty feet. The original palace was destroyed in the ninth century during a period of internal strife. In 1645, during the life of the fifth Dalai Lama, Ngawang Lobsang Gyatso (all Dalai Lamas have the same name, because each is the reincarnation of the previous one), reconstruction was begun, and the Potala as we see it now was completed after the toil of half a century. Viewed from outside, the palace is divided into two parts, the whitewashed White Palace started during the fifth Dalai Lama's reign, and the red-painted Red Palace added later.

Extensive construction by the Chinese has changed the appearance of the city from a quiet mass of trees and huddled roofs to a nondescript cluster of corrugated roofs, squat government buildings, and concrete streets with lots of truck traffic. Yet, despite all the changes and modern incursions, Lhasa retains, in some hidden corners, the mystery and fascination of a forbidden city. I shall never forget the Jokhang area, its dark and narrow passageways crowded with throngs of Buddhist worshipers holding burning butter lamps; or the Potala, superbly detached, its massive red and white walls rising from the plains, a solitary testimonial to a past that is no longer.

We toured these cultural sites, and others, by Red Flag army truck, the local minibus having been booked by other tourists. No matter, we were happy with our open truck; it gave us

intimacy with the Tibetans and better photographic opportunities. Returning to our quarters one evening, we had the unique opportunity to meet both Tenzing Norgay and Sir Edmund Hillary, the first conquerors of Mount Everest in 1953. Tenzing was here as the representative of an American travel company, while Hillary had just returned from the Kangshung Glacier, our own destination. Hillary had suffered a bout with high-altitude illness and, if that were not enough, had been kicked in the head by a yak gone wild. He was recovering at the guest house outside Lhasa when we met him there with Tenzing.

Four days after acclimatizing and sightseeing in Lhasa, we started off on our three-day, six-hundred-mile road trip to Everest, known to the Tibetans as Chomolangma, the Mother Goddess of Earth. Heading west (in our minibus once again) onto the Tibetan Highway, we followed the wide and deep Tsangpo Valley, the breadbasket of Tibet. Then our bus climbed steeply out of this fertile oasis to the first of a series of high passes, the 17,500-foot Kamba La. At our feet on the far side of the pass was magnificent Yamdrok Lake (14,400 feet), the largest in southwestern Tibet. Although the shores are inhabited and the lake is reportedly abundant with fish, I saw no fishing activity of any kind, no boats, no nets. That night, after a dusty eleven-hour ride from Lhasa, we reached Shigatse, the second largest city in Tibet. A visit here to the famous fifteenth-century Tashilumpo was a highlight of our journey. The huge monastery was built in the fifteenth century by Ganden Truppa, successor to Tsong Khapa. Tsong Khapa was the great reformer of Tibetan Buddhism and founder of the Gelugpa sect (Yellow Hats). More than three thousand monks lived here before the Chinese took control.

The monastery was filled with lamas; the practice of Buddhism was very much alive. We observed many monks praying in the temple halls, and in the central hall hundreds of monks were engaged in loud and sonorous religious chanting, while drums and three-foot-long trumpets added a feeling of magic and mystery. This was in stark opposition to the monasteries of Lhasa, where only a handful of older monks quietly guarded the

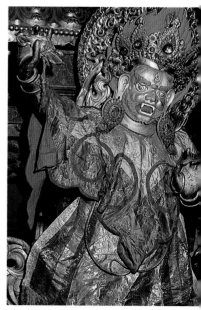

*Vajrapani, guardian deity who holds power over evil, wielding a vajra, a ritual tantric object symbolized by a thunderbolt.*

*Young Tibetan wearing sheepskin on the trail toward Mount Everest.*

*The Kamba La, looking south toward the Himalayas. Passes in Tibet are traditionally festooned with prayer flags, cloth imprinted with sacred mantras (mystic prayers) to protect travelers against evil spirits.*

shrines. Tashilumpo contains more than twenty-eight major temples, the largest and most important being Champa Hall, which houses an eighty-seven-foot statue of Maitreya, "Buddha of the Future," the largest religious image in Tibet.

From Shigatse (12,500 feet) we continued the next day to Shekar Dzong (*dzong* means "fort"). The road now became progressively narrower and dustier, the countryside more spacious. Here were the big open spaces of the Tibetan Plateau that I had read about. Later in the day we started climbing hills again; soon we crossed the Thso La (14,800 feet), then the Jatso La (17,200 feet), high and barren passes with great vistas of snowy peaks to the south. Finally we reached Shekar Dzong.

It is said that Everest—about fifty air miles from Shekar—can be seen from the top of the fort, although no one in our group found time to climb up. Monastery and fort were built, one above the other, on a steep rock peak that juts up fifteen hundred feet from the flat valley floor. We were told that monks used to kindle juniper fires at dawn

each day, praying for a glimpse of Everest's summit. The monastery buildings were connected with tunnels and walkways to the fort above; four hundred monks once lived here. According to C. K. Howard-Bury, the leader of the 1921 British reconnaissance expedition to Everest, the main lakhang (temple) contained a fifty-foot statue of Buddha that was regilded every year. All is in ruin now because of disuse, decay, and destruction at the hands of the infamous Red Guards during Mao's Cultural Revolution of the 1960s.

The English climbers of 1921 walked from Shekar Dzong to Everest base camp, a journey of more than two hundred miles. Our trip would take but one day by open army truck, from Shekar across the 17,300-foot Pang La, which on a clear day (alas, it was not) affords a stunning panorama of the north face of Everest as well as the entire Everest region.

Donning heavy down jackets and covering ourselves with a large tarp, we managed to keep dry and protected from the sleeting snow and the cold as we crossed the pass. Then we descended south to the Dzangkar

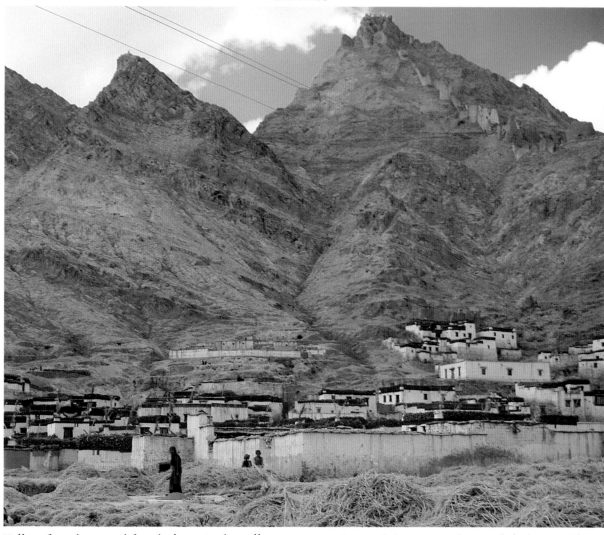

Valley, five thousand feet below. At the village of Tashidzong we veered east, following the broad Dzangkar River, whose waters drain the Rongbuk Glaciers of Everest. A new and well-built stone bridge across this river gives access to the immense Everest watershed. Following the stream to the confluence with the mighty Arun River, which flows into Nepal, we eventually reached Kharta (12,300 feet), our road-head, in late afternoon. Here our twelve-day round-trip trek to the Kangshung Glacier of Everest was to begin.

Everest's lower slopes were not always so accessible. Before the reconnaissance expedition of 1921 only one European had been near the peak: Captain C. G. Rawling, a member of Sir Francis Younghusband's military mission to Lhasa in 1904, viewed Everest from sixty miles away and thought of climbing it. Between 1921 and World War II the British were to send six additional expeditions to Everest, all of them starting from India and requiring a lengthy approach march through southeastern Tibet. (Nepal was sealed off for political reasons during this time.) Although

members of these expeditions failed to reach the summit, they did carry out a tremendous amount of exploration. They climbed scores of satellite peaks, drew maps, and published books. Mainly as a result of their efforts, our libraries have more material on Everest than on any other mountain.

A quick chronological review of the accomplishments of these parties reveals the scope of early exploration and mountaineering on Everest.

In 1921 the north, west, and east sides of Everest were reconnoitered and the extensive valley and glacier systems surrounding the peak explored. George Mallory, that superb mountaineer, was the first European to view the classic pyramid of Everest from the north and to see the now famous Rongbuk Monastery. (This Buddhist monastery, at 16,500 feet, is the highest inhabited dwelling on earth.) Mallory was also first to reach the Lho La, a 19,500-foot pass at the foot of the west ridge of Everest, from which he looked into Nepal and glimpsed the Khumbu Icefall, the successful approach route for Hillary and Tenzing

*(Overleaf) "Rising from the bright mists Mount Everest above us was immanent, vast, incalculable—no fleeting apparition of elusive dream-form: nothing could have been more set and permanent, steadfast like Keats's star, 'in lone splendour hung aloft the night' . . . ."*
*—George Mallory.*

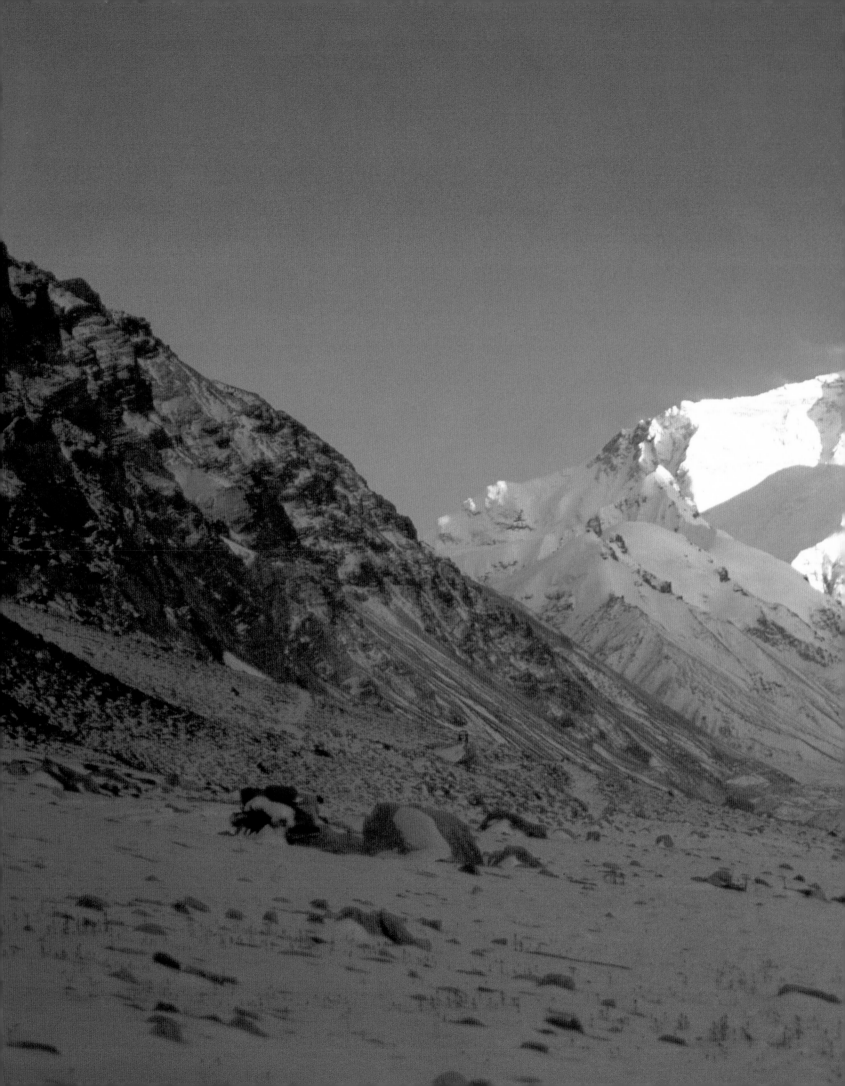

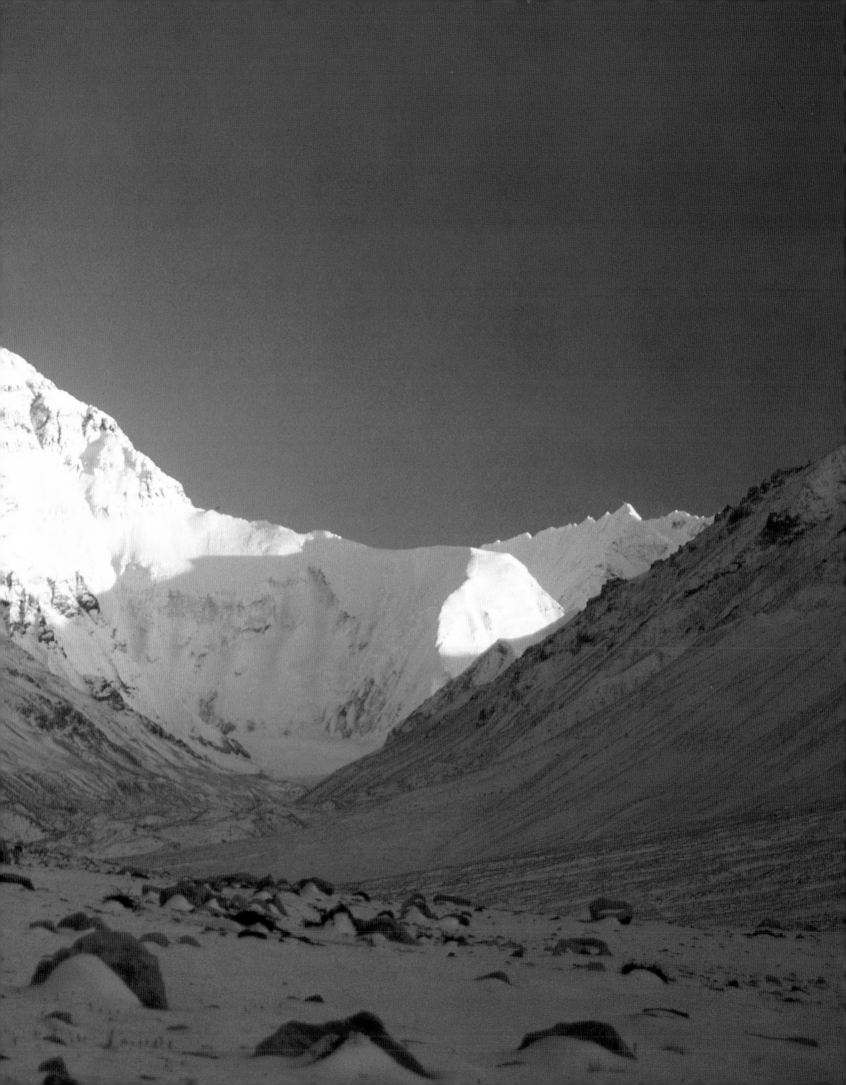

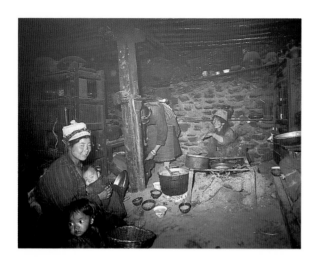

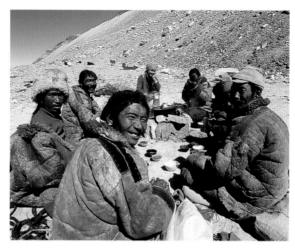

*(Top Left) The women of Kharta preparing the evening meal over the traditional open firepit in the center of the room. (Top Right) Our Kharta herders having lunch along the trail. (Bottom) The spectacular Kama Valley from near the Chao La. Mount Everest is partially hidden in swirling high-altitude clouds.*

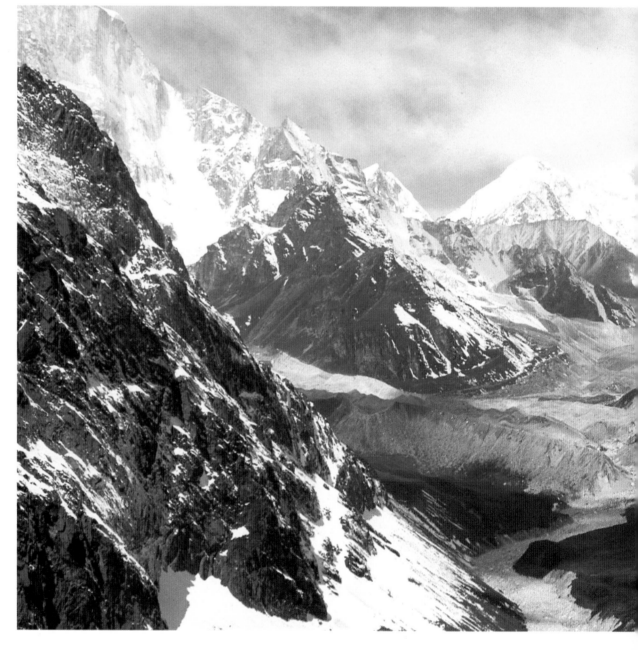

thirty-two years later. Mallory and his team also discovered the Lakpa La at the head of the Kharta Glacier. This 22,500-foot pass leads directly into the East Rongbuk Glacier and the foot of the Chang La (North Col), the eventual route to the summit from the Tibetan side. Mallory and two others managed to reach the North Col, at an elevation of 22,900 feet, but were not then prepared to go higher.

The British returned in 1922 to carry out the first full-scale assault on the mountain. Charles Bruce and George Finch reached 27,300 feet with oxygen; George Mallory, T. H. Somervell, and Edward Norton reached 26,800 feet without it. Both these altitudes were world records. The expedition also reached the Raphu La, a small col on the northeast ridge that afforded a look at the east side of Everest. In 1924 Norton reached 28,126 feet, a record that was to stand for twenty-eight years. Then George Mallory and Andrew Irvine, team members of Norton in 1922, disappeared at about 27,600 feet on the north face; they were presumed to have fallen into a crevasse.

A third full-scale expedition tried for the summit in 1933. L. R. Wager reached the great northeast ridge below the first rock step. In 1935 Eric Shipton made a second reconnais-

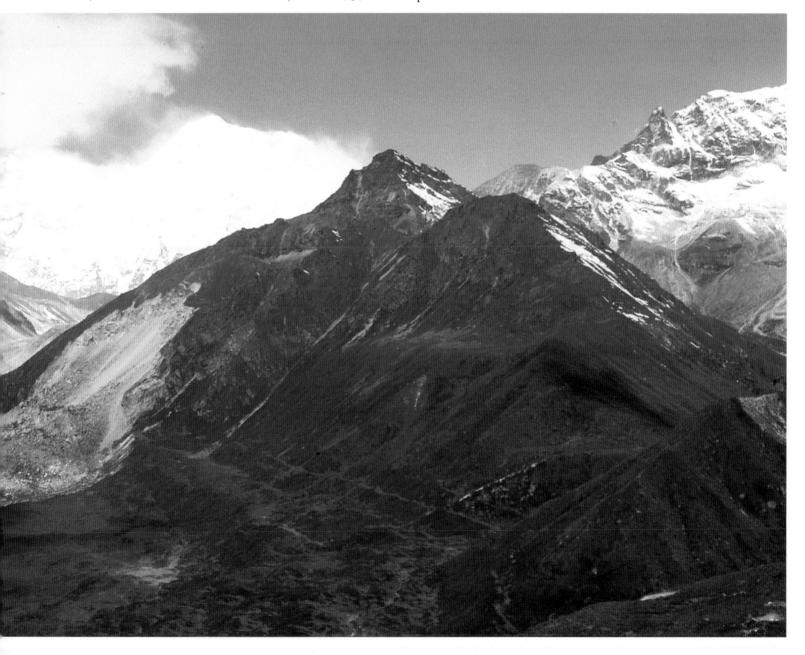

*Our camp in the upper
Kama Valley at 16,500
feet, during a lull in a
blinding snowstorm.*

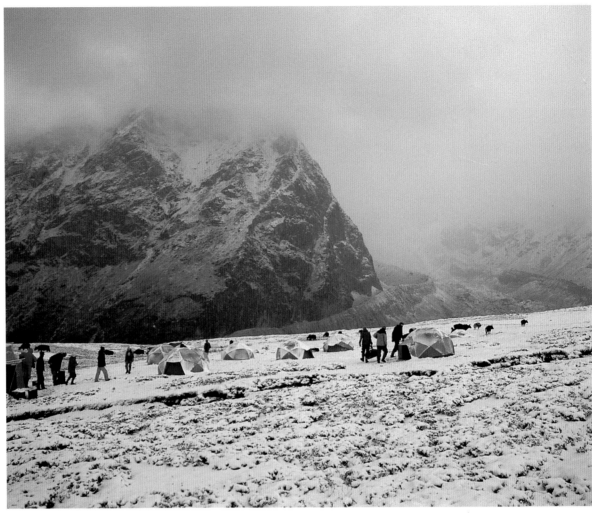

sance, without attempting the summit. Twenty-four peaks above twenty thousand feet were scaled during that expedition. Shipton spent two nights on the col between Pumori and Lintgren and was the first man to look deep into the Western Cwm, the glaciated valley on the Nepalese side of Everest. Michael Spender made photographic and photogrammetric surveys of the north side of Everest.

British attempt number five in 1936 explored the western slopes leading to the North Col, but these were judged too steep for the load-carrying porters. In 1938 Tilman led the sixth and last attempt before World War II. He crossed the Lakpa La into the Kharta Valley, reached the North Col from the west side, and attained twenty-seven thousand feet on Everest. Deep snow forced his retreat.

Shortly after the 1938 expedition the north side of the mountain was declared off limits to the West; indeed, all of Tibet and

China were closed by the communist revolution until 1979, when the government of the People's Republic once again opened the Everest and Shishapangma areas to foreign mountaineering and trekking expeditions.

After unloading gear and setting up camp at Kharta, I went to see the village headman to complete arrangements for yaks and herders to support our trek to the east face of Everest and back, a journey of twelve days. Having been assured that all was in order, we set off the following morning, delighted to be walking again after the noise and dust of three days of truck travel. We left early, taking in the fresh mountain air and the clear views of peaks all around us. As the yaks had not yet arrived in the village, I left Nigel Dabby, my assistant, in Kharta to bring up the yaks with the expedition loads. Kharta is not really a village but a district of small hamlets, each a cluster of homes built tightly onto one an-

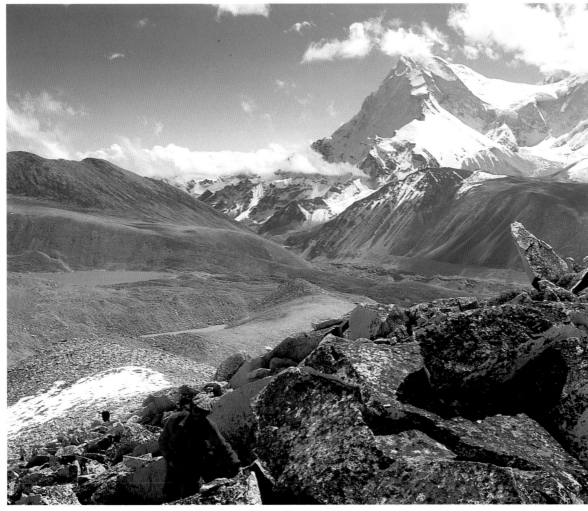

*View down the Kama Valley with Makalu peak rising to the right, from our twenty-thousand-foot ridgetop.*

other and linked by narrow, dark alleys and overhead passageways. As we walked through these hamlets and the fertile barley fields between them, smiling and playful children came out by the dozen to greet us. The villagers of Kharta have not always enjoyed the best reputation. On the American East Face of Everest Expedition, which preceded us, frictions between the members and the porters of Kharta led to a few fist fights after accusations of theft. However, we did not experience anything of a negative nature. To the contrary, we enjoyed visiting with the local inhabitants, who, although poor, welcomed us into their homes. The wife of the village headman, who had just given birth to their first baby, even visited our camp with the infant several times.

Past the villages the trail followed the Kharta River. After several miles in the narrowing valley dotted with wild roses and tall poinsettia bushes the trail headed straight up the south slope of the Kharta Valley over grass-covered mountainsides toward the Chao La (16,500 feet). At two o'clock our yaks were still not in sight, so I called a halt on reaching a dry meadow at around fourteen thousand feet. A big bonfire from rhododendron wood kept us warm until near dusk, when we heard with relief the faint peal of yak bells far below.

The eastern side of Everest is accessible to trekkers only from the roadless, V-shaped Kama Valley. This can be reached via two high passes to the north, the Chao La and the Langma La. Because both of these passes are due south of the Kharta Valley, it was our plan to cross first the Chao La, trek to the east face, then return by way of the higher Langma La (about 18,000 feet) to our roadhead, where our truck would await us for the ride back to Lhasa.

During the night a light snow fell, but the morning was clear and the sun soon melted the thin ice glazing our tents. Above camp a

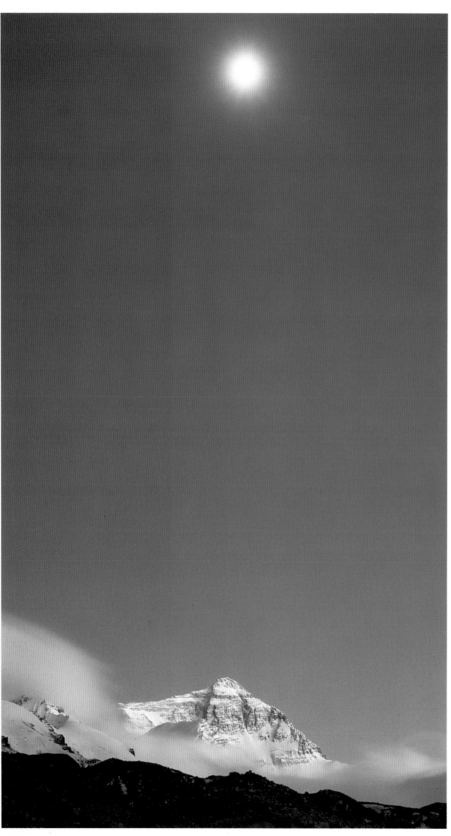

*Frosted moon over Everest.*

steep five-hundred-foot rise led to a shallow lake. Beyond, a steep gully led to a broad shelf set with a magnificent turquoise lake. Before seeing the lake I glimpsed the summits of some huge mountains to the south, which I immediately knew to be Makalu, the world's fifth highest mountain, and its sister peak, Chomolonzo. Although it was barely noon, we called a halt here to acclimatize and to savor the beauty of our location on the grassy shore of this pristine mountain lake.

We continued our journey the next morning, climbing a short but steep slope to the top of the Chao La. From here I looked up to a vast wilderness of superlative mountain passes and peaks: Chomolangma (Everest), the world's highest pinnacle; the South Col; Lhotse (27,940 feet); Chomolonzo; Pethangtse (22,100 feet); Makalu II (25,120 feet); and Makalu I (27,766 feet).

Described by Charles Howard-Bury as "one of the most beautiful valleys in the world," the Kama lay below us in a sea of clouds. After lingering for an hour, we descended grassy hillsides covered with flowers to a forested shelf two thousand feet below, yet still a thousand feet above the Kama Valley floor. Here, with water and wood available, and in a forest ablaze with the foliage of deciduous trees, we set up camp among carpets of gentians and primulas.

The next morning was again cold but clear. Across the valley towered the cliffs of Chomolonzo and Makalu, their snow-covered faces jutting more than ten thousand feet into the azure sky. They seemed much higher than Everest, still some distance away. Continuing our journey to reach the Kangshung face, we now followed a yak trail alongside the northern flank of the valley; here we saw silver fir, mountain ash, Tibetan cypress, rhododendrons of many varieties, and iris and other flowers. Around lunchtime we found a beautiful blue lake that I tentatively identified as Shurim Tso, and later that day we reached one of the campsites occupied by the early explorers, which the local yak herders said was called Tangshan. All afternoon we lay about enjoying the scenery, with the incomparable mountain wall of Chomolonzo seemingly an arm's length away across the valley.

After a cold but clear night we continued our traverse along the valley floor, a grass-covered plain interspersed with rhododendron shrubs, juniper, and dwarfed conifers. My altimeter read 15,200 feet. Except for a few grazing yaks and an occasional herder in the distance, we saw no one. The east side of Everest was ours alone as we pitched our tents on the tough, short grass.

On day six, following a faint trail along the north side of the upper Kama, we began to ascend toward the Kangshung Glacier. After passing a steep hanging glacier descending from the south side of the valley, which according to the 1921 party had almost barred access to the Kangshung Glacier (the smaller glacier has since retreated considerably), we finally emerged along the lateral moraines of the glacier, less than ten miles from the summit of Everest. We set up our base camp on a flat grassy meadow at 16,500 feet. This was where Mallory had first camped in 1921, and where he had gazed on the inaccessible east face of Everest. From that year until 1981 the Kama was empty of Western explorers and mountain climbers. In 1981 the American East Face Expedition made an unsuccessful attempt on the peak. In 1983 the core team returned and made the first successful ascent, setting a new landmark for Americans in world-class mountaineering.

During our two-day stay at base camp great avalanches thundering down the east face made loud cracking sounds like the firing of cannon. On the second day we climbed a rocky spur opposite the mighty face to the northeast. No rope was required for the climb, just stamina and willpower to negotiate the steep rocky ridge alternating with talus slopes. At last we reached the top of the ridge, which must have been twenty thousand feet high, and had a stunning view of the entire east face, now less than four miles away. To the south of the summit we could see the South Col, the original route that Tenzing and Hillary had taken to climb Everest in 1953. Farther south rose the peak of Lhotse, and across from us was the conical shape of Pethangtse. Farther east, between Chomolonzo and Pethangtse, we could see Makalu. To the north the Kharta Glacier lay spread out below us,

framed by countless twenty-three-thousand-foot peaks. To the west our ridge culminated in the ice-clad summit of Khartse (21,500 feet). Down and to the side of the ridge by which we had climbed, the shores of several dark glacial lakes offered convenient spots where we stopped to munch on salami and candy bars before returning to base camp in mid-afternoon.

We were now ready to return to Kharta. The Langma La, north and west of the Chao La, is higher and perhaps a bit more difficult. After two days of retracing our steps down the Kama, staying well above the river on the north side, we camped in cloudy weather above a junction on the now familiar trail. From here it would be up and down for two more days to cross the pass and reach Kharta. That night, however, snow began to fall. By late morning two feet had fallen. Our yak drivers, in a great rush to get going, were concerned that their animals would be unable to cross the pass, still two thousand feet above us. We started packing loads while the herders rounded up their yaks. We would have been hard-pressed to find our way safely across the eighteen-thousand-foot pass in the blinding snowstorm, especially since we had not come this way before, had it not been for the cunning and skill of one of the herders, who knew the route intimately.

Once we were over the pass the weather improved quickly, and as soon as we arrived below the snow line we set up camp in the gathering darkness. The next morning dawned overcast but rainless, and, passing a few lovely lakes on the way, we soon reached the Kharta River, which we followed along a good trail back to our camp by the village. Here we were greeted by our truck driver, who had waited for us with great concern. His tent had blown down in the storm two nights earlier, and he imagined a much worse fate for us. Three days later we were back in Lhasa, happy at having accomplished what I believe to be the finest trek in Tibet.

The valleys, ridges, and peaks Mallory discovered in 1921, 1922, and 1924 remain a challenge for all who long to visit the great Himalayan valleys surrounding the north and east sides of Everest.

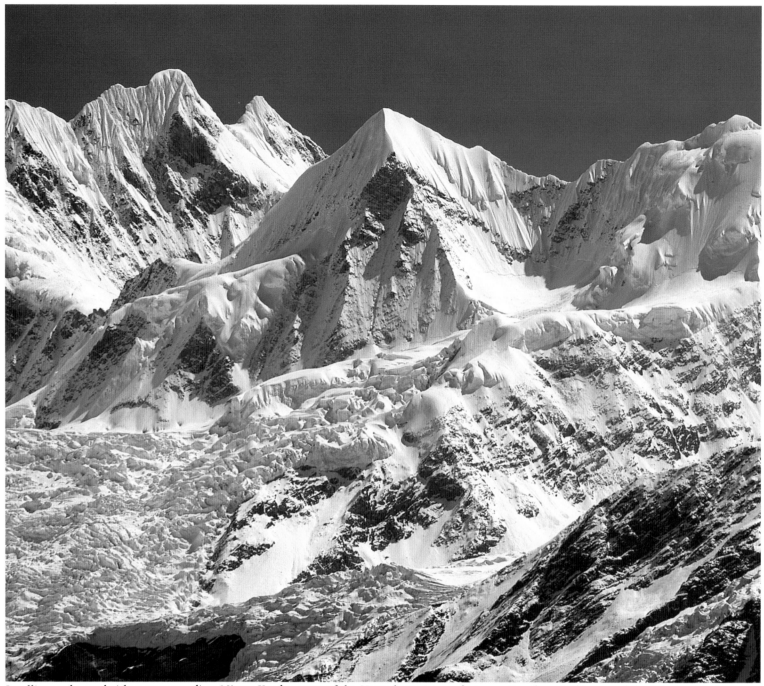

*Satellite peaks and ridges surrounding Minya Konka, part of the Hengduan Range between Southwest China and the Tibetan Plateau.*

# The Minya Konka Trek

*What a sight greeted our eyes! We were in a tremendous amphitheater hemmed in on all sides by jagged snow peaks which towered many thousands of feet above us . . . ; razor-like ridges were fantastically capped by coxcombs and cornices of snow so huge and weird that only in the Himalayan system do such formations exist. We forgot our tent, supper, and everything else to stand enthralled by the magnificence of the scene.*

*—Richard L. Burdsall and Arthur B. Emmons*

THE highest peak of the Chinese motherland, Minya Konka (also known as Bo Kunka, Minya Gonkar, and Gongga Shan) stands in the remote Hengduan Range near the border between southwestern China and Tibet. The peak was first glimpsed by the German explorer Lieutenant Gustav Kreitner in 1879 while he was traveling across eastern Asia with the exploratory party of Count Béla Szechenyi of Hungary. Kreitner sighted Minya Konka's sharp-edged summit from the small Tibetan village of Dsongo (Huin Qan Sai in Chinese), about thirty miles northwest of the peak, and calculated its height at roughly 7,600 meters, or 24,934 feet.

The mountain was not seen again by Westerners until fifty years later, when the American explorer Joseph Rock entered the Konka Longba Valley and found a six-hundred-year-old Buddhist temple at the base of the peak. He mapped, measured, and photographed the surrounding area for the National Geographic Society in May and June of 1929. His calculations of the mountain's elevation led him to believe he had discovered the world's highest peak, and in February 1930 he wired the Society: "Minya Konka highest peak on globe 30,250 feet—Rock."

The Society was unwilling to publish Rock's astounding figure, but a great deal of excitement was created in the mountaineering world by the possibility of a peak higher than Everest. Later that year another survey of the mountain was carried out; Swiss cartographer Eduard Imhof placed the height of the peak at a more realistic and nearly accurate 7,700 meters; the latest figure is 7,556 meters, or 24,790 feet.

In 1979 the Chinese government decided to open a number of high peaks in areas that had been closed to foreigners since the communist takeover in 1949. The Chinese did not understand the concept of trekking, so I decided to apply first for a mountain-climbing permit. Later I would explain what trekking was about and request permits for trekking as well. I therefore sent a long telegram to the Chinese Mountaineering Association in Beijing, requesting to attempt Minya Konka, which was on their list of permitted peaks.

This mountain had fascinated me for

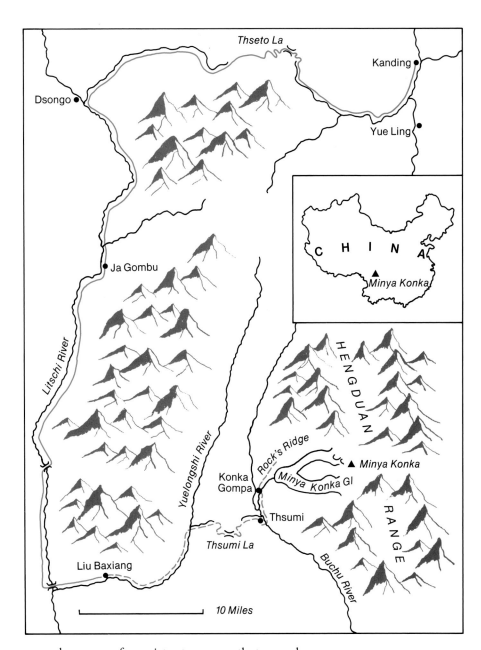

years because of persistent rumors that a peak over thirty thousand feet existed in that area of China and also because I had read *Men Against the Clouds*, a classic work relating an amazing feat of mountaineering and exploration by four young Americans from Harvard University, Arthur Emmons, Richard Burdsall, Terris Moore, and Jack Young. This group of friends organized an expedition to Minya Konka in 1931 to establish the height of the mountain—still presumed by some to be the highest mountain on earth—and attempt to climb it. Crossing all of China to the Tibetan frontier, a journey that took nearly a year, they accomplished the first ascent of the peak and

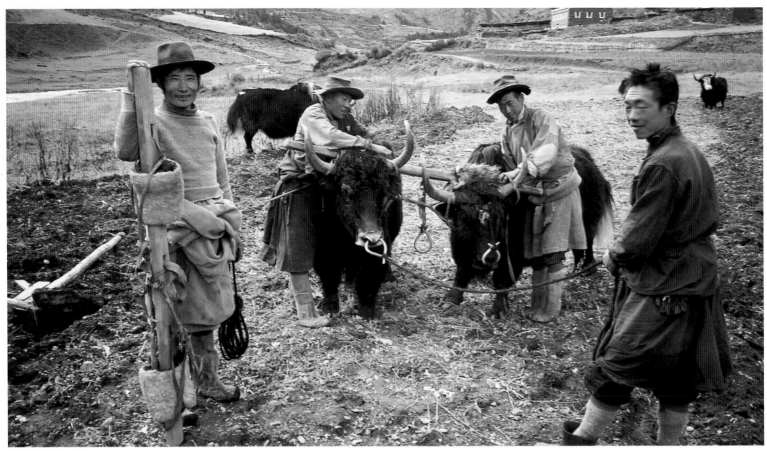

*Minya Tibetans with their yaks at work in the fields of the fertile Yuelongshi Valley.*

calculated its height at 24,900 feet. Minya Konka remained for twenty-six years the highest mountain ever climbed by Americans.

The second ascent was accomplished in 1956 by a Chinese team led by Shi Zhanchun, now vice-chairman of the CMA. At that time the now official height of the peak was calculated. The issue of the mountain's height later became a painful subject to the aging Joseph Rock, according to his biographer, S. B. Sutton. When Terris Moore of the 1932 climbing team visited Rock and brought up the subject of the calculations that led him to send that famous telegram to the National Geographic Society, Rock "instantly switched horses and plainly did not want to discuss it."

Three months after I cabled the CMA the reply came from the Chinese: "You are invited to come to China with your mountaineering team to attempt Gongga Shan at your own expense." During the next nine months, while we assembled our team, frantic negotiations went on to find the huge sums of money the Chinese requested. Eventually the ABC television network agreed to sponsor the expedi-

tion and film the climb. There were fifteen of us, experienced mountaineers from across the country intent on climbing this giant and repeating the route of the first ascent by Americans forty-eight years earlier. We carried with us Terris Moore's best wishes for success. Except for occasional visits by Catholic missionaries from Kanding (Tatsienlu) up until 1948, we were the first Westerners to penetrate the Minya Konka valleys since 1932.

The journey to the Hengduan Range and Minya Konka begins in Chengdu, a thriving city of three million. Chengdu is the capital of Sichuan Province, an area of central China renowned for its spicy food and agricultural wealth. Access to Chengdu is by air or train from Beijing or Guangzhou (Canton). After a brief stop in Beijing we took the train to Chengdu, a journey of eighteen hours. From this gray and haze-filled metropolis we drove in two minibuses west along the Sichuan–Tibet Highway to Ya'an, an ancient and equally gray town on the Ya Jiang River. Huge crowds gathered and followed us around in Ya'an because we were the first Westerners they had

*Descending the east side of the Thsumi La, we encountered untouched primeval forests of birch, spruce, larch, and oaks.*

seen: the town is not on the official tourist list and cannot be visited without a special permit. Soon we were driving up mountain roads and crossing narrow, densely vegetated river gorges. Finally we reached the Erlang Shan Pass (9,215 feet), where we had our first distant view of Minya Konka, its summit clearly visible less than thirty miles away. Beyond and to the west stretched a panorama of the Tibetan tableland, the largest high-altitude plateau in the world. Closer and more to the southwest rose the Hengduan Range, of which Minya Konka is the highest summit. The range is only about thirty miles long. It runs in a north–south direction, a rarity in China.

The road now descended several thousand feet of hair-raising S curves into the Tatu River Valley, an immense mountain-rimmed gorge. We stopped here at the historic village of Luding and walked the centuries-old chain bridge of Liu Ting Chiao ("The Bridge Made Fast by Liu"), now a national monument. This bridge enabled Mao Tse-tung's Red Army to cross the Tatu River at a critical moment during the Long March in 1934.

We continued along the river to the Kanding tributary, then headed west to Kanding, an ancient gateway city to Tibet. Kanding is a fascinating town full of contrasts: new stucco and cement buildings stand alongside traditional Chinese wooden houses. Tall Tibetans, who roam the streets dressed in long sheepskin *chubas*, tower over the slender Han Chinese, who outnumber them two to one. Several old Buddhist lamaseries still stand but are no longer used for religious purposes. Walking up to one of these Tibetan monasteries on a hilltop high above Kanding, hoping to see Minya Konka, I found only ruins. The fires of devotion still burned, however: a small altar had been erected in a cavity in a wall. Tibetans had placed fruits for the deities and were burning juniper boughs, a traditional Buddhist offering.

After spending the night at the government guest house in Kanding we headed west and crossed the Thseto La (14,090 feet), one of the higher passes on our journey. This road, the Tibet Highway, links Chengdu with Lhasa, a distance of more than sixteen hundred

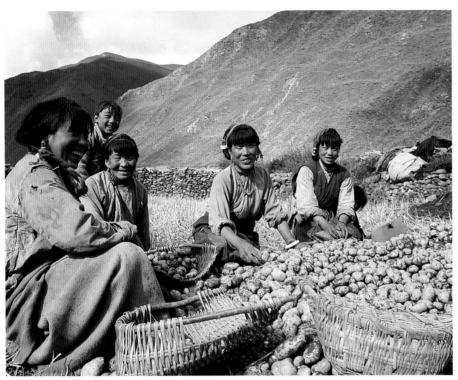

*Women from the Yuelongshi Valley villages with their potato harvest.*

Here we unloaded our gear and re-sorted everything in packhorse loads; fifty-six horses were needed. The next day we began our approach to Minya Konka. (The approach march to base camp constitutes this trek.) In a storm of both rain and snow we at first followed the Yuelongshi Valley upstream. Passing small villages I noticed an unusual number of prettily dressed girls and young women, all wearing red scarves in their long black hair. I later learned that the potato harvest, a major local event, was in full swing. These friendly Minya Tibetans also grew substantial crops of wheat and barley. We spent the night in an old Buddhist temple, now converted to the local commune's headquarters.

The next day we soon reached a small side valley to the east leading to the Thsumi La. Large herds of yaks grazed on the grasslands. It was with some trepidation for the unknown territory beyond that I started climbing toward the snowed-in Thsumi La and the remote world of the Hengduan Range. From the top of the pass—the highest point on the trek (15,288 feet)—the entire chain of peaks of the Hengduan Range was spread before us. Unfortunately, the summits were again shrouded in gray clouds. But below the cloud cover I could see the narrow and darkly forested Buchu Valley, which led toward the base of Minya Konka.

After we plodded down the pass through two feet of fresh snow an entirely different world unfolded before us. Gone were the yaks, the potato fields, and the pretty girls of the Yuelongshi Valley. Here untouched primeval forests of birch and spruce competed with larch, oak, and thick stands of forty-foot-high rhododendron. Pheasants and chipmunks scurried everywhere in the underbrush. Having come down four thousand feet from the pass, we now arrived at the picturesque and peaceful village of Thsumi, where Buddhist prayer flags on tall bamboo poles fluttered in the afternoon breeze.

The Tibetans of this hamlet—there were perhaps five houses, all large and well built—were friendly and received us warmly. We were the first Westerners they had seen, and they offered us the use of an entire house and brought us firewood and drinking water. An old man with a beaming smile kept trying to

miles. It was built in less than two years by more than one million Chinese workers.

Now on the Tibetan Plateau, we could see massive square Tibetan houses isolated on the open and windy plains. Horsemen galloped their ponies in the far distance. Passing through the village of Dsongo, I recalled Gustav Kreitner's sighting of Minya Konka more than a hundred years ago. But on this day a heavy overcast hung over the entire plateau, obscuring all views of the peak. We left the highway here and turned onto a graded dirt road leading south toward the Litschi River.

In the village of Ja-Gombu I noticed some ancient stone watchtowers, perhaps eighty feet tall. They were once lookouts for raiding bandits from the Konkalin Mountains to the south, a testimony to days when travel in these remote provinces of China was extremely hazardous.

At the confluence of the Litschi and Yuelongshi rivers we crossed a new cement bridge, then drove up the narrow gorge of the Yuelongshi amid dense stands of fall foliage. After an hour or so on this track we at last reached our trailhead, the commune of Liu Baxiang, only to be mobbed by the entire population of Minya Tibetans, who had never seen Westerners.

communicate with me, but I did not understand until our Chinese interpreter translated: The old man remembered the Americans who came in 1932 to climb the mountain. At that time he was a young monk studying Buddhism at the Konka Gompa, the monastery below the mountain. (*Gompa* means "monastery.") Stripped of his priesthood by the Communists, he had become a lay worker in this small village. He took both my hands in his and shook them vigorously. I was very touched.

Turning north we headed upstream, crossed the Bhud Chu, walked by the confluence of the Konka River, crossed again, over a recently built log bridge, and were on our way up the Konka Valley. The valley here was narrow and V shaped. A steep trail led for several hours through dense forests of prickly oak covered with graybeard lichens, large ferns, and long streamers of moss hanging from dead trees, until we finally emerged onto a grassy bench fifteen hundred feet above the

Konka River, which raged below. Suddenly we had our first close-up view of Minya Konka high above, bathed in sunlight, the snow-and-ice walls of the peak filling half the sky. Below were the ruins of the Konka Gompa, the "snow monastery," destroyed by the Red Guards during the infamous Cultural Revolution of the 1960s.

We unloaded here and set up base camp for the expedition. From this excellent location, the end of the trek, several fine overnight excursions can be made. One of these leads to Rock's Ridge, the seventeen-thousand-foot hill where Joseph Rock took photographs and bearings of Minya Konka.

I hiked up Rock's Ridge after recovering from a bout with pulmonary congestion. I sat down amid a group of Buddhist shrines—age-old chortens (stone shrines) covered with lichens. Far below I could see the ruined gompa. Then, looking up, I was awed by the brilliance and majesty of the huge mountain

*Log bridge across the Konka River that the Chinese had built especially for us. While the climbers and trekkers walked, the Chinese rode Tibetan ponies.*

*(Overleaf) Minya Konka, highest peak of the Chinese motherland, as seen from Rock's Ridge at seventeen thousand feet.*

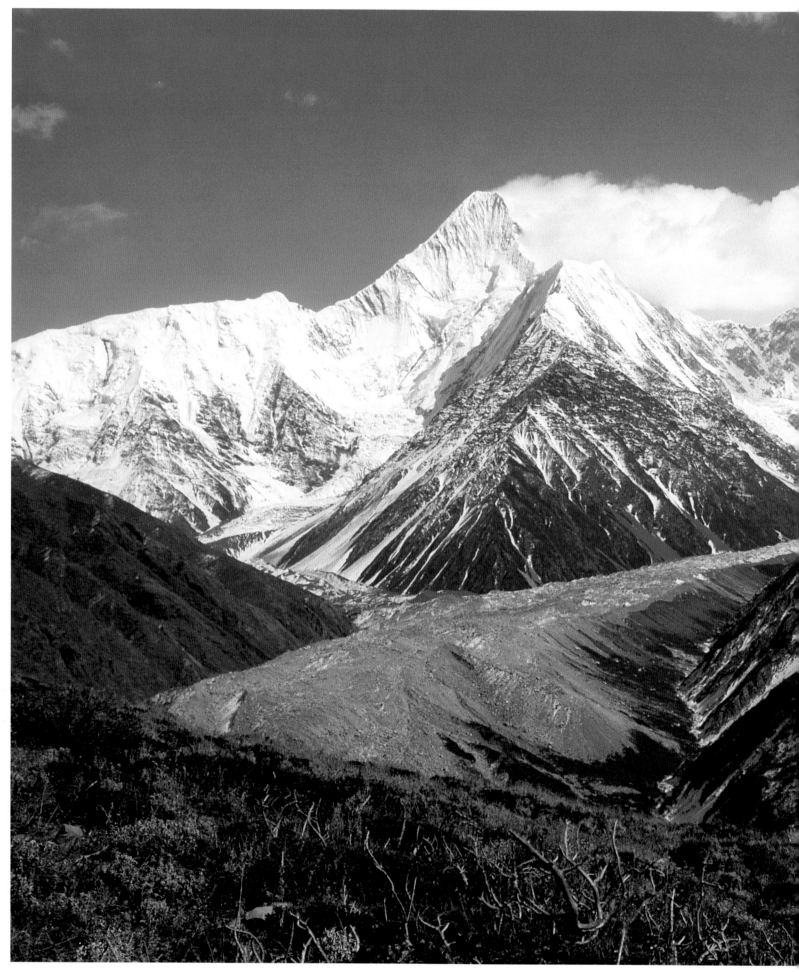

towering nearly eight thousand feet above me. It brought to mind a Tibetan inscription that Rock had read in the gompa fifty-one years earlier: "There is no more beautiful spot on earth than Minya Konka. One night spent on the mountain is equivalent to sitting ten years in meditation."

When I had started in the morning not a cloud marred the sky, but by afternoon clouds started to form. Though I did not stay overnight on Rock's Ridge, I found good camp spots there. One could bring a tent and a sleeping bag and spend an evening and morning taking photographs of Minya Konka. Alpine flowers grow to about fifteen thousand feet. I photographed miniature azaleas and dark blue and white-striped gentians.

Himalayan black bears reportedly roam the forest below Rock's Ridge, so I was careful on my return to the gompa and base camp not to surprise them by making sudden noises. I saw a Tibetan white-eared pheasant, a sambar deer, and—across the canyon—what looked like a bear. Takin, rare antelopes that the Chinese call *ya-nu* ("wild cow"), still inhabit these mountains, which are as untouched now as they were when Professor Arnold Heim visited them in 1934 and made the only trek completely around them. He saw an entire herd of these beasts in one of Minya Konka's eastern valleys.

From the gompa one can hike to the site of the advance base camp used by the expeditions that have attempted Minya Konka from the northwest. This strenuous three-day round-trip walk, so rugged that no horse or yak can make it, leads down to the river fifteen hundred feet below, then proceeds up and alongside the Minya Konka Glacier to the campsite, which is beneath the "rock pyramid" described in *Men Against the Clouds*. The area supports sparse shrubs and bushes; water or snow is plentiful. Members of the 1932 and 1956 expeditions climbed from this camp up past the rock pyramid to the mountain's northwest shoulder, then ascended via the northwest ridge to the summit.

Minya Konka is sacred to Tibetans. Although attempts have been made to erase all evidence of the Konka Gompa, many local people still come to the ruins to pray and to perform religious ceremonies, such as funeral services. We found fresh parchments inscribed with the holy mantra "Om mani padme hum" ("Ode to the jewel in the lotus") everywhere around the gompa ruins, a sure sign that people have not forgotten their religion. Below, by the river, I found a clearing in the forest where ribbons, cheesecloth prayer flags, safety pins, combs, and old shoes, old hats, and other clothing were hanging from trees, pinned against trunks, or looped over bushes. This was a mystical place of hidden worship, or of penance, where strange rites of tantric Buddhism take place, where sinners and murderers come to seek absolution and implore the gods for mercy. Minya Konka was worshiped by the lamas who prayed to Dorje Lutru, the feared Thunder God; his name, no doubt, has to do with the continuous roar of avalanches coming off the mountain. In 1929 Joseph Rock spent a night shivering in the gompa amid silent lamas and chortens containing the ashes of deceased priests. "Outside," he wrote, "the glacier stream roared, the thunder rolled, and Dorje Lutru staged his electrical displays."

Our expedition ended in tragedy. An avalanche swept the advance climbing team fifteen hundred feet down the west flank of the mountain, killing one member and severely injuring another. Dorje Lutru had the last word. The accident signaled the end of our expedition; we returned to civilization. But my fascination with Minya Konka—one of the most striking of all the mountains I have seen—remains. I want to trek once again to Rock's Ridge and the Konka Gompa; I want to recapture that strange and powerful emanation exuding from one of the world's great peaks.

In addition to the trek described—the quickest route to the mountain—other routes lead to Minya Konka. One begins at Yue Ling, a small village six miles south of Kanding, and proceeds across the 15,685-foot Djezi La into the Yuelongshi Valley, where the regular route across the Thsumi La is followed. It is also possible to trek around the entire Hengduan Range, a journey of about twenty days. One can begin at either Yue Ling or Mosimien, a Chinese town on the Tatu River west of the mountains.

# TREKKING IN CHINA
## Expedition Planners

*Advance base camp on Minya Konka—digging out from under a heavy snowfall.*

## General Information

*Visas:* A Chinese visa can be obtained in several airports on arrival, including Shanghai, Guangzou (Canton), and Beijing, or through a Consular Office in major cities in the United States.

*Logistics:* At present, all trekking and camping in remote parts of China is restricted. Permits must be secured and payment made in advance. Treks are operated by adventure-travel agents and several outdoor clubs, such as the American Alpine Club and the Sierra Club. It is possible to inquire directly to China International Sports Travel, 10 Tiyuguan Road, Beijing, People's Republic of China. The charges are high compared with those in India and Nepal. The Chinese can supply equipment, food, guides, and local transportation. Overall standard of CIST-run trips is low. Do not expect first-class trekking as it is now available in Nepal.

*Vaccinations:* None are required for the treks described here.

*Water Purification:* Water should always be boiled or purified with water purification pills or iodine crystals. In hotels, drinking water is provided in thermos bottles in each room. Do not drink tap water.

*Sources of Official Information:* Local Consular Offices in major U.S. cities. China National Tourist Office in New York, N.Y.

*Further Reading:* See Bibliography, Chapters One, Two, and Three.

## The Karakoram Trek to K2 (Chapter One)

*Special permit:* Required to visit the restricted area of the Karakoram.

*Nearest Airport:* Kashgar Airport in Sinkiang Province.

*Means of Transportation:* Special bus or jeep from Kashgar for a three-day trip to roadhead with stops in Kargalik and Khudi (camping). Camel caravan to meet trekkers at Mazar Dara, as described in text.

*Logistics for This Trek:*

Trips into the northern Karakoram are possible only in the spring and fall, when waters of the great Shaksgam River are low enough for camels to ford. Late spring can be a dangerous time to go, because fast-rising waters may cut off retreat; it is wiser to go in the fall. The area beyond Aghil Pass is uninhabited, so provisions for the entire journey must be carried in. Trekking, climbing, and exploring possibilities are unlimited.

*Travel Tips:*

*Best season:* The trip is best in the fall; September is the best month.

*Trekking days:* Twelve days to base camp round trip. Six more days round trip to advance base on glacier.

*Distance covered:* About 120 miles, round trip to base camp. About sixteen miles round trip to advance base.

*Food:* No food is available past Kargalik.

*Special equipment:* For travel on K2 Glacier, bring stout leather boots and ice axe.

*Difficulty:* For moderately strong hikers with some glacier experience.

*People:* The people of Sinkiang Province are Uigurs of Turkish origin and are very friendly and hospitable. On the trek there are isolated settlements of Kirghiz who move to higher pastures during the summer.

*Cautionary Notes:* Respect the people and their customs. The majority of the people in Sinkiang Province are Muslim Uigurs, and women should wear long pants or below-the-knee-length skirts rather than shorts in towns and villages. Long-sleeved shirts and occasionally a scarf are recommended for touring the towns. Be discreet in using cameras and ask permission before taking photographs. Avoid taking photos of women, as it is against Muslim custom.

Tourist regulations in China are constantly being updated, revised, and/or changed. Consult with appropriate agencies for the latest information.

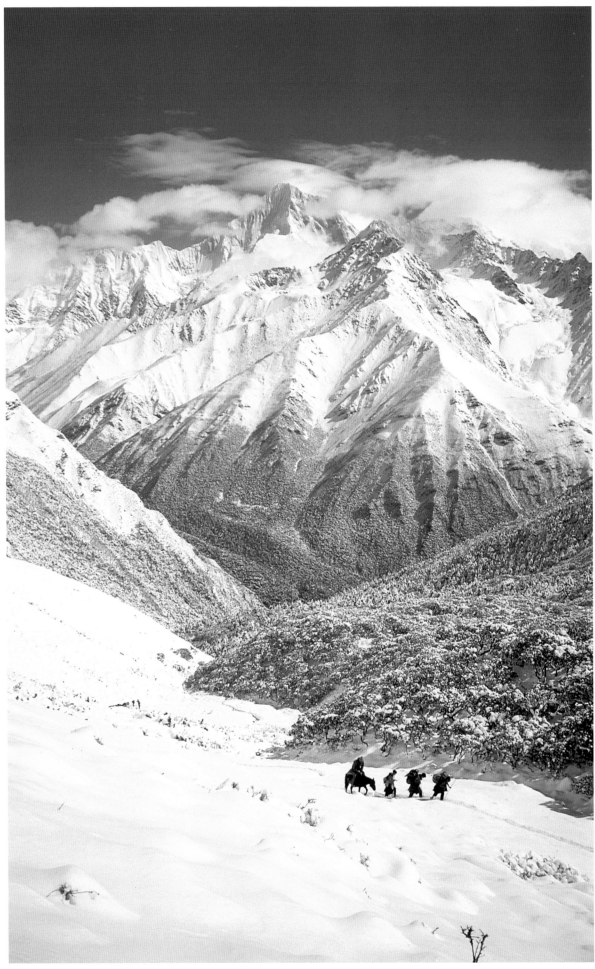

*Tibetans on their way to the Thsumi La amid a snowed-in landscape dominated by the Hengduan Mountains and Minya Konka.*

## Everest: The Kangshung Trek (Chapter Two)

*Special Permit:* Required to visit the restricted area of Everest.

*Nearest Airports:* Lhasa and Kathmandu.

*Means of Transportation:* Regular bus service from Lhasa to Shigatse, and sporadic to Shekar. From Shekar to Kharta or Rongbuk, special arrangements must be made with China International Sports Travel (previously C.M.A.), or other government agency. Yaks for load transportation must be arranged in advance. If coming from Nepal, irregular bus service to Shegar.

*Logistics for this Trek:* It appears that all of Tibet is open to foreign tourists, including the entry point at Zhangmu on the Nepalese border, but regulations change constantly. For treks to the Everest area, army trucks are used for the approaches to the Rongbuck Glacier, as well as to Kharta (be prepared for a rough and open ride with snow possible at any time). Note: be aware that Tibet is still a very remote and primitive land. Very few services such as lodging, food, and transport are available on the spot. It is wise to make all your arrangements well in advance with a reliable agent who deals regularly with the Chinese and Tibetan tourist authorities.

*Travel Tips:*

*Best season:* Mid-April to early June, and September to mid-November.

*Trekking days:* Thirteen or fourteen, including time at base camp.

*Distance covered:* About eighty miles.

*Food:* Supplies available in Lhasa, and only sporadic in Shigatse. The Rongbuk area is uninhabited and no food is available. For the Kharta section, no supplies are available at local villages.

*Difficulty:* For strong hikers; snow likely on the passes.

*People:* The Tibetans are extremely friendly and are generally delighted to pose for photographs.

*Cautionary Notes:* Tourist regulations in China are constantly being updated, revised, and/or changed. Consult with appropriate agencies for the latest information.

## The Minya Konka Trek (Chapter Three)

*Special Permit:* Required to visit the restricted area of the Hengduan Mountains.

*Nearest Airport:* Chengdu, in Sichuan Province.

*Means of Transportation:* Regular bus service from Chengdu to Kanding. A special vehicle can be arranged for from Kanding to trailhead.

*Logistics for This Trek:* Backpacking on one's own is not allowed in this region.

*Travel Tips:*

*Best season:* September and October (rain possible).

*Trekking days:* Six days round trip to Konka Gompa. Two days to advance base and back (snow possible on passes).

*Distance covered:* Fifty miles to Gompa and back. Five miles to advance base (one way).

*Food:* Most supplies in Chengdu; limited supplies in Kanding.

*Difficulty:* Moderate. Bring quality rain gear.

*People:* The Minya Tibetans are generally very friendly, but in some smaller villages the people are not accustomed to foreigners and may seem a bit shy.

*Cautionary Notes:* Tourist regulations in China are constantly being updated, revised, and/or changed. Consult with appropriate agencies for the latest information.

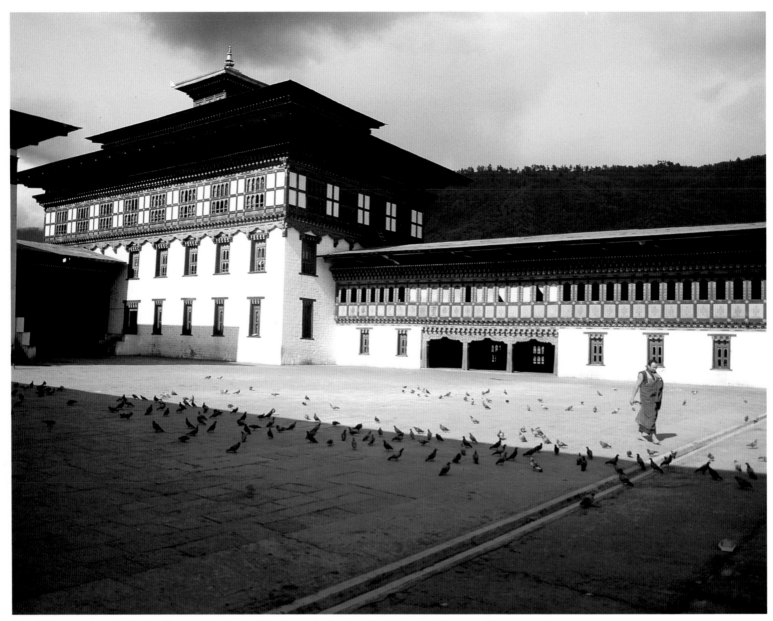

*The Tashicho Dzong, seat of government and palace of Bhutan, in Thimpu, the capital.*

# BHUTAN
# *The Chomolhari Trek*

*I went to the woods because I wished to live deliberately, to front only*

*the essential facts of life, and see if I could not learn what it had to teach,*

*and not, when I came to die, discover that I had not lived.*

—Henry David Thoreau

TWELVE centuries ago, according to legend, the great Buddhist saint Padma Sambhava arrived in Bhutan from Tibet on the back of a flying tiger. The tiger landed on the vertical side of a two-thousand-foot granite cliff near Paro in western Bhutan. There the monk meditated alone in a cave for three years before descending into the serene valleys of Bhutan to preach his apostolate of tantric Mahayana Buddhism. He thus became Bhutan's patron saint, laying the cornerstone for a religious practice so strong that to this day Buddhism remains an organic part of Bhutanese life. Bhutan (or Drukyul, Land of the Thunder Dragon) was never conquered or colonized and remained a theocracy of the Drukpa Kagyupa Sect until 1906, with all the political and religious power in the hands of a spiritual leader—much like the Dalai Lama in Tibet—the Dharma Raja.

Standing on the rooftop of Taksang Monastery, the "Tiger's Nest," built above the cave where Padma Sambhava lived, we looked out at the idyllic valleys of Paro, thousands of feet below. We had come to Bhutan to trek and explore the northwestern districts. Starting from Paro we would head for Chomolhari, the sacred peak of Tibetans and Bhutanese alike, then move on to Lingshi Dzong, an impressive fortress atop a steep hill near the frontier with Tibet. Finally we would return to Thimphu, the colorful capital of this small Himalayan kingdom.

Along the fifteen-hundred-mile southern slope of the Himalaya chain a necklace of small princely states—Hunza, Ladakh, Kashmir, Nepal, Sikkim, and Bhutan—stretches out between the huge land masses of India and China. Of these, only Bhutan has retained a nearly unblemished national heritage. Buddhism flourishes here as nowhere else, and foreign influences have been kept to a minimum. In Thimphu we saw young apprentice monks practice the art of blowing the twenty-foot-long Tibetan horn called the *tungchen*. In Paro the lay Bhutanese wear the *kho*, a traditional robe, at religious and official functions and also at work. The national sport is archery, and dance and song are a way of life.

A visit to remote Bhutan enabled us to witness the colorful culture and religion as

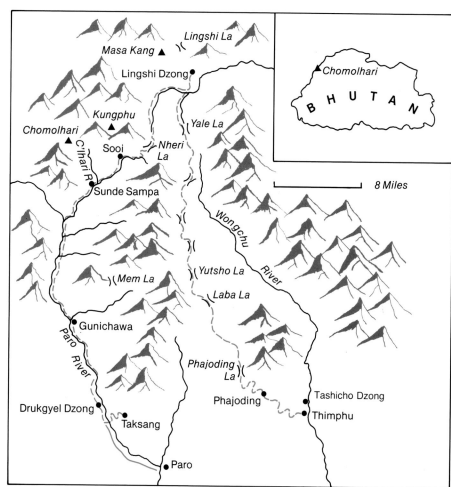

well as to enjoy nature at its best. We heard thousands of monks intone Buddhist incantations in the temples; we admired the wall paintings depicting the life of the Buddha in the Tashicho Dzong (the nation's largest monastery, which is also a fort and the seat of government); and we experienced a unique pastoral and nomadic culture based almost entirely on an animal—the yak. We also reveled in nature's full display: unclimbed Himalayan peaks, verdant and steeply rolling hills, and wildlife more abundant than in any other Himalayan state.

Racing down the two-thousand-foot vertical trail from the Tiger's Nest, my sixteen-year-old son Bill easily beat me to the road. Both he and my daughter, Suzy, seventeen, had been invited by the Bhutanese Tourist Board to accompany me on the first exploratory trek to Chomolhari. The board members were interested in feedback from a couple of American teenagers. After visiting the Paro Valley with its magnificent fortress, we asked to

low a ceiling of thick dark clouds; a storm was raging on the Mem La, the pass forty-five hundred feet above us. We felt that the trek over the Mem La—on a trail that provides grand views of the mountains on clear days—would be impossible because of the heavy rains. Our Bhutanese guides, however, were reluctant to take a low-level route leading directly to the base of Chomolhari, insisting that it was too near a major pass on the Bhutan–Tibet border and therefore politically off limits. After a few tense moments our guides relented, and we reached Chomolhari quickly and without incident.

We saw rhododendrons everywhere, with the blood-red, snowball-like trusses of *Rhododendron arboretum* dominating, and bamboo, which at this level surprised me. On the second day of the trek, as we approached the 10,300-foot level, we observed five-needle pine trees and spruce, and Spanish moss streaming in long shrouds from hundred-foot oaks. The forest became denser as the day progressed, but we found a clearing at noon and ate lunch on a moss-covered tree trunk. Visibility was poor, but there was no rain. The Bhutan tourist manager had been kind enough to send along a few riding animals, just in case anyone was interested, so I rode a mule that morning—a new experience. He was a strong, intelligent beast and, contrary to reputation, quite friendly. After three more hours in the forest we reached our second camp, Sunde Sampa, a small clearing at the confluence of two streams. In the evening we glimpsed, through breaks in the clouds, the lower slopes of Chomolhari's glaciers, thick with icefalls.

Later we crossed several small footbridges and visited the primitive village of Sooi, consisting of about twenty houses and sixty inhabitants. Most of the people raise yaks for a living. The yak's milk is delicious, its meat is eaten, and its dried dung serves as fuel. Now, in summer, the villagers had migrated to high pastures, where they lived in large black yak-hair tents, tended their yaks, and made cheese. One old man told me, "Yaks can be ridden down the mountain, but not horses, according to Tibetan custom." So I asked him, "What about a mule?" "The custom says nothing about mules," he replied laconically. On part-

*The hamlet of Sooi, on our way to Chomolhari.*

climb to the top of the famed Taksang Gompa. Then, after visiting this unique temple built against the vertical cliff, we hurried along the road to the trailhead to catch up with our guides and packhorses for our two-week trek. We overtook them near the once impregnable Drukgyel Dzong, a stupendous fort destroyed by an accidental fire in 1954. Three hours later we reached our first campsite, near a small military encampment called Gunichawa (9,200 feet). Here we were invited in for tea by the commanding officer, a young Lieutenant Tashi, who obliged me by giving Bill alcohol to clean a nasty cut on his knee resulting from a slip on a rock.

As we followed the course of the Paro River that afternoon the vegetation slowly changed from deciduous to alpine, the scrub oaks gradually losing out to varieties of conifer. Large ferns and colorful mosses occasionally gave way to small cultivated plots of rice, potatoes, and millet. Along the way we encountered pretty three-storied Bhutanese chalets with wide, flat slate roofs painted with intricate motifs.

The next morning we found ourselves be-

ing he suggested that we visit his son and family, who were tending his herd of yaks up on the mountain.

On the fourth night we camped in an open, flower-filled valley. We were forced to pitch the tents on top of hundreds of dwarf azaleas. Flowers bloomed everywhere as far as the eye could see, growing even on the rocky mountainsides of this valley.

The next day we drew closer to the big mountains, and by one o'clock we had reached Tegethang, a small settlement at 12,400 feet. We had walked all morning through extensive fields of flowers, some more than six feet tall. After lunch we reached a large meadow, enjoyed a break in the weather, and ran down the trail, playfully throwing flowers at one another. By late afternoon we reached the Chomolhari Chu (river) and the now ruined dzong that guards this valley. Dzongs were fortresses built to protect the Bhutanese against invaders from the north, but now many, like this one, have fallen into disrepair. Visibility was poor and cold winds swept down from the big peaks above, so we continued for another hour to the relative shelter of Jangh Kotang, a small village at the head of the main valley. We were now quite near the Himalayan crest. Half a mile farther up, the valley was blocked by an enormous and impassable terminal moraine. Beyond lay Tibet, so near yet inaccessible.

The village headman invited us to spend the night in his house and gave us his private praying room and gompa, with an altar to Buddha. After dinner I questioned him about local wildlife. He had seen only three snow leopards in the past ten years but said they were abundant. Last year alone the cats had killed two of his yaks. Bharal, or blue sheep, were also plentiful; he had seen thousands of them. He described how the snow leopard catches the bharal. First the predator approaches the herd from above. When directly overhead, but unseen, it pries a stone loose with a paw and lets it tumble toward the sheep. The rock startles the animals, but, as nothing further happens, they continue to graze. The snow leopard bides its time, then rolls a second stone. The sheep, accustomed to the stonefall, pay no further attention. At

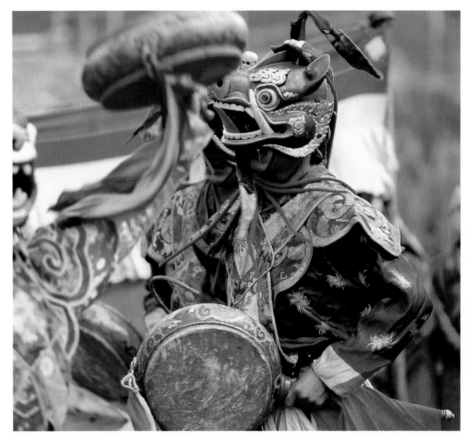

this point the snow leopard turns into a streamlined bullet and shoots down the slope, exploding amid the complacent sheep.

We spoke of mountains and of Tibet. "The border is completely sealed off," our host said, "but yak herders and others are known to cross illegally to trade in salt, butter, and rice, basic commodities that for centuries have been hauled across high Himalayan passes." The butter lamps burned late that night on the altar of the gompa. It was warm and snug inside this big house full of human, animal, and herbal smells.

I was awakened at 6:30 A.M. by Suzy, who was outside, shouting, "Come look at these peaks!" It was the first clear morning since the beginning of our trek. Several huge ice-clad peaks, unnamed and unclimbed, jutted sharply into the sky above our heads. Bill suggested that we run back to the Chomolhari River for a full view of our mountain—Chomolhari—before rising ground fog, combined with monsoon clouds, again obliterated the view. Yes, but what about breakfast? Never mind, we must see the mountain first! We reached the river in about fifteen minutes and had a mag-

*The Tsechu Festival in Paro celebrates various events in the life of Padma Sambhava, the eighth century Buddhist saint, who according to Buddhist scriptures flew to Bhutan from Tibet on the back of a tiger.*

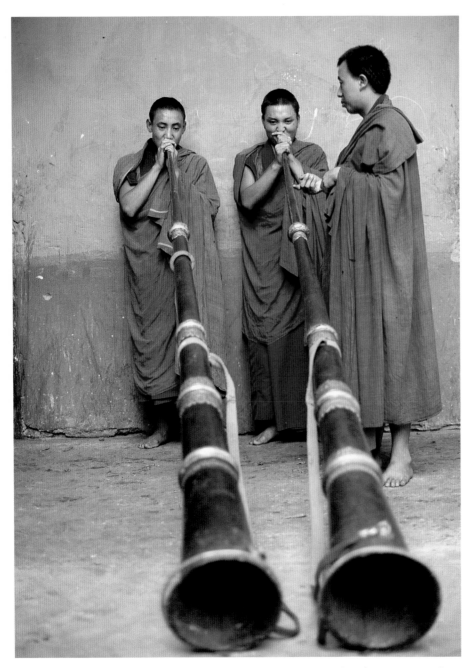

*Young monks learn to use the eight-foot-long Radung horns at the music school at the Tash-icho Dzong.*

he was tied with a climbing rope, fell backward and dragged him off his feet and down the southwest face. Chapman drove his ice ax into the snow to stop his slide and save them both from a ten-thousand-foot plunge. They lost vital equipment, their food, and their stove. The descent, without food or water, became a five-day survival epic.

To the right of Chomolhari was a large, rounded snow peak, Kungphu (23,600 feet). Nearby was a steep, unclimbed ice pyramid that the headman called Tsering Khang. It looked impossible. After exploring all the ridge lines and lower glacier reaches of Chomolhari with binoculars and cameras, we returned to our camp at Jangh Kotang for a late breakfast of porridge, eggs, and toast—and a day of rest.

Next morning the friendly headman saw us off by walking with us to the last bridge over the Po Chu. We said good-bye and started the steep climb to the yak pastures at the foot of Nheri La (16,100 feet), where we planned to spend some time with the herders from Sooi, learning what it was like to live in large nomad tents.

We reached the pastures (15,000 feet) by midafternoon, and there were lots of yaks around—big ones. Dogs barked, signaling our arrival. We waited at a safe distance for the owners to emerge from their tents to hold back their ferocious Tibetan mastiffs. Our guides then approached the yak camp. Soon we were motioned to approach as well. Within minutes we were asked inside a large tent belonging to the son of the old man we had met in Sooi.

The tents in which these Bhutanese live are made of closely twined yak hair so oily that filtered light is let in but rain is kept out. In the center of the tent, which measured about twenty by thirty feet, was a crude fireplace of rounded stones; a giant copper pot hung above it. Yak milk was boiling in the pot; several women in the corner were churning milk into butter. Four-inch squares of yak cheese, strung up in dozens of garlands, hung from long wooden poles suspended from the far sides of the tent. Rough mats (woven from yak hair, no doubt), rugs, and sheepskins were spread before us, and roasted tsampa (barley

nificent view of the smooth, glittering southwest face of Chomolhari, "Goddess Chomo," a twenty-four-thousand-foot sentinel on the border with Tibet's Chumbi Valley. As I sat on a rock with binoculars to observe the goddess's every curve, I thought about Spencer Chapman, who a half century ago first climbed that summit. He described his adventures—and ordeals—in his book *From Helvellyn to Himalaya*, and wrote of his narrow escape after reaching the top with his Sherpa guide. While Chapman was busy photographing Tibet and Bhutan from the summit, the Sherpa, to whom

flour) was passed around on small plates. Tibetan tea was poured into silver cups, in which the tsampa was mixed and kneaded to a dough, then eaten.

Sue and Bill rose to the occasion that day, for although they had no stomach whatever for what seemed to them bizarre concoctions, they downed the tasteless tsampa and the even less palatable tea (made with rancid yak butter and salt) without so much as a grimace.

Half a dozen near-naked children cavorted in and out of the tent, kicking up dust and dung. As usual, we had to put up with droves of the curious, who slipped into the tent and stared. We camped that night with these friendly people.

In the morning we crossed the Nheri La and surprised two small herds of blue sheep, perhaps thirty in all. The swift animals quickly disappeared. The bharal is protected in Bhutan: killing one brings a fine of 10,000 rupees (about $1,200). As a result of this heavy penalty many of these beautiful ungulates roam the grassland hills of Bhutan. This small sheep has a brownish gray to slate-blue coat and a black neck and chest. The horns are smooth, rounded, and swept back.

From the pass, a windswept ridge, grand views extended north to Tibet and east to Kula Kangri, a 24,780-foot peak. Other Himalayan giants were tentatively identified as Masa Kang (23,622 feet) and Kangcheta (22,966 feet), both rising above Lingshi, the village for which we were now headed. This part of the Himalaya (indeed, all of Bhutan's northern border) has been neglected by explorers and mountaineers, mainly because of the politically undemarcated border and the government's understandable reluctance to allow parties into this unstable area.

Before starting our descent we looked one last time at Chomolhari, partly obscured by clouds. We headed down several broad rocky valleys devoid of vegetation and could distinguish the village of Lingshi far below, and the famous dzong that dominates this area. Several hours later we walked into the small town and were cordially received by members of the local army garrison, who offered us a barracks replete with a wood stove for our exclusive use. That evening a heavy

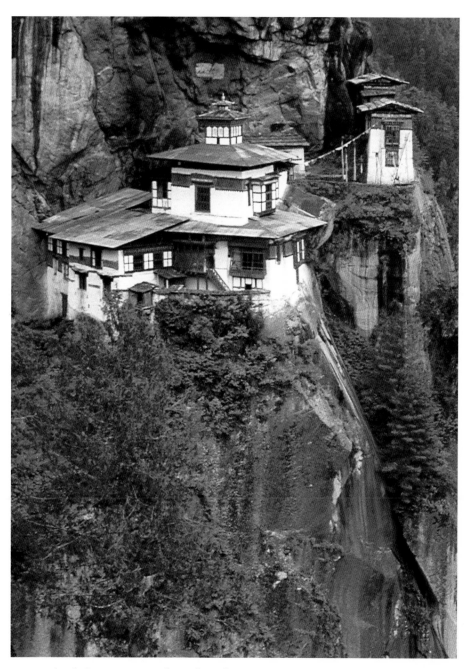

rain pelted the corrugated roof, and we were grateful for the good food, the warm fire, and the friendships made with the soldiers. A path leads from Lingshi to the big dzong and beyond to the Lingshi La, a seventeen-thousand-foot pass on the border with Tibet. A full day should be devoted to visiting this old fortress.

From Lingshi two routes lead to Thimphu, the capital. One follows the Punakha Valley and passes Punakha, the ancient capital of Bhutan. We chose a more direct route that would enable us to see the lakes and forests of the middle-elevation country.

*Taksang Monastery, the "tiger's nest." It is here that Padma Sambhava landed at the end of his flight from Tibet and spent three years of meditation in a cave alongside the cliff.*

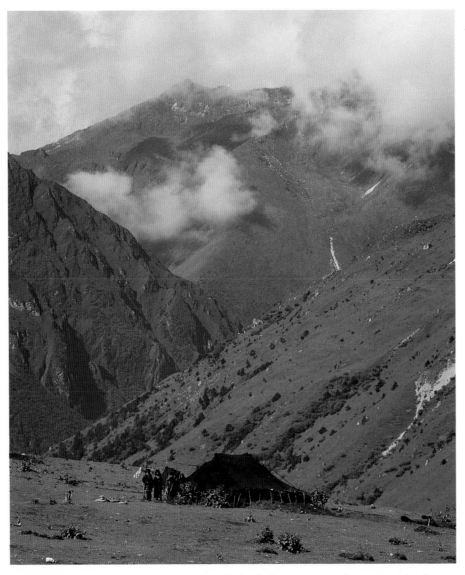

*A summer camp for yak herders, with tent made of yak hair.*

breaks up into a brilliant cascade several hundred feet high, then enters a deep rocky gorge along which a narrow trail has been cut. On close inspection it appeared that the trail would be unsafe for our horses because of slides caused by the rains, so we detoured over another sixteen-thousand-foot pass. By midafternoon, just as we topped the pass, rain and snow came down in heavy sheets. Racing down the far side we reached a yak herder's stone hut at fourteen thousand feet. Everyone headed for shelter when our guide announced, to our great joy, that the day's journey was done—we would camp here.

It was a welcome feeling to enter the dark one-room hut and see a blazing fire. The hut was crowded with herders, but they made room for us so we could thaw. Although primitive, this hut contained all one needed to survive a Himalayan storm. The inside was filled with goats, chickens, and small pigs; yak cheese hung in long garlands from the rafters alongside animal entrails, strings of garlic, and stacks of blankets. A yak head lay in the corner. Pots and pans were lying around, some filled with foodstuff that bore no resemblance to anything I had ever seen. Our wet clothes were strung up on overhead ropes. An old woman was poking the fire; a young one was breastfeeding an infant while preparing Tibetan tea for us. We crouched on the floor, happy and fascinated with the primitive world. Outside, the storm raged.

I was up early, but the herders had already left the area with their yaks. The morning was cold, the sky crystal clear. Fog drifted among the ridges and corries below and filled the valleys leading toward the Indian plains to the south. The wet grass, soaked by the rainstorm, steamed in the morning sun. I spotted a large herd of bharal high on a ridge just as Bill and Sue stumbled out of the dark hut, squinting. I motioned them to sit down and be quiet. We observed the sheep for half an hour as they slowly filed down the near-vertical mountainside.

It was good to be together, to share this adventure with my teenagers, despite the hardships caused by the monsoon. The night spent in this hut was a new experience for them, a glimpse of man's primitive life, unchanged

We hiked downstream from Lingshi for a short distance, crossed the Punakha River, and climbed back up the opposite bank to the confluence with the Chabechang River. Several hours later we entered a broad, green valley dotted with thousands of grazing yaks, which feed on mosses, lichens, and the tougher varieties of grasses that grow at elevations of twelve thousand feet. In the valley behind us rose majestic Lingshi Dzong, strategically overlooking the four valleys that converge on the town and its fort.

At the head of the Chabechang we reached the rocky, steep Yale La, more than sixteen thousand feet high, but because of the heavy overcast we could see nothing. Down we went along the Wongchu River, which leads to the capital. Farther down this stream

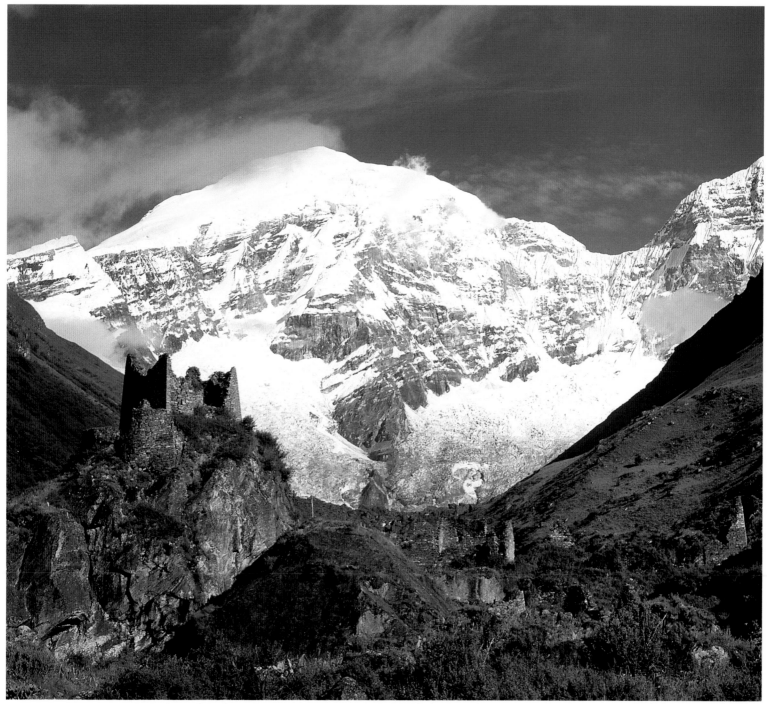

for hundreds, perhaps thousands, of years.

We crossed two fifteen-thousand-foot passes that day and two more on the next. During the second day we walked through forests of rhododendrons and magnolias, some specimens perhaps fifty feet tall. Entire hillsides were covered with these large flowering trees—a floral wilderness unique in the world. Unfortunately, we were too late in the season to enjoy their full bloom.

On our last day of trekking we walked a total of eleven hours and crossed four passes, two of them over fifteen thousand feet. We crossed the Yutsho La and the Dungtsho La, the two highest, as well as the Laba La, and fi-nally the Phajoding La. These passes, all easy, connect strings of steely-blue alpine lakes, famous in Bhutan for their color and beauty. We reached Phajoding Monastery at eight-thirty that night, walking the last hour in complete darkness. Nearby, the tourist department runs a chalet for tourists who come up from Thimphu Valley, three thousand feet below, to see the Himalayas.

We spent a comfortable night in a bungalow; then, on the last morning, we saw Thimphu spread out below our feet. At noon we walked into town, eager for some of civilization's creature comforts—beer and soft drinks, a hot bath and clean clothes.

*The huge southwest face of Chomolhari (Goddess Chomo), the Divine Mountain of Bhutan (23,977 feet). The ruined dzong, or fort, is in the foreground.*

# THE CHOMOLHARI TREK
## Expedition Planner

*Balcony detail and an apprentice monk.*

*Visas:* A Bhutanese visa must be obtained before departure through the Bhutan Tourism Corp. in New York or the Embassy of the Kingdom of Bhutan in New Delhi. Individual travelers are at present not allowed in Bhutan and those wishing to visit the country must join a tour program. All travelers to Bhutan should also request an Indian visa, because they must pass through India to enter Bhutan.

*Vaccinations:* The following are suggested: cholera, tetanus, typhoid, polio, and gamma globulin, and malaria suppressant tablets. The cholera immunization is strongly recommended. Regulations change frequently, so please consult your physician or U.S. Public Health Service. Begin your immunizations early. Gamma globulin must be taken just before departure.

*Source of Official Information:* Bhutan Tourism Corp., P.O. Box 159 Thimphu, Bhutan, and The Permanent Mission of the Kingdom of Bhutan to the United Nations, New York, N.Y.

*Nearest Airport:* Paro Airport is serviced exclusively by Bhutanese Druk Air with flights to and from Calcutta, India. Bagdogra Airport in India is used by tourists reaching Bhutan overland.

*Means of Transportation:* From Paro, travel to starting point of the trek by car. All arrangements are made by Bhutanese Tourist Department.

*Logistics:* Travel in Bhutan is restricted. All travel arrangements must be made in advance and prepaid. Tours and treks can be booked through knowledgeable travel agents or via Bhutan Travel Service, Department of Tourism, Thimphu. Only groups are allowed at present and must number at least six persons. All parties are met and escorted by a Bhutanese guide trained by the government. Trekking arrangements are possible on a limited basis only by purchasing a pre-planned itinerary designed by the Bhutanese. Backpacking is not allowed. A few selected peaks are open to climbers. Independent outfitters do not exist and those active in nearby countries are not allowed to run treks in Bhutan. Presently, the most exciting and remote treks available are the Chomolhari trek and the long, arduous journey to Lunana, one of the most remote and untouched high valleys in the Himalayas.

*Travel Tips:*

*Best season:* April to May and October to November (avoid the monsoon months, June to September).

*Trekking days:* Eight to ten days, depending on exact route.

*Distance covered:* Forty miles from Drukgyel ruins to Lingshi; forty-five miles from Lingshi to Thimphu, via the lakes region.

*Food:* The food is entirely catered by the Dept. of Tourism of the Government of Bhutan and the meals are planned to appeal to Western taste. No supplementary food is available at villages along the trail.

*Water Purification:* Water should always be boiled or purified with iodine pills or crystals. The kitchen crew will provide the trekkers with boiled water and hot drinks to fill their water bottles and during meals. In hotels drink only bottled water.

*Difficulty:* Moderate.

*People:* The people of Bhutan are friendly and hospitable and very proud of their heritage. Sometimes women and children may appear excessively shy due to the lack of exposure to foreign travelers. The official religion is Buddhism.

*Cautionary Notes:* Respect local people and their customs. Be discreet in using cameras and ask permission before taking photographs. Discourage handouts of candy and other items to the children of Bhutan. Besides being psychologically damaging to these children, "junk food" is dangerous because dental care is nonexistent. Below-the-knee-length skirts or long pants, rather than shorts, are recommended for women trekkers. Bhutanese women do not expose bare legs and western women can show respect for the local culture by doing the same. Avoid washing and bathing nude near villages.

*Further Reading:* See bibliography, Chapter Four.

*Harvest time in the Marsyangdi Valley, central Nepal.*

# NEPAL
# *Around Annapurna*

*For the first time Annapurna was revealing its secrets.*
*The huge north face, with its great rivers of ice, shone and*
*sparkled in the sunlight. Never had I seen so impressive a*
*mountain. It was a world both dazzling and menacing, and the*
*eye was lost in its immensities.*

*—Maurice Herzog*

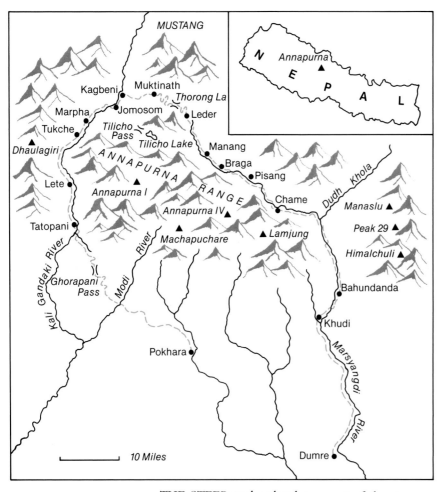

THE STEEP and unbroken crest of the Anna-purna Himalaya is sixty-four miles long. From Lamjung (22,910 feet) on the eastern end to the summit of Annapurna I (26,545 feet) on the western end this ridge, continuously over twenty thousand feet high, is one of the larg-est rock-and-ice barriers on earth. Keeping within twenty-five miles of this spine one can trek around the entire range in twenty to twenty-five days, traversing terrain ranging from tropical rice paddies to icy passes, from moist rhododendron forests to moonlike landscapes.

Exploration of the Nepal Himalayas began in 1950, when the maharaja of Nepal, Mohan Shumshar, permitted the French expedition of Maurice Herzog to attempt Dhaulagiri, or An-napurna I. Under Mohan Shumshar's rule Ne-pal began to open its doors to foreigners after having been closed for hundreds of years. He belonged to the aristocratic Rana family, which had been established as rulers of Nepal in 1846 by the then prime minister Jang Bahadur

Rana. The latter, a despotic and feared man who personally cut off the heads of his cabinet ministers who had offended him, had taken power from the king and banished him to his palace. It was not until 1950—a century after the Ranas established their regime—that the legitimate heir, King Tribhuvan, managed to escape to India. An armed rebellion devel-oped against the rule of Mohan Shumshar, and the king returned in 1951 and proclaimed an end to the Rana dictatorship.

When the French set out that year from the foothills above Pokhara, Nepal's second largest town, they had no idea how to ap-proach their goal. Lucien Devies, then presi-dent of the French Himalayan Club, outlined the problem before their departure: "Until now other expeditions have picked mountains in regions already known and explored. But we have absolutely no information about our two eight-thousanders. We know nothing about the approach routes. The maps at our disposal are sketchy, practically useless above a certain height. . . ." Nevertheless, the French not only found Annapurna but climbed it as well.

Their success on the first "eight-thou-sander" (a mountain higher than 8,000 meters, or approximately 26,250 feet) is well known. On June 3, 1950—a historic day for mountain-eers—Maurice Herzog and Louis Lachenal stood atop Annapurna. "The summit," Herzog wrote, "was a corniced crest of ice, and the precipices on the far side which plunged verti-cally down beneath us, were terrifying, unfath-omable. There could be few other mountains in the world like this. Clouds floated halfway down, concealing the gentle, fertile valley of Pokhara, 23,000 feet below. . . ."

The French thus opened access routes to the Annapurna Range; they also explored ex-tensively to the north of the peak. They dis-covered Tilicho Pass and Tilicho Lake, as well as a route down the east side of the Tilicho basin to Manang (for experienced trekkers with climbing skills). Gaston Rébuffat, a mem-ber of the team, made the first known Euro-pean crossing of the Thorong La (17,771 feet), a key pass on the Annapurna circuit, and vis-ited the holy shrine of Muktinath. The French also discovered the approach route into the North Annapurna sanctuary, over an unlikely

pass crossed on April 27. To this day it is called "The Pass of April 27."

For the present-day hiker in central Nepal the trek around the Annapurna massif starts from Pokhara and ends in Dumre, or vice versa. Situated in a lush, subtropical valley at twenty-five hundred feet, Pokhara, a rural town of bazaars and teashops, is less than one hour by air from Kathmandu. A road connects the two and can be comfortably driven in six hours by car or bus. The climate is balmy year round, and the Pokhara Valley presents scenes of unequaled beauty. Gargantuan snow-clad peaks tower above the lush greenery, and thatched terra-cotta houses shimmer above flooded checkerboard rice fields.

It was here that I led my first Himalayan trek, in 1967. Our group, composed mostly of experienced hikers and backpackers, included Barry Bishop, who had climbed Everest in 1963 with the American expedition led by Norman Dyhrenfurth. We were also the first party of hikers organized by an American agency to trek into the Annapurna mountains. At that time the northern portion of these mountains, as well as the trek route around the range, was closed to all foreigners, and we were allowed to travel only as far as Jomosom, a small government outpost on the north end of the Kali Gandaki Gorge, a deep trench separating Dhaulagiri from Annapurna.

After what must rank as one of the world's most scenic short flights, along the crest of the range, we landed at the small Pokhara strip, back then a simple grassy field. Cows had to be chased off the runway by youngsters before a plane could land, and the sight of an airplane was an event drawing a good-size crowd. Porters hired in advance, a small army of Tibetan refugees and Nepalese, were waiting for us. As soon as all our gear was taken off the plane we started for the hills, leaving the details of loading the porters to our local outfitter.

In 1967 everything about Asia, Nepal, the Himalayas, and the Sherpas was new to most of us, so Barry's previous experience with Nepal was highly valued and helped us overcome the culture shock we felt at first. In addition to our porters we had also hired a team of Sherpas. These legendary inhabitants of the valleys below Everest had played key roles on most major Himalayan expeditions, serving as high-altitude porters. The leader, or sirdar, of our team was Nima Dorje, an efficient but somewhat shy trek manager, who impressed me by having climbed Dhaulagiri, a mountain we were soon to see, during the first ascent in 1960. Also with us were Pemba Tharkay and Sona Ishi, young camp helpers who would later become well-known sirdars and climbers.

Those first days on the trek were magical. Everything was new and different as we wandered from village to village, walking among giant banana trees, groves of fern and bamboo, and twenty-foot-tall poinsettia shrubs. The natives stared at us, and we at them. We drank tea and the more potent *chang*, the local rice beer, at wayside inns. Wandering minstrels, accompanied by three-stringed violins called *sarangui*, sang songs of love and legend. One popular song praised Tenzing Norgay, the conqueror of Everest, who had become a national hero in Nepal and India.

Soon, where the subtropical Pokhara Valley narrowed to a canyon, we entered the foothills and climbed endless steep stairs of manicured flagstone. After crossing several densely forested ridges we reached the famed Ghorapani Pass (9,295 feet), with its sweeping views of Dhaulagiri (26,795 feet) and, several thousand feet below, the Kali Gandaki River. From its source in the remote district of Mustang, north of the Himalayas, this river cuts a cleft eighteen thousand feet deep between two of the highest mountains on earth, Annapurna and Dhaulagiri, illustrating the fact that the watershed of the Himalayas lies not along its main axis but much farther north, on the Tibetan Plateau. Besides the Kali Gandaki four great rivers well up from the plateau: the Indus, the Yarlung Tsangpo (which becomes the Brahmaputra on entering India), the Sutlej, and the Karnali. The extraordinary fact is that the rivers are *older* than the mountains. The Himalayas were pushed up after the landmass of the Indian subcontinent drifted across an ancient sea and crashed into Asia. Before the collision the rivers flowed due south. After the beginning of the uplift, a process that took millions of years, the rivers had to either cut through the new range or flow around it. To-

*The narrow flagstone main street of Marpha, a picturesque village in the upper Kali Gandaki Valley.*

*The temple of Swayam-
bodnath in Kathmandu,
capital of Nepal.*

point were home to Gurung and Magar, color-
ful tribal people of the middle hills; Brahmins
and Chettris also lived in the foothills, sharing
with other ethnic groups the meager farming
lands and the Hindu religion. But beyond Ta-
topani the landscape and the culture changed
dramatically. Signs of devotion along the
trail—white prayer flags made of strips of
cheesecloth—were now of Buddhist tradition,
reflecting Tibetan, rather than Indian, influ-
ence. Deciduous forests gave way to subalpine
and alpine habitat, sparse juniper-studded hills
framing wide gravel bars. Following the Kali
Gandaki River toward Tibet for several days,
we passed large donkey caravans transporting
salt and wool from the Tibetan highlands to
the valleys of Nepal.

Later tightly clustered houses with flat
mud roofs appeared, their windproof inner
courtyards protecting the villagers of Lete, Lar-
jung, Tukche, and Marpha from the blasting
winds that race up the Kali canyon, one of the
deepest wind funnels in the world.

When we arrived in the principal village
of Tukche the locals, who had not seen a large
group of Westerners since Herzog's expedi-
tion of 1950, greeted us with warmth and un-
expected ceremony. We were stared at,
touched, and talked to in Hindi, Thakali (the
local dialect), and Tibetan, none of which we
understood. Eventually someone said that the
villagers were expecting a visit from the zonal
commissioner, and that they mistakenly
thought our group to be part of his entourage.

The important government official arrived
in due course, riding a white pony. He was
preceded by loud beats from a large drum
hung around the neck of a soldier wearing an
old English Army jacket. Behind the commis-
sioner two foot bearers held a large and or-
nate parasol over his head. No doubt this was
to impress the villagers, as it was neither
sunny nor rainy. A retinue of officials, some in
pajamas, others in old Gurkha army uniforms,
followed. Great preparations had been made
for the occasion: marigold garlands hung
across the trail, on trees, and from wooden
balconies; brightly colored paper stars and
crescents covered walls and doors. A platform,
on which crudely made armchairs had been
placed, had been erected in the town square.

day the Karnali and Sutlej cut directly through
the mountains. The Indus to the west and the
Tsangpo to the east flow around the
Himalayas.

We camped near the pass that night and
rose early for a view of the peaks from a small
hill above. Large stone stairs now led steeply
down to the gorge and to a large village
across the river. Before walking into Tatopani
(3,870 feet) we found the hot springs (by the
bridge) that make the town famous, and en-
joyed a revitalizing soak and cleanup.

The villages we had visited up to this

The villagers were dressed in their best. Some children began to sing (some cried), and the headmaster made a welcoming speech. Not wishing to disturb these festivities with our presence or to compete for the villagers' attention, we quietly retired to the tents our Sherpas had set up some distance away.

But much to my surprise I was summoned from my tent by an army chap clad in pajama bottoms and carrying an officer's baton under his arm; he marched me toward the commissioner, now seated in his chair. Gesturing me to join him and to participate in the festivities, the commissioner began to ask questions regarding our group's presence in Tukche. "Why have you come to this inhospitable land?" he wanted to know. "There is nothing here, we are very poor. You, on the contrary, have everything—radios, telephones, even cars. Besides," he added while pulling his U.S. Air Force flight coat snugly around him, "it is quite cold in these high mountains."

I tried to explain that we had come to enjoy the beauty of Nepal and perhaps to discover some hidden values as well, such as happiness and serenity. Later, after I returned to my tent, unsure whether or not I had convinced him that we were not foreign spies, I started to think of the reasons why, in fact, I was there. A stanza from Robert Frost came to mind:

> I shall be telling this with a sigh
> Somewhere ages and ages hence:
> Two roads diverged in a wood,
>     and I—I took the one less travelled
>     by,
> And that has made all the difference.

I fell asleep happy under the cold, bright moonlight.

Continuing on our "divergent" trail in the hills we reached Marpha on our seventh day of trekking. A maze of narrow, flagstoned streets filled with a mixture of Hindus and Tibetans, trading caravans, teashops, and small inns awaited us. The most interesting of the upper Kali Gandaki villages, Marpha is an important trading center for the area; here also we found the first active Buddhist gompa. De-

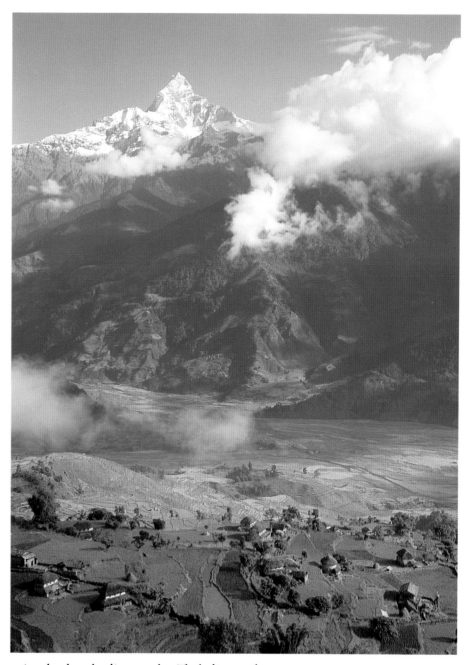

spite the harsh climate, the Thakali people who live here are prosperous. Women can own property, and while their husbands are away trading lowland rice and oil for Tibetan wool and salt they move down into Hindu country to open teahouses or engage in other lucrative activities.

Crossing some wide gravel bars between Marpha and Jomosom we were hit by a brief but strong dust storm. At Jomosom, the last town allowed on our trekking permits, we looked enviously north toward Muktinath and beyond, then headed back to Pokhara and the

*Machapucchare, the "Fish's Tail," looms above the fertile Pokhara Valley. This sacred peak is unclimbed, and the government of Nepal forbids anyone to do so.*

*Camp on the Thorong La, the 17,771-foot high point on the trek around the Annapurna Himalayas.*

end of our pioneering venture.

After this first visit to Nepal in 1967, I decided to return to complete the trek around the mountains as soon as the Manang District and the Thorong Pass were opened. This finally happened in 1977, making it possible to circle the entire Annapurna Range, from Pokhara to Dumre, on the Kathmandu Road. I brought along a friend, Dick McGowan, and his wife, Louise, and completed the circular route in twenty-four days. Dick was an experienced mountaineer who had been to Everest in 1955 with Fred Beckey and had made the first guided ascent of Mount McKinley in 1961, and was interested in joining me at Mountain Travel as a partner. Retracing my steps of 1967 we again visited Tatopani, Tukche, and Marpha, then passed quickly through Jomosom, which had since acquired shops, inns, and even a small bank. The government had also posted a small army garrison here and built a bush airstrip at 8,900 feet. We were now north of the Great Himalayan Range, in the rainshadow of the mountains. At Kagbeni (9,200 feet), a fortresslike village commanding the wide bed of the Kali Gandaki River, we left the

main trail to Mustang and Tibet and climbed up and east to Muktinath (12,560 feet). A famous pilgrimage site to Hindus and Buddhists alike, its temples are built above natural-gas fissures in the bedrock; flames flicker under stone altars. This colorful and fascinating place is also the staging ground for the journey across the Thorong La, the pass leading to the Manang District.

Above Muktinath, the trail climbed continuously and steeply for five thousand vertical feet to the 17,771-foot pass. It was a long crossing, with little water, no shelter, and few good places to camp. The pass was a wind-swept expanse of gravel and snow with panoramic vistas of peaks, ridges, and icefalls. The descent into the Manang District was long but technically easy; the first water and campsite, at Leder (14,500 feet), lay far below, on the banks of the upper Marsyangdi River.

While the French were working their way up Annapurna in 1950, the great English mountaineer H. W. Tilman was exploring the other side of the Thorong La, along the Marsyangdi Valley. Tilman later explored the upper Dudh Khola Valley and reached the Larkya Pass, north of the giant peak of Manaslu (26,781 feet). He made several unsuccessful attempts on Annapurna IV (24,688 feet), then went on to make the first crossing of the Mustang La, an eighteen-thousand-foot pass connecting the Manang District to Mustang. He also ventured into Mustang as far as Tange, becoming only the second European to visit that remote kingdom.

Dick and Louise McGowan, together with Murray Alcosser, a photographer from New York, and Richard Wohns, a neurosurgeon from Seattle, spent a long day descending through alpine meadows to the idyllic village of Manang, with its primitive flat-roofed multistoried houses and interconnecting log ladders; countless prayer flags hung from stripped pine poles. Here Dick picked up a stray mastiff puppy, which he lovingly carried and fed for the rest of the trek and eventually took back home.

A day's walk below Manang, which was mostly deserted, we reached Braga (11,250 feet), an incomparable jewel of a village. Square whitewashed houses cascaded down a

steep and grotesquely eroded volcanic cliff jutting into a green meadow. Above the village stood a five-hundred-year-old gompa; the head lama boasted that it contained a treasure of more than a thousand bronze Buddhas. The religion, dress, and culture of these Manang people are Tibetan, but their ethnic origins are apparently lost in time. They are independent, somewhat reserved, and suspicious of visitors. Some mountaineering groups reportedly have been held up for "protection money," and Tilman, in 1950, was "not delighted" with them. "The traveler to remote

*One of the scarier moments on trek. Due to the light construction of the span, only five people are allowed to cross at one time.*

*Mani stones, which line most trails in Buddhist Nepal, represent prayers to the divinities. The text reads "Om mani padme hum" (Hail to the jewel in the lotus).*

parts," he wrote in his wry manner, "wishes, indeed expects, to find the natives unsophisticated enough to regard him with the respect which he seldom gets at home. At Manang he will be disappointed." Treating the Manang people with respect and courtesy should alleviate any serious problems; no incidents have been reported since I visited Manang in 1977.

Below Pisang, at the lower end of the Manang Valley, the trail follows a narrow canyon into a precipitous gorge where the waters of the Marsyangdi River crash down vertical chasms of rock. The river leaves the Himalayan rainshadow as it approaches the hamlet of Chame on the north slope of Lamjung Himal, the last large peak of the Annapurna ridge. In Chame, the first settlement where one can purchase supplies, signs of the Hindu sphere of influence are visible again. Richard, our doctor, posted himself in the village center

with his medical kit and was soon surrounded by dozens of locals seeking treatment. At that time not a single doctor was available in the entire Manang District.

Beyond Chame we spent several more brilliantly clear days following another deep gorge, occasionally passing Gurung tribal villages, with their wheat- and cornfields stretching out along the hillsides. From several high points on the trail the great peaks of Manaslu (26,781 feet) and Peak 29 were visible, their rocky faces dominating the eastern sky.

When the Marsyangdi River emerges from the canyon near the village of Bahundanda, it has descended to less than four thousand feet above sea level, and the landscape abruptly changes again. The valley flattens out and the trail becomes easy, with a few long hills now and then. Along the river the soil is fertile; between stands of broadleaf forest rice, wheat,

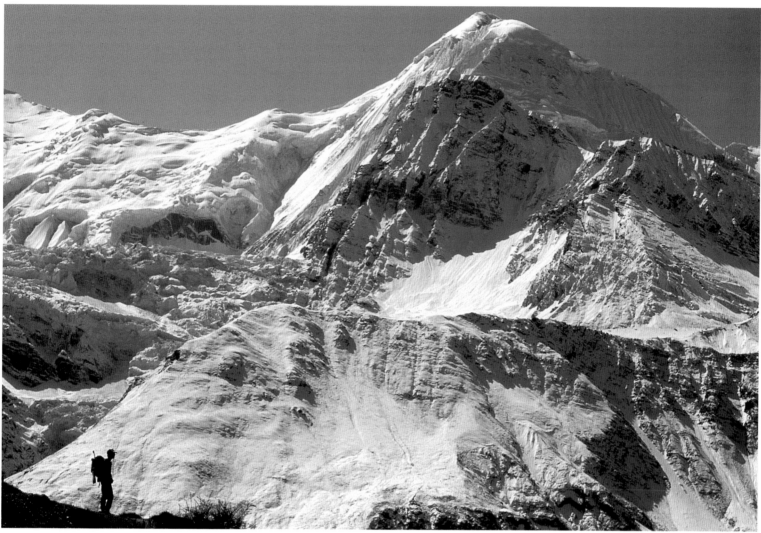

corn, and millet are cultivated. South of Ba-hundanda the route continues to Bhulebhule, crossing a long suspension bridge to the river's west side and the town of Khudi (2,500 feet).

Two and a half long but level days, sometimes hot, led us farther southward past steep-pitched thatch villages. Monkeys, water buffaloes, chickens, and ducks, not seen since we had left the Pokhara Valley, appeared again on the trail. The end of the trek was near. Tired but elated we reached Dumre, a dusty truck stop on the Kathmandu–Pokhara road, at only 1,450 feet of elevation.

Elated we certainly were: our eyes had beheld the radiant smiles of beautiful young women planting rice seedlings in muddy paddies; our spirits had risen above the vast snow peaks of the Himalaya; our ears had heard musicians, dressed in white flowing gowns,

play at night on golden instruments; our senses had been touched by the gesture of a small child as she reached out and placed a marigold garland around my neck.

Sunburned, dirty, and the men with month-long whiskers, we were welcomed by friends who had driven up from Kathmandu to meet us.

Though the most popular portion of this trek is the Kali Gandaki area, the northern and eastern sections of Manang and Marsyangdi are less visited and are therefore recommended. Crossing the Thorong La requires good physical preparation as well as proper equipment and food. The possibility of sudden, deep snowfall is always present and can result in hazardous conditions. There have been fatalities due to the inexperience and unpreparedness of individuals and small parties. A reliable guide is recommended.

*Trekker is dwarfed by the scale of the Annapurna Himalayas, as seen here from above the village of Manang, near Thorong La.*

*On the trail, passing through the village of Talphi, a primitive settlement of animistic Nepalese, west Nepal.*

# The Kanjiroba Trek

*To fitly paint the grandeur of the scenes*

*Words fail me quite; what can I, helpless, do?*

*These scenic beauties on the Himal'yan range*

*E'en human eyesight fails to comprehend.*

     *—Ekai Kawaguchi*

JUMLA, the trading center and chief village of western Nepal, is rather difficult to reach. No roads lead from the lowlands, so the only practical approach is to fly from Kathmandu by Royal Nepal Airlines; service to Jumla is erratic at best, mostly because of the unpredictable weather and the scarcity of aircraft. To compound the problem, the few available seats are usually booked months in advance by locals. Another, more expensive, possibility is to charter either a Twin Otter, a sixteen-passenger Canadian-made STOL (short takeoff and landing) plane, or the smaller and more economical seven-seater Pilatus Porter, a reliable aircraft built in Switzerland especially for difficult bush country and high mountain terrain. Charters are not easy to book either, due to limited aircraft availability and the heavy demand for flights to such popular spots as Khumbu and Langtang. Nevertheless, if one is willing to wait a few days and pay charter rates, it is possible to reach Jumla, an unattractive community of three thousand Hindu Nepalis.

After enduring these touch-and-go travel arrangements—and after one look at Jumla—you may wonder why you took the trouble. But you are now in position to start a fabulous trek into untouched and primitive country—much like the rest of Nepal some thirty years ago, before the nation became known as a trekker's paradise. Most of the goods traded in western Nepal pass through Jumla, from Tibet to India and vice versa, a process helped by the Bhotias (Nepali nationals but ethnic Tibetans who practice Buddhism), pastoral nomads who move to and fro across the border with their herds of yaks and goats. Some staples can be purchased in Jumla, although it is wiser and safer to bring everything from Kathmandu.

As we took off from Kathmandu for Jumla we enjoyed a clear, bright morning with no cloud cover of any significance over the mountains—a rarity. Soon the big peaks of the Himalayan crest began appearing in an extraordinary display of mountain grandeur. We were, in fact, on one of the world's most spectacular mountain flights. The first peak we sighted was Ganesh Himal (24,373 feet), somewhat to the north. We saw Himalchuli (25,896 feet), where our friends John Cleare and Ian

Howell were then struggling to reach the summit. Behind stood Manaslu, at 26,781 feet the seventh highest mountain in the world. Then the four great Annapurna peaks came into full view—a scene without equal. Slightly below was that incredible pyramid of rock and ice Machapuchare, "The Fish's Tail," which flashed past the window of our small plane all too quickly. A thin, high haze then began to obscure the view. Dhaulagiri (26,794 feet) briefly appeared above this mist, then disappeared. Soon we were past the Dhaulagiri group and could see into the northern regions of Nepal, the forbidden district of Dolpo, and Tibet beyond. Finally the Kanjiroba Range came clearly into view, with dozens of peaks showing. We were, on our first approach to these mysterious mountains, seeing them all at once; John Tyson, who organized four expeditions to climb Kanjiroba, caught sight of the mountain only once, and then only for a short time.

Kanjiroba, at 22,579 feet, is the highest peak of the Kanjiroba Himal and the highest point on the main Himalayan crest between Dhaulagiri in central Nepal and Saipal (23,068 feet) in the westernmost end of the kingdom. But the beautiful pyramidal peak is hidden deep within a forest of 22,000-foot mountains.

Within minutes we were over the Jumla Valley and soon landed uneventfully on a small grass strip a few miles east of the seven-thousand-foot-high town. The Sherpas unloaded our supplies and set up camp in a dry rice paddy two hundred yards from the runway on a bank overlooking the Tila Nadi River.

Four main areas attract trekkers to this part of Nepal: the Kanjiroba Himal; the smaller Sisne Himal; the Mugu district—at present closed—an area of strong Tibetan influence near the border; and Lake Rara, Nepal's largest. We intended to trek around the Sisne Himal, visit Lake Rara along the way, and return via the high ramparts of the Kanjiroba.

Although several early expeditions penetrated into western Nepal the Kanjiroba Himal remained largely untouched until 1953, when the Austrian mountaineer Herbert Tichy climbed several smaller peaks during his remarkable journey on foot from Kathmandu to Jumla (via Mustang and Dolpo) and into India. Earlier explorers of western Nepal include the

*Animistic carving along the trail.*

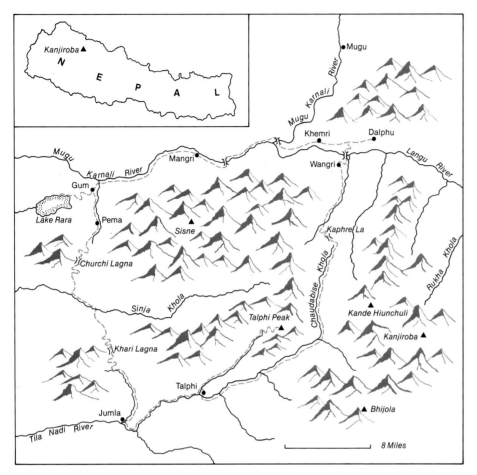

Japanese monk Ekai Kawaguchi, who walked from India to Tibet and back in three years (1903–1905), and the Survey of India pandits—men who traveled in disguise all over Nepal, mapping the country for the British. Two of these men, Lal and Thapa, visited the southern end of the Kanjiroba in 1926 and again in 1958 and produced the first map of the area. But the most colorful traveler to the region was Henry Savage-Landor, who in 1897 forced his way into then forbidden Nepal by overpowering the border guards. Others include Dr. Tom Longstaff, a British explorer, and Augusto Gansser and Arnold Heim, Swiss geologists who completed valuable scientific research that they published in their classic book *The Throne of the Gods*.

John Tyson's four Himalayan expeditions (between 1961 and 1969) constituted the first real penetrations. He explored and surveyed the southern, western, and northern flanks of the massif, then finally found a way into the heart of the range from the north, traveling up the treacherous Langu Gorge. Later he wrote:

"There can be few places on earth more savage and forbidding than the Langu Khola, the gorge of the Langu River." In 1969, on his fourth expedition, he discovered the Rukha Khola, a side valley that led toward unclimbed Kanjiroba. Crossing south over a high pass that now bears his name, Tyson came within two miles of his coveted summit. But the monsoon struck and warm winds soon swept the peaks; the climbers sank to their knees in the snow. Exhausted and feeling isolated in this remote corner of the Himalayas, they gave up. The first ascent was accomplished the following year by a Japanese expedition from Osaka University.

With our own hopes high and with prospects of fine weather, Ray and I made last-minute purchases in Jumla—rice, salt, and tea. We then walked around the town. Visiting the local high school, we learned that only two hundred ninety students were enrolled from the region's total population of forty thousand.

The next day we left town on foot and headed toward Lake Rara, which lay twenty miles to the north, at an elevation of ten thousand feet. That first day was steep going. We climbed from 7,600 feet to the first pass, the Khari Lagna (11,650 feet). Here, with good views of the Kanjiroba peaks to the east, we stopped for lunch, watching a pair of beautiful hen harriers engage in a mating dance.

After descending a steep trail to the Sinja Khola we camped by the river.

The Churchi Lagna, another eleven-thousand-foot pass, was tackled and crossed the following day. We then descended steeply into the village of Pema. The trail, though broad, was covered with ice, and we had a long day of it. On day three we descended from Pema in the early morning toward the wide Mugu Karnali River, which drains all of the districts of Mugu and North Dolpo. At one memorable spot I was nearly gored by a big yak that was galloping up the trail. The frantic screams of the yak driver barely gave me time to get out of the way as the beast stormed past. After I regained my composure we continued down to Gum, a small government town by the river, at 5,620 feet the lowest elevation of the trek.

A strenuous side trip that included a four-

thousand-foot climb gave us a look at Lake Rara. This area, a national park since 1972, abounds with wildlife. With luck and some patience one may observe such exotic animals as the red panda (quite different in appearance from the giant panda found in China), musk deer, and the goral, a small, goatlike antelope. Since the park was established the government has been forcibly removing the local tribal groups who inhabited the area—much to their consternation and suffering. As a result, the Lake Rara area is now mostly uninhabited.

Returning to the Mugu Karnali River, we continued our journey eastward. Two days of enjoyable, warm-weather trekking led along the left bank of the river through lovely forests of *Rhododendron arboretum*, the national flower of Nepal, called *lali guran* in Nepali. Eventually we came to the Tibetan-type village of Mangri, which possessed a charming old gompa. The resident monk allowed us to enter, but the temple had not been kept up and most of the murals had deteriorated.

The following day we crossed the wide Mugu Karnali River by a narrow cantilever bridge. The main span, a single flattened tree trunk less than two feet wide and more than one hundred fifty feet long, was suspended a hundred feet above the water. After this challenging feat we continued east and began to see increased evidence of the Buddhist world of the Bhotias. The villages now had walk-through chortens guarding their entrance; some chortens had beautiful old mandalas (mystic images) painted on their ceilings.

Since Jumla we had not seen another Westerner. We were traveling in a truly primitive and isolated country, where people live in small, scattered hamlets, usually on hillsides. The clusters of houses resemble a southwestern pueblo; the terrace of one dwelling is the roof of the one below. I had the feeling of traveling on the very edge of existence. Not a single doctor served the district when we were there; we saw a people living in medieval conditions where diseases we have long forgotten run rampant, where people die because they do not know what infection is. Amoebic dysentery goes untreated, and gangrene kills.

*Young woman from Dalphu, undaunted by a snowfall.*

At the sacred confluence (river confluences are considered sacred by Buddhists) of the Mugu Karnali and Langu Khola a bridge over the Mugu signaled the start of the Langu Trail, which we planned to follow. The main trail continued along the Mugu Karnali, eventually leading to the large settlement of Mugu, where Nepalese officials control the traffic of men, beasts, and goods heading into Tibet, a few miles farther up the river.

After a short lunch stop in the shade of ancient, gnarled junipers we set off on the Langu Trail. The narrow path immediately steepened, and for the next four hours we climbed a good three thousand vertical feet until we reached the village of Khemri just as evening approached. During the afternoon the sky became overcast, then slowly turned dark, then black. As we entered Khemri snow started to fall. Unable to find a suitable camping place, the Sherpas finally talked someone into letting us pitch our tents on his roof.

It snowed all night, and by morning a foot of snow lay on the ground. The scene,

*Kanjiroba Main Peak, one of the more elusive of the big Himalayan peaks and king of the vast Kanjiroba Himalaya.*

when I climbed out of the tent, was simply overpowering. Silken clouds swirled at eye level across the Langu Gorge and well below us to where the river, now swollen to a furious torrent three thousand feet below, was faintly audible. (The scene reminded me of a windswept snowstorm I once saw breaking over Yosemite Valley from Glacier Point, three thousand feet above.) After the snowfall ended that afternoon, all of Khemri's labor force turned out on the rooftops armed with wooden shovels and began shoveling the snow into wicker baskets. Ray asked the villagers why they were doing this and was told that their water supply, a small stream, ceased flowing several years ago; fresh-fallen snow supplies them with water during the winter, which saves them the arduous and dangerous trek down to the river, an hour's walk away.

Because the trail from Khemri to the next

village, Dalphu, is narrow and hazardous, especially after a snowfall, we decided to stay at Khemri all day. We got to know the villagers, and Ray cared for an old woman with suspected amoebic dysentery who had not left her bed for more than two years.

The track to Dalphu *was* difficult, certainly not a track for animals, not even the sure-footed yaks, which are taken around an easier path that crosses a high, open pass. We decided to risk the harder route, and in several spots we almost had to downclimb (facing into the slope) a series of narrow steps sheeted with ice. Before arriving at Dalphu we reached 10,800 feet, the highest point on the trail. It was in total darkness that we found this small village, situated at 10,200 feet and perched on a steep cliff overlooking the gorge. The hike had taken eight hours—a strenuous day.

The Dalphu porters, John Tyson had told me, were the strongest of any Himalayan porters he had ever seen. "If you need any, go see the headman; he may remember me," he had said. We were not in need of porters, but we did meet the local headman; he was the son of the man who had helped Tyson cross the Langu Gorge in 1969.

Across the gorge, and at a level somewhat below where we stood, we could see the village of Wangri, our objective for the day. Hours later we crossed the last bridge spanning the river, three thousand feet below, without incident, and soon reached Wangri, a sunny village of friendly Bhotias who had not seen a Westerner for ten years. We made a reconnaissance into the Changda River Gorge and the glaciers above, but heavy snow cover slowed our progress so much that we decided to abandon this side trip. Returning to Wangri we saw a magnificent stag, the Himalayan thar, standing motionless on a rock outcrop, his long brown coat rippling in the reflected rays of the setting sun. Later we were fortunate in seeing several iridescent monals, the national bird of Nepal, in flight. This highest-living pheasant occurs in Nepal up to fourteen thousand feet, the elevation where we saw them.

We were now ready to return to Jumla over a pass known as the Kaphre La (17,600 feet), south of Wangri. This route would lead

*Snow leopard.*

*Buddhist shrine in the village of Kemri, high above the Langu Gorge.*

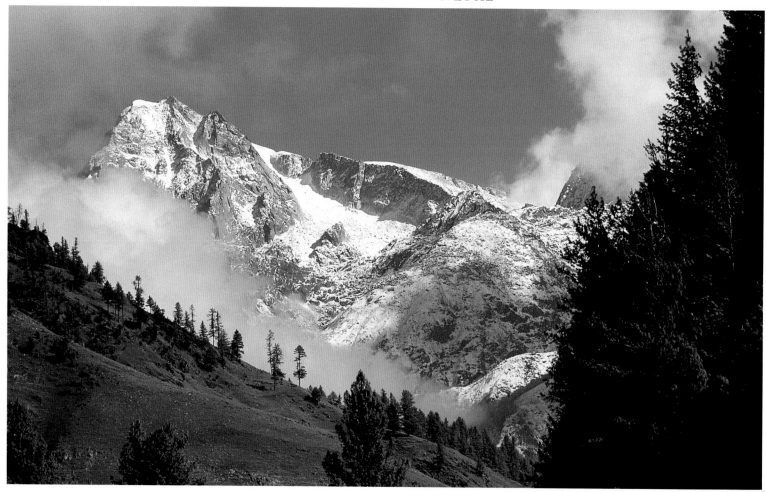

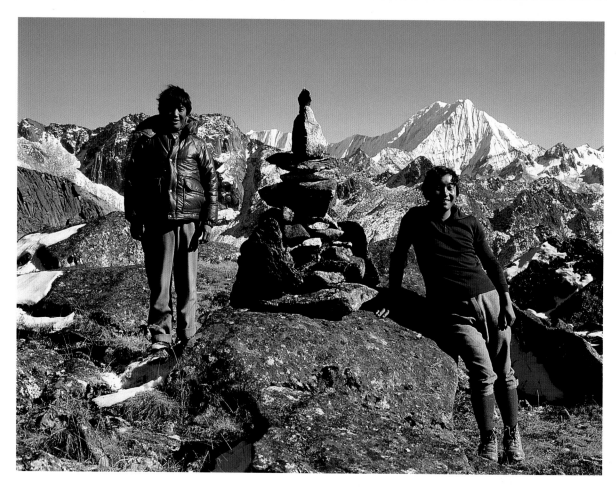

*(Top) Talphi Peak (18,000 feet), which was first ascended by Ray Jewell, Ang Phu, and the author. (Bottom) Sherpa guide Ang Phu, right, was later killed in a fall on a Mount Everest expedition.*

to the Chaudabise Khola River and Talphi, where an easy trail led to Jumla. Our friends in Wangri told us that the route would be snowed in and the pass difficult to cross; they suggested we take along their local guide, Purba, an offer we gladly accepted. We moved out as soon as possible, Purba leading the way, and made good progress toward the pass, camping at around fourteen thousand feet that night.

We were hit by a big snowstorm the next day and were tentbound for forty-six hours. The storm abated on the third day, and within four hours—thanks to our heroic Sherpas— we were standing on the Kaphre La, enjoying fine views of the Kanjiroba. All the peaks were visible, from Api and Saipal in the far west to Kanjiroba, Bhijora (20,951 feet), Kande Hiunchuli (21,742 feet, climbed in 1977 by the Japanese), and Dhaulagiri in the far distance. That night we camped under some large boulders at thirteen thousand feet. In the morning we saw tracks in the snow near our tent. Purba said they were made by a snow leopard.

We were now in the upper catchment basin of the Chaudabise Khola, a stream draining into the Tila Nadi River, which flowed toward Jumla. Below the Kaphre La we enjoyed two days of very fine trekking through incredible forests of rhododendron, giant fern, and giant bamboo—all covered by a thick mantle of snow. On the third day we arrived at Talphi, a village inhabited by animistic Nepalis, whose bridges, buildings, and fields are adorned with primitive, eerie-looking wooden carvings of local deities. Jumla was now only two days away, but before returning for our rendezvous with our chartered plane we hiked for a week into the Sisne Himal, a small range on the main Himalayan axis that has no summits over nineteen thousand feet. These peaks, mostly rocky and with little or no glaciation, are easily accessible from Talphi (at the most a two-day walk) and present no particular difficulty to the trekker or climber. There we made the first ascent of Talphi Peak (18,000 feet) with our Sherpa sirdar, Ang Phu. From the summit we had yet another set of incomparable views of the Kanjirobas. That day brought our western-Nepal adventure to a fitting and glorious end.

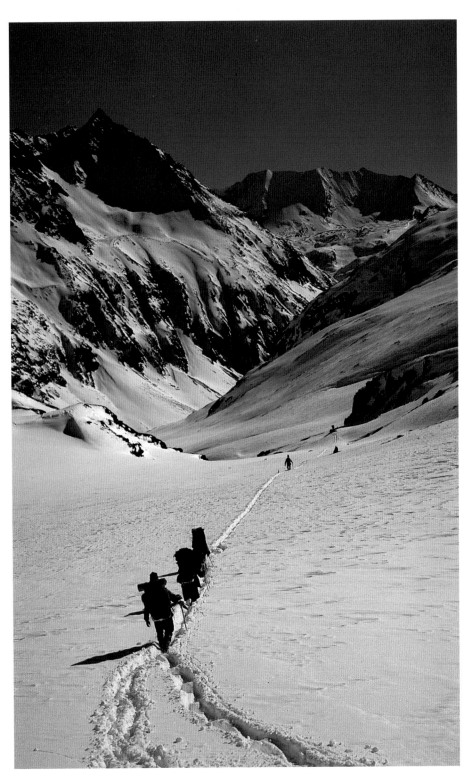

*Crossing the Khapre La,*
*highest point on the trek.*

# TREKKING IN NEPAL
## Expedition Planners

### General Information

*Visas:* A Nepal visa can be obtained at Kathmandu airport for a ten-day stay. A thirty-day trekking visa can also be obtained from the Royal Nepalese Embassy in Washington, D.C. Extensions of tourist and trekking visas can be obtained either through the Nepalese Embassy in the United States or in Kathmandu through travel agents or specialized tour operators.

*Vaccinations:* The following are suggested: tetanus, typhoid, polio, and gamma globulin, and malaria suppressant tablets. Regulations change frequently, so please consult your physician or U.S. Public Health Service. Begin your immunizations early for maximum comfort. Gamma globulin must be taken just before departure. All tourists planning to trek in Nepal have been advised to receive meningococcal vaccine (bivalent A–C vaccine), available in both the United States and Nepal.

*Water Purification:* Water should always be boiled or purified with water purification pills or iodine crystals.

*Nearest Airport:* Kathmandu International Airport for flights from Bangkok, Hong Kong, New Delhi, and Calcutta.

*Logistics:* Although trekking has now become an established tourist business in Nepal, it remains prudent to decide beforehand how one wants to trek. It is possible to do it alone, either backpacking and camping, or eat and sleep in native huts and inns, or travel with a Sherpa and a few porters. It is also possible to join an organized group. It all depends on your own personal level of experience, skills, and the amount of risk you are willing to take (with your health, the food you wish to eat, the guides and porters you wish to hire). Of course, the ex-penses go up in relation to the services provided. Once you decide how you want to travel, reservations should be made in advance, especially if you plan to go in the high season, October and November.

*People:* The people of Nepal are very friendly and hospitable. They are shy at times, especially the women.

*Cautionary Notes:* Respect the local people and their customs. Be discreet in using cameras and ask permission before taking photographs. Avoid handouts of candy to the children.

Because deforestation has become a big problem in some areas in central Nepal, due in large part to tremendous population increases, it is advisable to avoid the use of firewood for bonfires and cookouts.

*Source of Official Information:* Royal Nepalese Embassy, Washington, D.C.

*Further Reading:* See Bibliography, Chapters Five and Six.

### Around Annapurna (Chapter Five)

*Means of Transportation:* Kathmandu, the capital of the small kingdom, can easily be reached by air from Delhi, Calcutta, Bangkok, and Hong Kong—all by direct service. To reach Pokhara, one can either fly (a short but extremely scenic flight along the flanks of the Annapurna massif) or drive along a well-paved road, a journey of six hours.

*Travel Tips:*

*Best season:* October and November are usually clear; April and May have long days, with warmer, mostly clear weather. This is one of the most popular treks in Nepal, visited by perhaps as many as two thousand trekkers annually. To avoid the big crowds, go in late spring.

*Trekking days:* Twenty to twenty-five days, depending on stop-overs and pace.

*Distance covered:* About two hundred miles.

*Food:* It is possible to buy meals along the trail at local teahouses, except for the section over the Thorong La. Cooked food is usually OK, but beware of raw fruits and vegetables, and have a look in the kitchen before you order your meal. Should you decide to do your own cooking, buy food in Pokhara and rely on local shops along the trail only to supplement your supply. Very few problems are found in organized treks where the kitchen crew has been properly instructed on food handling and hygiene.

*Difficulty:* For strong hikers. The Thorong Pass, when snowed-in after storms, is not for beginners. Good mountain boots are needed. (Running shoes or lightweight "hi-tech" hiking shoes are not appropriate).

### The Kanjiroba Trek (Chapter Six)

*Means of Transportation:* Treks in western Nepal generally start from Jumla, though it is possible to walk in from Pokhara or from the Terai (Nepalgang). The only practical access is by air, either with the regular scheduled Air Nepal service (very unreliable either because it is booked up months in advance by local traders or because of technical difficulties), or by chartering your own aircraft. The latter is not easy, however, and is very expensive. Difficult access and high cost, not the lack of scenic values, are the principal reasons why very few tourists go to western Nepal. The best and surest way to get there is to charter a Pilatus Porter (a seven-seater STOL craft) from Royal Nepal Airlines.

*Travel Tips:*

*Best season:* April–May; October–November.

*Trekking days:* Fourteen, including side trip to Lake Rara.

*Distance:* 150 miles.

*Food:* All food has to be purchased in Kathmandu because virtually no supplies are available in Jumla and in villages along the way.

*Difficulty:* Difficult trek. Khapre La can be snowed-in after a storm and is steep and icy on the north side. Good mountaineering boots are a must. An ice axe will come in handy on the pass, especially after a snowstorm. Some trails, particularly in the Langu Gorge, are exposed and can be treacherous after a storm.

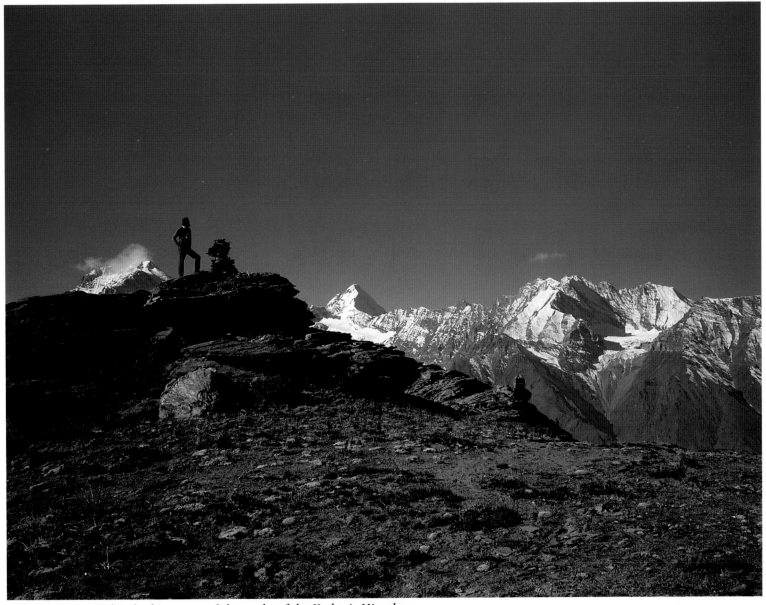

*Atop Nun View Ridge, looking toward the peaks of the Kashmir Himalaya.*

# INDIA
# *The Trans-Himalaya Trek*

*Never be in a hurry when exploring the valleys of Ladakh.*
*You can tell the time by how high in the sky the sun is, and*
*the days are like caravan routes stretching away into the*
*distance as far as the eye can see.*

*—Heinrich Harrer*

WHEN I organized the first trek from Kashmir to Ladakh in 1976, the name Trans-Himalaya was an immediate and obvious choice for this route. It was not an original name: Asian explorer Sven Hedin's book on his travels across Tibet uses it as a title. But a walk that traverses three mountain ranges—including the Great Himalaya—and visits, in depth, two centers of the world's largest religious cultures, Islam and Buddhism, is in my opinion well qualified to use that name.

Since the late 1960s I had been lobbying the Indian government for a permit to enter the then closed region of Ladakh, and though they refused all such applications I kept pestering Indian tourism officials at every opportunity. When word came in 1974 that Ladakh was finally open I cabled my friend Ray Jewell, who was then in India, and asked him to drive to Leh, Ladakh's capital, for a firsthand report on the area. He came back very excited, and with a plan for the trek. He had mapped out a route that began from the eastern fringe of the

Kashmir Valley and ended at Lamayuru Monastery, a journey he estimated would take three weeks. With the cooperation of an Indian colonel we later laid the groundwork for the journey, but it was not until the fall of 1976 that we managed to send out our Trans-Himalaya Trek.

Ladakh was closed until 1974 because of India's border troubles with China and Pakistan. After the start of the 1962 war with China over the Aksai Chin, a desolate but strategic strip of land between Tibet and India, Indian engineers built a two-lane paved highway linking Srinagar with Leh. Today this road provides the main access to Ladakh. The drive, by car or bus, takes two days. The Zoji La (11,600 feet) across the Great Himalaya Range is crossed the first day. The night is usually spent in Kargil, a large Muslim town near the Suru Valley. The second day one reaches Lamayuru Monastery after crossing the Ladakh Range over the Fotu La (13,430 feet). The tortuous road then drops abruptly into the deep can-

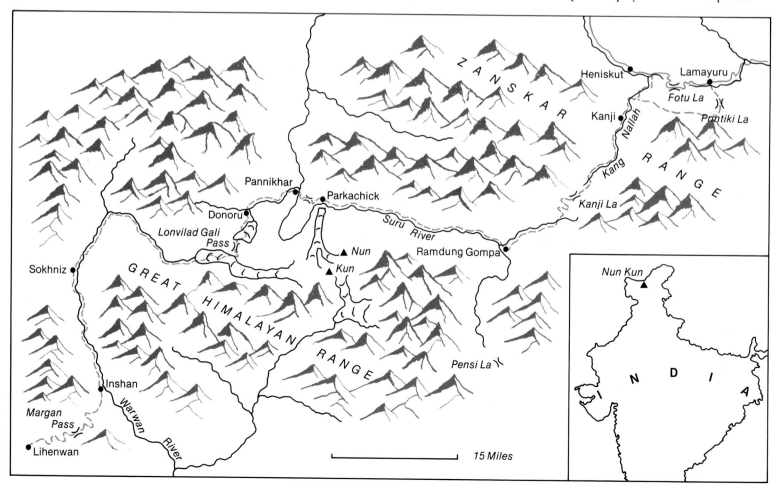

yon of the Indus River and follows it to Leh. Before 1962 this same journey, on foot or by horse, took two to three weeks.

To the early explorers of this fascinating region the natural line from Srinagar to Leh was the route of the present highway. It is said that Genghis Khan's army used the Zoji La. The first European to travel this dramatic passageway was the Italian Jesuit missionary Ippolito Desideri during his epic journey from Delhi to Lhasa. He crossed the Zoji La in May 1715, passed Leh in June 1715, and finally arrived in Lhasa in March 1716—one and a half years after leaving Delhi. The great nineteenth-century English explorers William Moorcroft and George Trebeck and the American Alexander Gardiner also visited the region. In 1909 members of the big Italian reconnaissance expedition to K2, led by the duke of Abruzzi, traveled as far as Kargil before heading north toward the Karakoram.

We had previously trekked extensively in the Vale of Kashmir, a wide, flat valley five thousand feet above sea level and ringed by mountains, but the high Buddhist world of mysterious Ladakh across the ranges had eluded us. Soon the mystery would be over.

When we set off for what I now consider to be one of the finest trekking experiences of all—the trip has become a classic—we wanted to cover as much varied ground as possible, experience the vastness and desolation of Ladakh from the perspective of verdant Kashmir, and at the same time avoid modern-day intrusions such as roads, army camps, and airfields. We therefore chose to start the trek from a pastoral and fertile valley east of Srinagar and then head in a more or less direct line eastward to Leh. Our travels would take us across no fewer than three mountain ranges—the forested and relatively low Pir Panjal Mountains, the Great Himalayas, and the Zanskar Range of central Ladakh.

Few neighboring lands can be as different from one another as the Vale of Kashmir and the high country of Ladakh. The former is a lush valley with a balmy climate; the latter is a barren, convoluted, and inhospitable high-altitude desert. Ladakh is dry country, cold and windy, especially in winter, when temperatures drop to minus thirty degrees Fahrenheit.

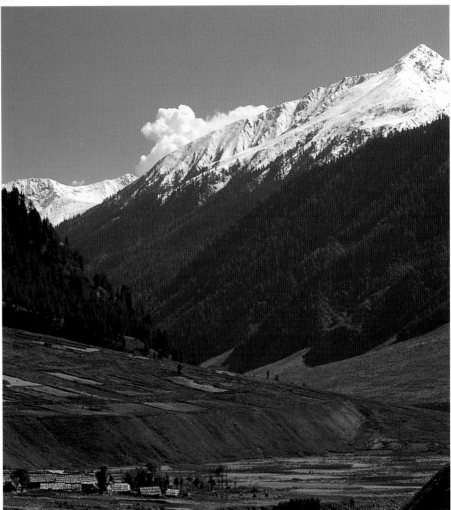

*The low lying Warwan Valley below the Pir Panjal Range.*

Here one finds immeasurable vastness, magnificent mountain scenery, and the legendary friendliness of the Buddhist inhabitants.

Our trek began at Lihenwan, a shepherds' hamlet reached by car from Srinagar, a half day's drive away. Although arrangements for horses and provisions can be made here in advance, I would recommend that any serious trekking party consider hiring horses and guides from the Suru Valley, as we did. The Balti people from Suru are much more adept at mountain travel than the Kashmiris; they know the trail conditions and will have had intimate knowledge of the route by the time they arrive at Lihenwan. Moreover, they are anxious to turn around and go back home, thus ensuring a trek free from delays or strikes. The Baltis will also come prepared for possible storms and snowfall, which can occur at any time at higher elevations in the Himalayas.

Outside Lihenwan the trail started off winding through forests alive with the sounds of whistling Gujar shepherds, whose rustic tented camps we could see in the clearings. That first day was long and steep; the trail

*(Upper left) Balti horse-man, who contracts out to trekkers, in upper Warwan Valley. (Upper right) Buddhist banners flying atop temple roofs, indicating that one is entering the Buddhist world of Ladakh. (Bottom) Our party crossing Lonvillad Gali pass between Kashmir and Ladakh.*

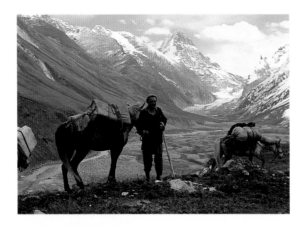

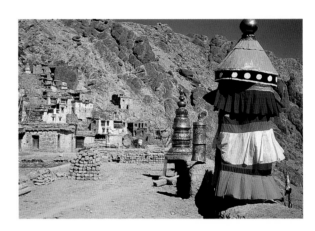

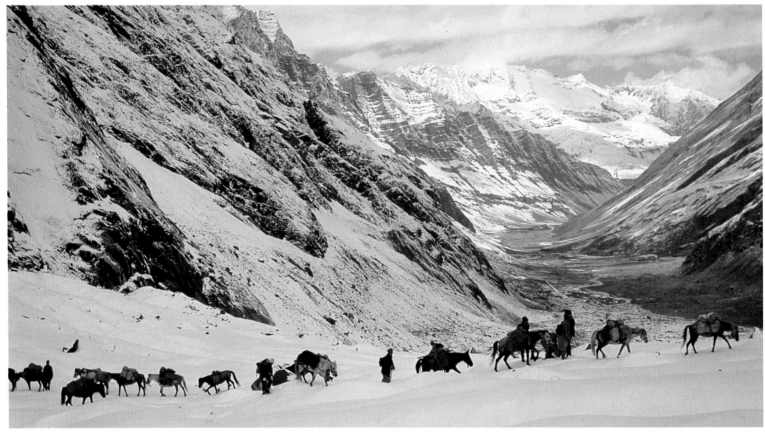

wandered up and out of the local valley and over the 13,140-foot Margan Pass of the Pir Panjal. We camped atop this pass—an open expanse of rock and meadows—and descended the following day into the Warwan Valley and the picturesque town of Inshan (8,100 feet), set among terraces of corn and millet. Dense forests dominated the hillsides of this idyllic valley, along which we ascended for several days. We made occasional river crossings on long, swaying bridges, some constructed entirely of wooden planks. We saw many families working together in the fields;

most women put on veils as we approached.

Gradually the forests disappeared, and as the valley narrowed before turning eastward we left behind the last village, Sokhniz (9,100 feet). Higher, we crossed a huge snow bridge deposited by winter avalanches, and gained the east bank of the Warwan River. Striking panoramas of great snow peaks began to appear as the canyon bent, then widened into a broad gravel bar. The rolling foothills provide summer pasturages for the goats and horses of the Gujars, but now, in late September, they were empty. The Gujars, nomadic herdsmen

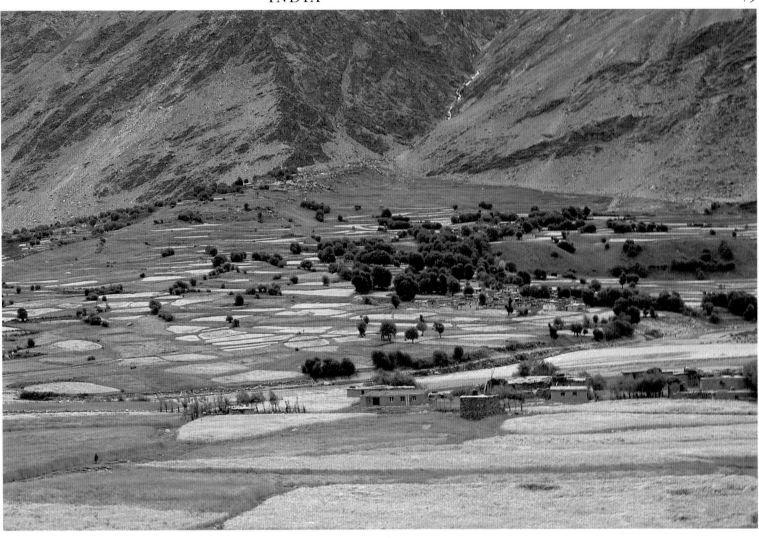

who live in these mountains, are generally friendly, though they can be aloof and reserved. There have been unconfirmed reports of trekkers being robbed by them.

Above the last Warwan meadow the entire valley was blocked by a huge unnamed crevassed glacier. Our route wound through the cracks in the glacier's toes, and after several hours of intricate route finding we exited west of a nineteen-thousand-foot Matterhorn-shaped summit. Above we could see the short but steep Lonvilad Gali Pass (14,530 feet). This pass was crossed by an army led by Dogra general Zorawar Singh on his conquest of Ladakh in 1834. Once on top we looked east into the upper catchment basin of the Suru River, which empties into the Indus in Pakistan. Down we went across several more glaciers to a campsite known as Donoru. The ground here was barren; we had crossed the crest of the Himalaya.

Now in the rainshadow of the Kashmir Himalaya, we dropped from Donoru into a long steep canyon, which became drier as we descended. We eventually reached the Suru

River and the village of Pannikhar. We were now in a southern extension of Baltistan, an ancient Buddhist fiefdom of Dards and Mongols, recently converted to the Shiite sect of Islam. (While driving through this region in 1981 I noticed numerous images of the Ayatollah Khomeini on walls and doors.) The Balti people here live in bare adobe houses without any decoration or ornaments. Roofs are made of willow wands smeared with mud. The only color in these villages is the turquoise Moorish turret of a mosque, from which the muezzin calls for prayer. Baltis are mostly horse traders and farmers. The men wear baggy homespun wool clothes and caps, as in northern Pakistan, while the women wrap themselves in heavy black garments covering the head and shoulders.

Southeast of Pannikhar the Suru River makes a major loop under the massive bulk of Nun, which was first climbed in 1953 by Claude Kogan, Bernard Pierre, and Pierre Vittoz, a Swiss missionary living in Ladakh. At 23,410 feet, this is the highest peak on the Himalayan crest in Ladakh.

*The village of Tangul in the Suru Valley.*

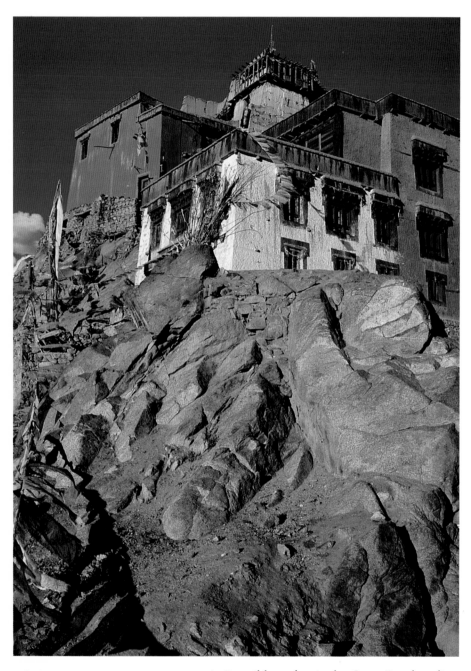

*Leh Gompa.*

From Pannikhar one can either walk the road around this major bend in the Suru River to the village of Ganri or, for a much more exciting and rewarding alternative, hike up the Nun Ridge. Choosing this, we crossed the Suru River at Pannikhar (there are two bridges—use the one farther downstream from the village) and hiked up and over a ridge that since we discovered it has become known as Nun View Ridge. Several chortens make their first appearance on this ridge, an indication that one is about to enter the Buddhist world. Once on the saddle we walked up the crest of the ridge for a grandstand view of the entire Suru Valley, the Nun Kun massif, and back toward the peaks on the Himalayan crest and the Lonvilad Gali Pass, which we had just crossed.

From the saddle we descended east to the road, then walked to Parkachick, the last Muslim village in Baltistan. We then followed a narrow gorge that led by the large tongue of the Parkachick Glacier, descending from Nun above. The road dropped to the river's edge, and soon the valley opened into a broad expanse of pampa dotted here and there with shallow marshes. After a short walk in a religious no-man's-land we spotted the profile of Rangdum Gompa in the far distance—the beginning of Ladakh and the Buddhist world.

Once a satellite of Tibet and Mongolia, Ladakh is now part of the Indian state of Jammu and Kashmir. The capital, Leh, centrally situated in the broad Indus Valley, once housed the royal court of Ladakh, now abolished. The Ladakhis broke away from Lhasa in the seventeenth century, only to see their independence usurped by incursions of Muslims from the west. Forced conversions to Islam then threatened an end to the culture of "Little Tibet," as Ladakh had become known. In the nineteenth century the district was again conquered, this time by the Dogra rulers from Jammu. Though they subjugated the kings of Ladakh, the Dogras allowed Buddhism to prosper. Ladakh has remained under Hindu rule ever since. "With the disappearance of Tibetan Buddhism and Tibetan culture in Chinese-occupied Tibet, [Ladakh] remains now as the most significant representative of the greater Tibetan cultural area that once existed," according to Professor

At Pannikhar also is the Suru Road, a dirt track that parallels the river and leads to Kargil. Unfortunately, one cannot avoid crossing this reminder of civilization, which is suitable only for trucks and four-wheel-drive vehicles. The road now stretches eastward as far as Padum, in the heart of the Zanskar district. Traffic is limited to one or two trucks daily and proves of little hindrance to the trekker. I have actually enjoyed walking this track along the Suru River for several days; for a change I did not need to look at my feet every step of the way.

David Snellgrove in his *Cultural Heritage of Ladakh*.

At Ramdung, an impressive gompa built on a natural promontory in a most unusual location—five canyons radiate from this spot—we found only one aging lama, riddled with arthritis. "The gompa belongs to Incarnate Nari Tsang Lama, the younger brother of the Dalai Lama," said Lobsang Tserap, who was then sixty-nine years old. He was the sole monk because "all the others had gone to the village." What village, I wondered—there is no village around here. He said he had only a few years to live, bent over as he was with his painful affliction. (When I drove by Ramdung in 1981 on my way to Zanskar I was worried about his fate, but he was still there, recognized me, and looked rather better.) In the temple is a fine chapel with an image of Tsong Khapa, founder of the Yellow Hats, the Gelugpa sect of Buddhism.

After lunch we continued our trek. From Ramdung it is possible to walk or drive (jeep or truck only) to the source of the Suru River, the 14,500-foot Pensi La, and cross into Zanskar, an ancient Himalayan kingdom that time has forgotten. We proceeded northeast, however, toward Leh, along a less-traveled foot trail that ascended narrow and deep canyons surrounded by multicolored mountains—a veritable painted desert.

From a marginal campsite in a canyon bottom the trail turned upward—at one spot passing through a deep, four-foot-wide rock slot—and ascended expanses of loose shale for several thousand feet to the Kanji La, a 17,240-foot pass with good vistas over countless gnarled mountain ridges extending toward the distant Chinese border. Once over this we entered the lunarscape of Ladakh, descending over endless large stones into the deep, winding gorge of upper Kang Nullah. Scattered thornbushes grew here, but not much else; the vast dry hillsides were home only to an occasional deer or ibex and the elusive snow leopard. Level ground for a camp was a long way below; we spent hours moving down this colorful rock maze. In the late afternoon we came to a whitewashed medieval settlement that has scarcely changed in hundreds of years—the village of Kanji.

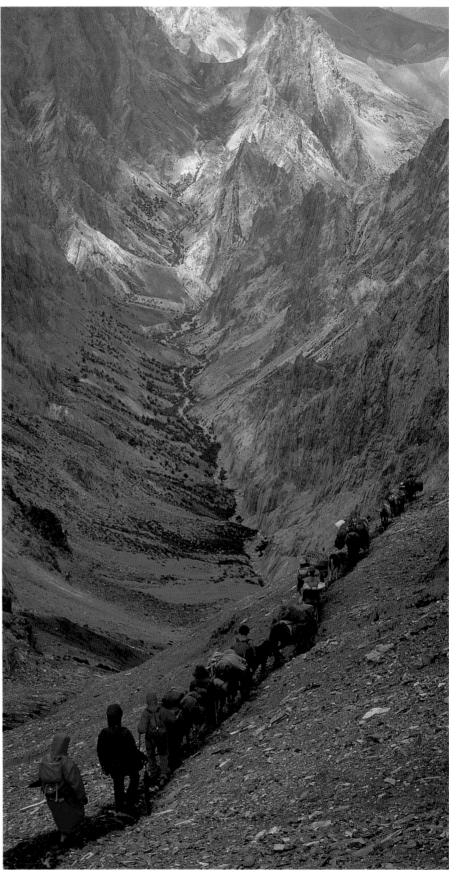

*Near the summit of Kanji La.*

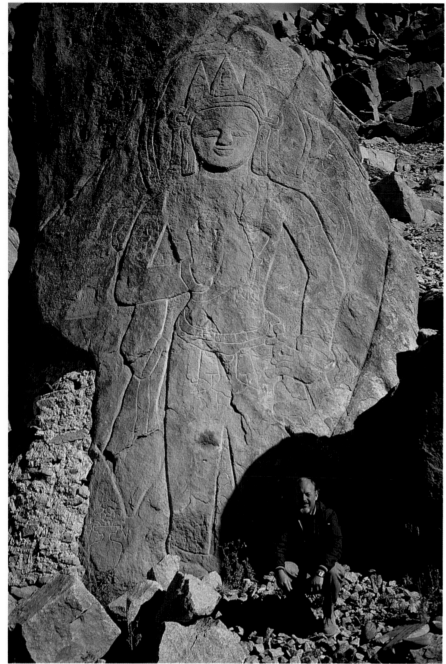

*Buddhist carving near Shey Gompa, Indus Valley, Ladakh.*

ing—we were welcome to try our hand at the last—every person in town can be heard singing the same ancient songs, which echo off adjacent cliffs in an eerie, moving symphony from forgotten times.

From Kanji we now had to find our way to the Srinagar–Leh Highway, which lay somewhere to the north. Two possibilities offered themselves, and we decided to explore both routes. By far the shorter one is the Kang Nullah Gorge, which leads in four hours to the main highway and the village of Heniskut. This gorge, perhaps the most dramatic segment of our trip, became so narrow that we often had to ford the icy stream to find level ground. Looming high above, the vertical walls folded in hues of brown and purple. From Heniskut there is bus service to Leh.

The alternative is to continue east for two more days, crossing the Yurma La (16,100 feet) into a small tributary of the Spangtang River. From Wanla, an isolated village with a striking gompa on a steep hill, three more hours of easy walking lead to the Printiki La, which debouches into a deep valley. Nearby are the lofty ramparts of Lamayuru, the most magnificent of all monasteries in Ladakh, founded and built by Rinchen Zangpo in the eleventh century. This monastery is built on rocky cliffs descending from the 13,430-foot Fotu La, over which the Srinagar–Leh Highway passes. Lamayuru marked the end of our trek, one that had probably never before been traveled in one continuous journey, although inhabitants of the various regions have walked segments many thousands of times.

Although the trek has officially ended, one can proceed to Leh and fly or drive back to Srinagar. The drive from Lamayuru to Leh is highly recommended, and so is a stay of several days in the Indus Valley to visit the important gompas of the region. Beyond Leh one can drive south up the Indus Valley. This largest valley in Ladakh is dotted with small villages dominated by impressive monasteries—usually built on natural promontories, like the renowned Thikse Monastery. Beyond Hemis, one of the most important monasteries in Ladakh, the road is closed to all foreign visitors because of the proximity of the Chinese border.

Typical of Ladakhi people, the villagers of this town were open and friendly, quick to make a joke. Several women in Kanji had more than one husband—often the husbands are brothers—a cleverly evolved system of birth control that, combined with Buddhist monastic celibacy, helps keep the population from growing beyond the food supply. Few people in Kanji own wristwatches or radios, and their thick red homespun clothing, winged stovepipe hats, and goatskin shawls reflect nothing of twentieth-century influence. Because the economy is based on barter (there is nothing to buy with money), co-operation is essential to survival. During periods of crop planting, harvesting, or threshing—

*The Chenab River, awash with the full power of summer meltwater.*

# From Kishtwar to Zanskar

*There will be memories of the moon turning glaciers to gold. Pieces of old Tibetan love songs will come floating down a canyon already drenched with loneliness. Drums once more will beat in such a frenzied rhythm that one will want to cast off convention, join the natives, and jump and whirl in a mad exciting dance. Miles of snow-capped peaks will suddenly appear far above the earth and disappear as quickly and as magically as they came.*

*—William O. Douglas*

THE Kashmir Himalaya of India and Pakistan forms an integral part of the Great Himalayan Range. It extends roughly from the Indus Valley west of Nanga Parbat (26,658 feet) in Pakistan southeasterly as far as the Sutlej River, a distance of about three hundred fifty miles. The axis of this formidable barrier is pierced by several well-known gaps or passes, as well as by a number of lesser-known but no less spectacular alpine passages.

There are two important passes in the Kashmir Valley area: the lowest and farthest north is the Zoji La (11,600 feet), a road pass that links Srinagar, the capital of Muslim Kashmir, to Leh, the capital of Buddhist Ladakh. South of the Zoji La is the Lonvilad Gali (14,530 feet), a foot pass linking Kashmir with the Suru Valley in Indian Baltistan. (We crossed this pass on our Trans-Himalayan Trek; see Chapter Seven). On the eastern end of the Kashmir Himalaya lie the Bara Lacha La (16,200 feet) and the Shingo La (16,750 feet), both of which provide access to Ladakh.

Halfway between these two sets of passes is a range known as the Kishtwar Himalaya, containing some very fine peaks. A glaciated pass called the Umasi La marks the southeast end of the Kishtwar mountains. It was this pass I planned to cross. The Umasi La links the Kishtwar area, a subalpine region of verdant valleys, dense coniferous forests, and cascading streams, with desertlike Zanskar, hidden away for centuries from the major trade routes. An area of about three thousand square miles, the high valleys of Zanskar (average elevation 13,000 feet) support a culturally isolated population of Tibetan-type Buddhists who live near ancient gompas.

Starting from the village of Kishtwar, a curiously walled Muslim town set high above the gorge of the Chenab River, I intended to follow the river as far as Atholi; then, crossing the Chenab by the first footbridge near this village, we would work up toward the mountains, cross the Umasi La, drop down into Zanskar, pass the village of Ating and several others, and end up at Padum, the capital of the lost kingdom.

With this general plan in mind we flew to Srinagar in Kashmir, made local arrangements for a guide and a cook, then took a crowded local bus to Kishtwar, a fifteen-hour ordeal. At first the bus followed the main highway from Srinagar to Jammu, crossing the Banihal Pass (8,990 feet) over a spur of the Pir Panjal Range, which forms the southern rim of the Kashmir Valley. Despite the tiring journey, the ride along the green fields and colorful villages of the Vale of Kashmir was new and fascinating, and the views of the peaks beyond were especially good. Few tourists ever see this remote part of India, yet local transport is available and cheap, and most large towns have government bungalows that are quite acceptable.

Once across the Banihal Pass we descended into the valley of the Chenab River, which drains all of remote Lahul District to the east as well as the southern glaciers of Nun Kun. Our bus crossed the river by a sizable suspension bridge, left the main highway, and followed the river upstream as darkness fell. We finally reached Kishtwar (5,200 feet), where we had booked rooms in advance at the government bungalow.

No public transportation was available beyond this point, so we hired a truck to haul our gear, food, and camp staff to Galhar, a cluster of stone huts at the end of a road leading east into the gorge of the Chenab River. I will never forget some of the narrow and exposed stretches of this track, cut out of the steep rocky slopes and perched several thousand feet above the ominous-sounding cataract. No place for the fainthearted! The track eventually became so narrow that I wanted to call a halt at the first possible turnaround, but just then we reached the hamlet of Galhar. Here, at dusk—for it had taken half a day to find a truck and another half day to drive the twenty miles or so to Galhar—we unloaded our gear. Below us the granite gorges of the Chenab Canyon glowed purple in the setting sun. Just past the village we set up camp on the track, the only level spot around, and laid out our bags for the night, forgoing tents. Later in the night, hired by prearrangement, our mules arrived; they nearly stepped on a few bodies sprawled across the track.

For the next three days we followed a foot trail cut mostly high above the river; twice the trail dipped to the water's edge,

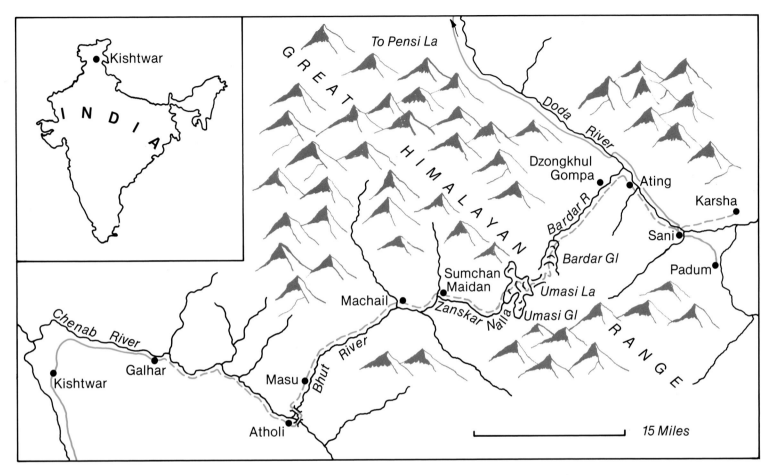

where we got a good feel for the size and the power of the massive stream. The trail snaked up and around large granite promontories and across sections of blank wall, where wooden planks fastened onto the rock bridged deep voids. Graceful waterfalls cascaded in many places from the rim of the canyon above, and wildflowers covered every flat surface with a thick carpet. This important trail linked all the villages on the Chenab—as well as those villages along the many side streams—and sheep and donkey caravans were numerous.

Around eleven in the morning on our second day, somewhere between Lidrari and Kharti, John Martinek, Jean Hoerni, his son Jim, and I decided to wash up by an enticing waterfall. It was sunny and warm, and John, who was fond of such rituals, stripped and immersed himself under the cool cascade, standing in a shallow pool ringed by marijuana plants. Jim, our teenager, cut off the largest plant and tied it to his pack. That night, while camping on the flat roof of a large house at Kharti, he thought his plant sufficiently dry for

his experiment. He crushed the leaves, borrowed a cigarette from one of our muleteers, and replaced the tobacco with marijuana. I took expectant puffs as well but, alas, experienced no altered state of consciousness. On further examination the following morning we discovered that Jim had picked a male plant.

Continuing along the gorge we reached an open area around noon and soon arrived at Atholi, the administrative center for the region. Atholi, sometimes called Gulabgarh after the ruler Gulab Singh, who conquered Ladakh, was first seen by a Western explorer, Thomas Thomson, in 1848.

On a visit to India in 1847 Dr. Thomson was summoned to Simla, then the summer residence of the British raj, and was asked to undertake an expedition across the Himalaya to help delineate India's border between Ladakh and Tibet. He traveled extensively through Kishtwar and was the first European to cross the Umasi La (17,400 feet). He returned to India several years later, having become addicted to Himalayan travel, and

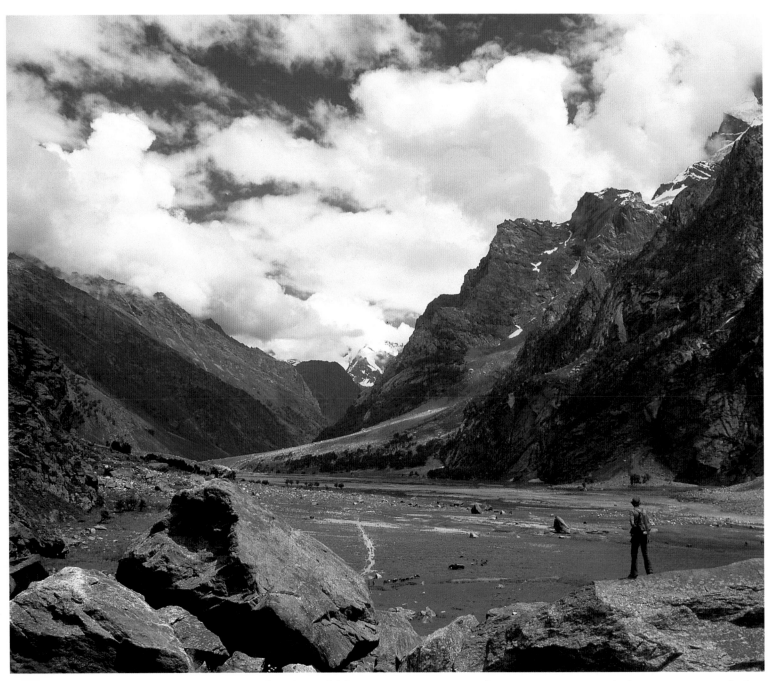

*Trekker surveying the Sumchan Maidan, the Meadow of Pregnant Horses, near the Himalayan crest.*

reached two other formidable passes, the Saser La (17,480 feet) and the arduous Karakoram Pass (18,605 feet). Both were first ascents. Thomson's book *Western Himalayas and Tibet*, published in 1852, has recently been reprinted.

After a friendly visit with the people of Atholi, and having donned Indian-made shirts bought at a small stall, we moved out of town and crossed the river by an iron footbridge. North of the bridge lay the vast wilderness of the Great Himalayan Range and the Umasi La,

the icy pass we intended to cross to reach the lost kingdom of Zanskar. We descended the Chenab for a few hundred yards, then crossed the Bhut River by a good suspension bridge just above the confluence.

The Bhut varied much in character. There were wide open stretches of slow-moving water, sandy beaches interspersed with rocky gorges, and several powerful cataracts, one of which was to my mind more impressive than Murchison Falls in Uganda. The trail steepened, and we passed the Hindu hamlets of

Drow (or Durdu) and Masu before reaching a parklike meadow where the Bhut meanders along various channels of sand and gravel. We camped here at Masu Maidan (*maidan* is Hindi for "meadow") surrounded by stands of large oaks, alders, and horse chestnuts.

From this camp (6,500 feet) we now began to gain altitude rapidly. Until Atholi our daily hikes had averaged about twelve miles, but now, with the terrain steepening, our distances would be shrinking to seven or eight miles a day. After crossing several hand-hewn wooden bridges of the cantilever type we reached Machail (9,000 feet), a large village perched on a hillock overlooking the river. Visible all around were snow-capped peaks, some heavily laden with glaciers. An old wooden Hindu temple in Machail contained finely carved panels.

Because the Umasi La cannot be crossed by laden animals, I planned to switch from mules to porters at Machail, the last village before the pass with enough manpower. So all the animals were unloaded and the muleteers paid. Away they went, leaving us open to higher demands by the Machail porters. We decided to take our time with the hiring, reasoning that if we did not appear to be in a rush we would be in a better position to bargain for the best rate. We therefore took the next day off. While the others washed clothes, hiked up a nearby hill, or played cards, I endured a quasi-philosophical conversation with the inebriated policeman of Machail, who complained bitterly of his remote post among the backward peasants. Meanwhile, our guide successfully negotiated for the required number of porters, though he had to pay somewhat more than expected.

We were now on our way toward the high mountains and the Umasi La. From Machail we hoped to reach the foot of the pass in three days, cross it in one day to Zanskar, and take two more days to reach Padum. Beyond Machail the trail narrowed considerably; soon we slowly followed a tributary of the Bhut, the Zanskar Nalla, straight up the mountain. Late in the morning we reached the tree line and then were in open country containing only isolated clumps of junipers and dwarf pines. Hiking over a small, rounded saddle we

*Buddhist shrine in Zanskar.*

reached a superb alpine meadow, about five miles in length, which our porters called Sumchan Maidan. According to our Kashmiri guide this means "Meadow of the Pregnant Horses," and indeed, the opposite bank of the valley was covered with many hundreds of horses. Near this meadow we met our first Zanskaris, people of Tibetan stock who crossed the main divide long ago and now prefer living in the lusher surroundings of the southern slope. With the people came their architecture: large stone houses, reflecting the classic style of Tibet, stood like fortresses on rock outcrops.

We located a superb campsite on a sandy beach near the river. Surrounding us like cathedrals were stunning rock-and-ice peaks, but there was no sign of our pass, which lay hidden behind intervening ridges.

The next morning, at the far end of the Sumchan Maidan, which we were traversing in its entirety, an overcast sky turned to rain, the first bad weather since we began. Reaching the foot of a narrow and steep gorge, we lunched under some large overhangs. Afterward, in thick fog, we tackled a trail that zigzagged up along the rocky walls. Above this

section, at around 12,500 feet, we debouched onto a small fairy-tale meadow filled with minute yellow iris and ringed with dark granite spires that appeared out of the swirling mists just at sunset.

The following morning, in continuing poor weather, we climbed steeply up the left side of the meadow, then traversed a large lateral moraine of rubble. We made our way slowly onto the solid ice of the Umasi Glacier. The bare, compact icy surface stretched out for many miles, both up and down. It was overcast, and we were constantly in and out of clouds, which made route finding extremely difficult. Travel on the glacier was surprisingly easy, though, as the surface was rough and pocketed with small pebbles. In the early afternoon we reached the Umasi Icefall, which barred all further direct progress. Contouring to the left we departed from the glacier and climbed up a steep, unstable lateral moraine of sand, mud, and boulders along the western edge of the icefall. Then, just yards from the enormous bulk of the glacier, near a large

*First encounter with the Zanskaris, people of Tibetan stock, near Sumchan Maidan.*

overhanging cliff at the top of the icefall, we found a spot to pitch our tents. At 16,500 feet, camped on broken talus, we were in for a long, uncomfortable night. Rain, falling heavily as we crawled into our tents, later turned to snow.

By morning the storm had ended and the sky was clear; it would be a perfect day to cross the pass. Frozen snowfields led gently upward into a wide glacial bowl surrounded by red rock peaks rising two thousand feet above the glacier. The Machail porters went ahead of us to stamp a solid track in the fresh snow, disregarding all suggestions of danger. Although I had brought ropes for safety on the glacier, I felt it was safe to travel unroped as long as we stayed firmly in the porters' wide track. (Future parties should carefully evaluate the situation regarding roped travel—ropes should definitely be at hand.) The névé, although covered with new snow, seemed totally free of crevasses on our mid-July crossing.

Ice axes proved handy, but crampons were unnecessary, though Jean insisted on wearing his, having brought them halfway around the world. After another steepish rise we came to a cirque enclosed by walls of red granite; to our right we spotted the small, airy notch in the rock barrier where our porters had assembled. A bit of easy rock climbing followed, and soon we stood on the Umasi La. The porters presented us with small bunches of wildflowers picked on the way up, as was their custom; we, in turn, offered a monetary tip for a job well done.

The view north—an overwhelming array of rock-and-ice peaks belonging to the Ladakh and Zanskar ranges—stretched into Zanskar. Immediately below, a steep but not impossible-looking snowslope fell to a wide, bare glacier that led to the valleys of Zanskar.

While munching on some salami, I marveled at the narrowness of the pass, described by Thomson as "a fissure in the ridge not more than two feet in width." This pass was first used by the feared Zorowar Singh, a general in the army of the Dogra ruler of Jammu. In 1846 Singh attempted to invade Zanskar and Ladakh with an army of three thousand men; he lost twenty men to exposure on this pass.

In the meantime our porters had started

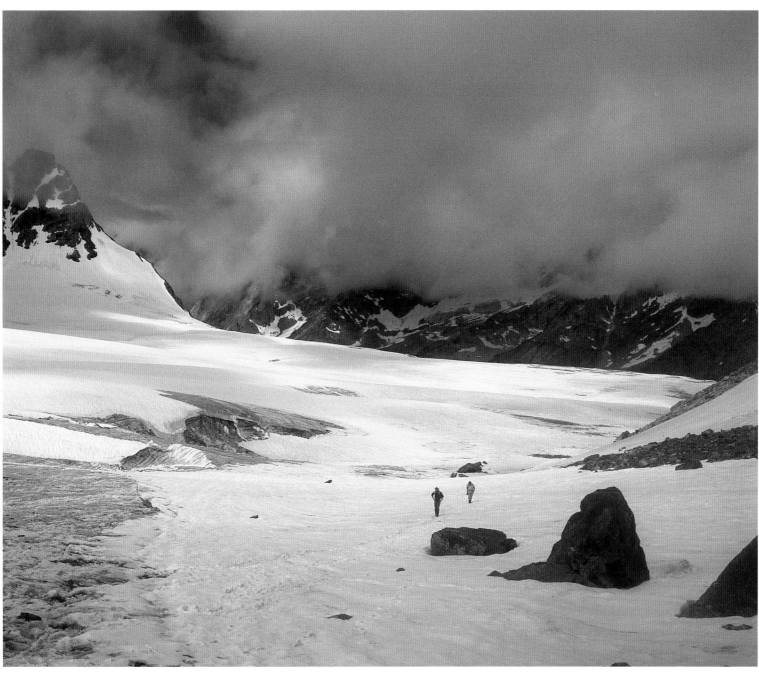

down, running and glissading down the snowslope in a most unorderly fashion. Some fell out of control, losing their loads; others crashed into each other. In the end I found myself three fourths of the way down the slope, medical kit in hand, passing out Band-Aids, alcohol swatches, and bandages. Just then a man crossed the pass with a young cow (I will never know how he got her to climb the rocks); it slipped and fell on one of our young porters, kicking the poor boy in the head. Fortunately, he walked away with no more than a

bloody nose, a few gashes, and a long-lasting headache. Continuing down the slope, we walked onto the bare ice of the Bardar Glacier, descended the steep gully at its snout, crossed a glacial stream over a natural rock bridge, then descended the wide and colorful rocky valley of the Bardar Chu to a campsite at a yak pasture known as Gaur (approximately 13,000 feet). Herds of yaks grazed on the slopes above; near the river I found several blue poppies, the extremely rare *Meconopsis horridula*.

*At 16,500 feet on the Umasi Glacier, approaching the Umasi La.*

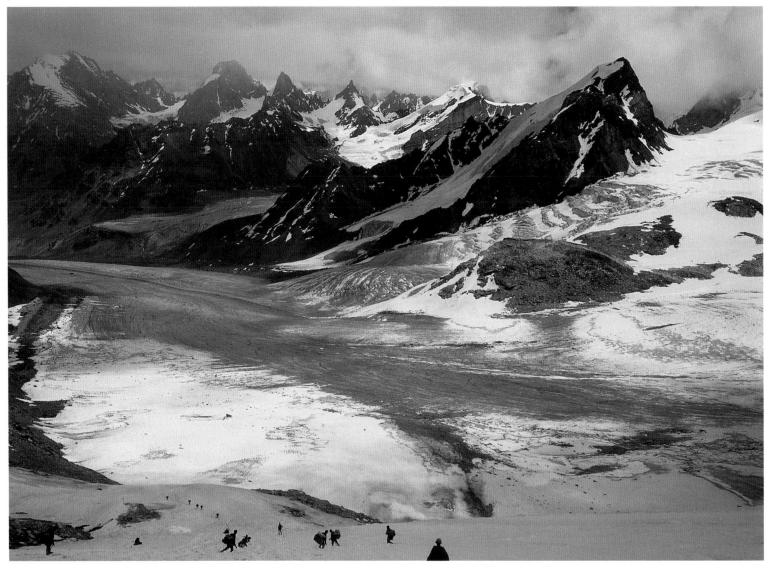

*View north from the Umasi La toward the Ladakh and Zanskar ranges. Porters, foreground, descend the slope.*

*(Page 91, Top) Leaving the Himalayas behind, we enter the Doda Valley, the longest valley of Zanskar. (Bottom) Karsha Monastery, largest and most important Buddhist monastic complex in Zanskar.*

We were now out of the high mountains and in the rainshadow of the Himalaya. The atmosphere was radiant and dry, and the sky was dark blue; the sun beat down mercilessly on this high-altitude, arid land. Vegetation was restricted to grasses, mosses, and lichens. Here and there patches of dwarf fireweed grew along the river's edge. In a matter of two days we had walked from wet, green terrain into a dry mountain desert.

Descending farther down the rocky and desolate Bardar Valley, John spotted ancient Dzongkhul Gompa, a small monastery built like a swallow's nest against a precipitous rock face, high above the river's left bank. Dzongkhul is famous for the visit of the Tibetan saint Naropa, who meditated here in the tenth century. Unfortunately, the river seemed too wide to cross and we were unable to visit the gompa. (I heard later at Padum that there was a ford above Gaur.)

We continued down the Bardar Valley and reached the Doda, the longest valley of Zanskar. Picturesque villages appeared along the northern slope; small clusters of whitewashed cubicles stood out against the growing darkness as we made our way toward Ating. Above this wide valley the sun cast its last golden rays on the highest mountaintops around us. We walked through Ating, a tightly constructed assemblage of white houses. Flat roofs were stacked with wood and boughs, and the people gazed at us curiously but with friendly smiles. We camped that night outside the village on the quiet schoolgrounds.

Founded in the tenth century as a Buddhist kingdom, Zanskar today is a forgotten corner of high-altitude desert. Access is mainly by foot, over high passes closed in winter. The one road, built less than ten years ago, is open only in the summer and is suitable only for jeeps and trucks; it crosses the Pensi La, a 14,500-foot pass over the Zanskar Range. The treeless, mountainous land receives little precipitation.

Zanskar's population is concentrated in the Doda Valley, although the Zanskar and

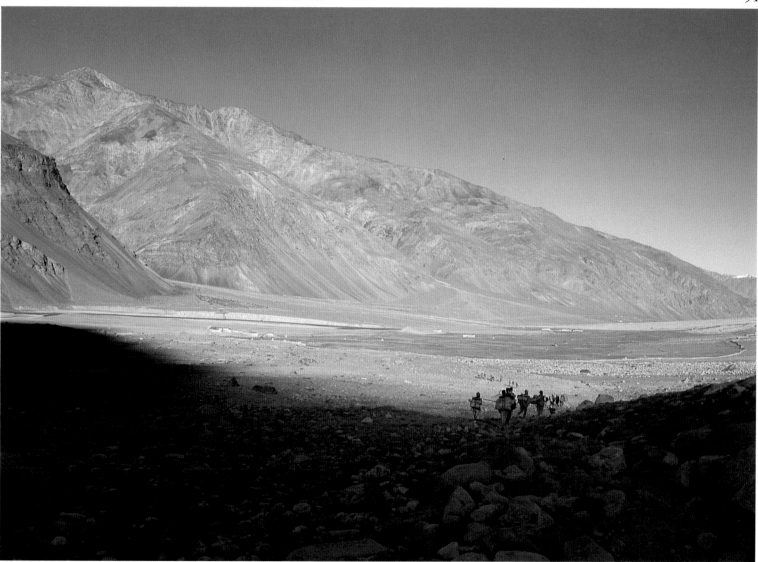

Lingti valleys, as well as the central Padum Plains, are fairly well inhabited. The land is strewn with whitewashed square houses and chortens. Mainly because of its isolation from the outside world, Zanskar lives in another century, the modern world ending where the road ends. The many active monasteries and gompas in Zanskar, including Sani, Karsha, Dzongkhul, and Phuktal, prove that Buddhism is not only alive and well but flourishing.

The Zanskaris live in harmony with the harsh land, the elements, and their religion. They pursue a simple yet unique lifestyle and have retained much of their cultural heritage. The traditional dress is still worn by many, especially the women. One of the most prominent parts of their costume, the *berag*, consists of a two-foot-long piece of cloth covering the head and shoulders; it is studded with large turquoise stones, the size and number of which reflect the family's wealth. The typical Zanskari hat, a high, black velvet affair with an upturned pointed rim, is seen in many vil-

lages. People practice the ancient art of home spun weaving, and the men delight in archery contests. During the short summer Zanskaris grow barley, some wheat, and peas. Although the monarchy was abolished long ago, there is still a king in Zanskar, a descendant of the old royal family. He lives in the village of Zangla in a large house below the old palace (now in ruins), and is involved in Indian politics. The monasteries of Zanskar, built along steep-sided mountains, across raging torrents, and on the summits of sheer rock cliffs, are a national treasure, filled with statues, ornaments, and ancient frescoes.

We were now within a day's walk of Padum, the end of our trek. As we hiked down the gently descending Doda Valley, passing fields of barley and peas and isolated hamlets and white chortens, horses grazed on the lower slopes and yaks dotted the highest hills. Above, multicolored rocky ridges merged into snow-clad peaks. The entire scene was capped by the darkest and bluest sky I have ever seen outside Tibet.

By noon it was unbearably hot. A dry wind sprang up, burning our faces and scorching our throats. We took refuge in the garden of Sani Monastery, cooling off in the shade of ancient cottonwood trees that sprawled over the meager lawn. It was soothing to listen to the wind blow through the large trees in this otherwise silent and treeless land. Above the trees white prayer flags and long red banners flapped from rooftop poles. Csoma de Koros, a Hungarian scholar who walked from Europe to India in the nineteenth century and was a pioneer of Tibetan studies, resided here briefly; he was the first European to visit Zanskar. We greeted the Incarnate Lama of Sani with "*julé*," the Ladakhi hail and farewell, as he passed by.

After lunch we started off for Padum. Crossing a wide grassy plain, we finally saw the town in the distance, looking rather like a large medieval fort. As we neared the village it became apparent that large boulders and the ruins of the fort on top of a hill had combined to create an illusion. Padum was nothing more than a rather unattractive small village of about six hundred people, half Kashmiris and half Zanskaris. We were back to the road, back

to the modern world. We camped at a deserted schoolground a safe distance from town.

Before heading for home we made an overnight trip from Padum to Karsha Monastery, the largest and most important in Zanskar. This group of buildings, home to nearly a hundred monks, cascades from a steep cliffside. The main temple, where friendly monks invited us for tea and tsampa, stood at the top of a bewildering series of twisting passages and staircases. From the roof we had a commanding view over the Padum Valley and the Himalaya to the south. The artwork in the various chapels was recent and of good quality, especially the paintings in the Gonkhang, the chapel of the guardian divinities. Also of interest was the lower assembly hall on the main courtyard, which contained murals depicting the life of the Buddha. One entire wall was covered with the books of the Kanjur, the Tibetan canon.

On the morning of our return to Padum a high lama with broad and radiant facial features, his entire bearing exuding indescribable joy, invited me to his cell. He had just that morning finished a seven-year vow of silence. What an incredible experience it must have been for him to be able to speak again—and so it was for me, to share with him such precious moments. We had a short conversation in broken English and I told him of my love for Zanskar—"a paradise"—and how I wished I could live there and be as serene and free as he seemed to be. He smiled. I presented him with some fruits I had bought in Padum. Slowly he told me: "It is not possible for you to be what I am. We have our preordained destinies to fulfill, you and I. Yours is in your country, where you must return. You will obtain merit by doing what you need to do. *Julé!*"

Our trip back to Srinagar involved three days of hard driving, via the twice-weekly truck service from Padum, over the eerie Pensi La. The truck made an overnight stop at Ramdung Monastery at the head of the Suru Valley; we camped out. Then, after another tough day along a rough, boulder-strewn track down the Suru River, our journey ended in Kargil, on the paved Srinagar–Leh Highway. Regular daily bus service is available from Kargil to either city.

# TREKKING IN INDIA
## Expedition Planners

*Dwarf fireweed.*

## General Information

*Visas:* An Indian visa is required and can be obtained at Consular Offices in major U.S. cities.

*Vaccinations:* The following are suggested: cholera, tetanus, typhoid, and gamma globulin, and malaria suppressant tablets. The cholera immunization is strongly recommended. Regulations change frequently, so please consult your physician or U.S. Public Health Service.

*Nearest Airport:* Srinagar, in Jammu and Kashmir State.

*Means of Transportation:* By air from Delhi and from Srinagar directly to Leh with Indian Airlines. Leh can also be reached by bus from Srinagar in two days with an overnight stop in Kargil. There is a bus service from Srinagar to Kishtwar, a fifteen-hour journey.

*Food:* Most food should be purchased in Srinagar. Some basic staples, such as potatoes and rice, may be available along the trek.

*Water Purification:* Water should always be boiled or purified with water purification pills or iodine crystals. Never drink tap water.

*Cautionary Notes:* The first sections of these trips take place in an area of Muslim culture and it is advisable not to take pictures of women. Below-the-knee-length skirts or long pants are recommended for women trekkers, rather than shorts.

*People:* The people of Ladakh, Kashmir, and Zanskar are very friendly. In Zanskar the people are less accustomed to foreigners and may appear shy at first.

*Source of Official Information:* The Government of India Tourist Offices in New York, Chicago, and Los Angeles.

*Further Reading:* See Bibliography, Chapters 7 and 8.

## The Trans-Himalaya Trek (Chapter Seven)

*Logistics:* Arrangements for a trek across the Himalaya will be made for you in Srinagar or Kargil by almost anyone, from the carpet seller to a storekeeper. Beware of such "outfitters," because they seldom know what they set out to undertake; most of them have no knowledge of the mountains. Deal with a reputable agent at home, or one of the better agencies in Delhi, but allow plenty of time so that an outfitter can pick up a good crew for you. Trekking on your own is easier in India than in most countries, but it is still difficult compared with arranging one's own trek in Nepal.

*Travel Tips:*

*Best season:* September and October.

*Trekking days:* Twenty days from Palgham to Lamayuru.

*Distance covered:* About 220 miles.

*Difficulty:* This is a long and difficult trek for very strong hikers. There is permanent snow and ice on Lonvilad Gali Pass. Good mountain boots are essential, as is first-rate equipment. An ice axe per party is useful.

## From Kishtwar to Zanskar (Chapter Eight)

*Travel Tips:*

*Best season:* July (crevasses on glacier are closed; some rain possible on the south side).

*Trekking days:* Nine to ten days.

*Distance:* About ninety miles.

*Special equipment:* Good mountaineering boots for the glacier crossing. No climbing equipment needed. A rope should be taken for safety on glaciers, and an ice axe may come in handy (one per party).

If you wish to backpack this trek (for experienced hikers only), the hiring of a guide along the way (to see you safely across the Umasi La) is highly recommended.

*Difficulty:* For experienced and very strong hikers. (Rocky, difficult notch on the Umasi La. Steep slope on north side).

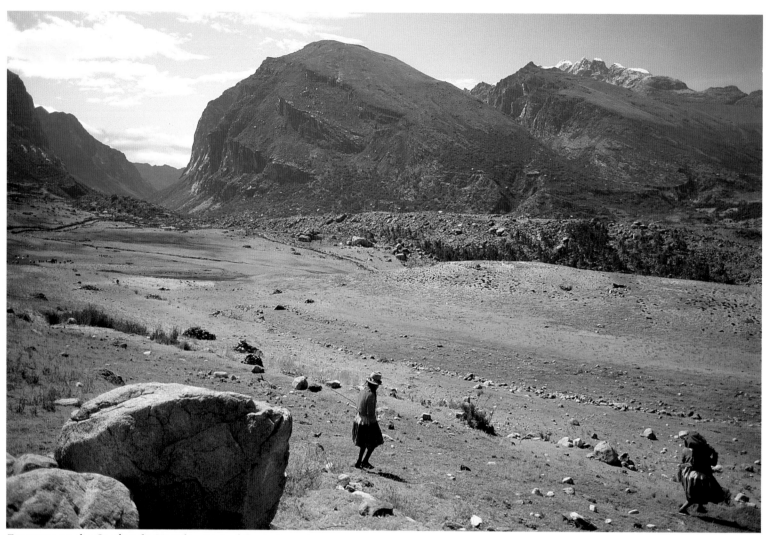

*Entrance to the Quebrada Honda, start of the trek.*

# PERU
# *The Cordillera Blanca Traverse*

*Behind nature, throughout nature, spirit is present,*

*spirit, that is, the supreme being, does not build up nature*

*around us but puts it forth through us.*

—*Ralph Waldo Emerson*

THE Cordillera Blanca of west-central Peru is a small but high range in the Andes, that great chain of peaks running the entire length of South America. It is also the highest tropical cluster of glaciated mountains in the world.

High-altitude trekking in the Cordillera Blanca (White Mountains) is one of the finest experiences one can have in any range, and I have enjoyed many memorable walks in this delightful countryside. Access is easy, the snow line is around seventeen thousand feet, and the climate is balmy because of the proximity of the equator. It is an alpine wonderland of ten-foot-tall mountain flowers, translucent turquoise lakes, unique reddish brown quenual trees, and, always above, the sparkling, fluted walls and cornices of the Cordillera's sharp summits.

Before engaging in any high-altitude walking it is important to acclimatize properly. This one does in Huaraz (10,000 feet), the capital of Ancash Province. Huaraz lies in the beautiful Río Santa Valley, which parallels the western escarpment of the range. It once took two days to reach Huaraz by car from Lima, but a good paved highway now allows the scenic journey to be made in about six hours.

An early explorer in this region, a young American journalist and adventurer named Annie Peck, sailed from New York in 1908 for the small Peruvian port of Samancos. After a ninety-mile ride on horseback across the interior she arrived in Yungay, a small village in the Río Santa Valley at the foot of Huascarán (22,205 feet). Peck believed that unclimbed Huascarán was the highest mountain in South America. Determined to become the first person to climb this gigantic twin-summited mountain, she succeeded in reaching Huascarán Norte (the lower north peak), which she estimated to be higher than Aconcagua (22,834 feet) in Argentina. "If the height is 24,000 feet as seems probable," she wrote, "I have the honor of breaking the world's record for men, as well as for women, the greatest height previously claimed being 23,800 feet by W. W. Graham in the Himalayas."

Peck's achievement was contested by Fanny Bullock-Workman, who claimed the woman's world altitude record with her ascent of Pinnacle Peak (22,810 feet) in the Himala-

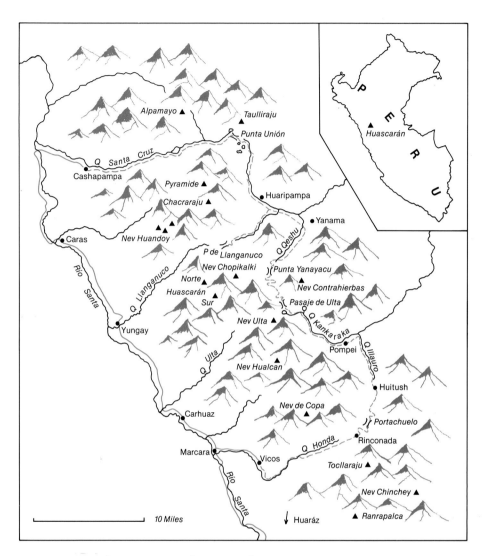

yas. To prove her point Workman paid a team of French surveyors to travel to Peru and accurately measure the height of Huascarán. Pinnacle Peak *was* higher, and the survey also proved that Aconcagua was by default the highest mountain in the Americas. Huascarán became simply the highest peak in Peru.

The Cordillera Blanca was relatively unknown until 1932, when the German Alpine Club sent a strong team of climbers and scientists to Peru. They climbed many virgin summits, including Huascarán Sur, and produced a good map and an excellent picture book. Additional Austro-German expeditions followed in 1936 and 1939, and our detailed knowledge of this beautiful range, a worthy rival to the Alps and the Himalayas, stems from the efforts of these explorers. More than twenty-five peaks over six thousand meters (19,685 feet) have been counted in the range; most of these

*Indian child from the village of Vicos.*

*Indian child from the village of Vicos.*

have now been climbed by at least one route.

Although it is possible to select from a wide variety of trekking routes, the Cordillera Blanca is not a very large chain and the crossings tend to be short. In addition, a new dirt road across the most scenic part detracts substantially from what was *the* trek in the area. With these considerations in mind, I discussed the possibility of a long trek—one that would cover the length of the range—with Jack Miller, a veteran mountain guide and an expert on trekking in Peru. Jack suggested the cross-range traverse of the section from the Quebrada Honda to the Quebrada Santa Cruz. (*Quebradas* are narrow V-shaped valleys that allow convenient access into the range.) This would entail crossing four passes over 15,600 feet and take approximately ten days. The serpentine traverse—winding back and forth across the crest of the range—would enable us to see the finest peaks close up, to descend into fertile valleys exposed to moisture from the Amazon, and to come in contact with the *campesinos*, descendants of the Incas.

After making advance arrangements for a truck to pick us up at the end of the trek, Nestor Morales, Jorge Alvino, Roberto Medino, and Máximo Alvarado, all experienced mountain men from Huaraz, and I were set to go. Problems began almost immediately. Nestor was to pick me up at the Hostal Andino in Huaraz, but he arrived at 5 A.M. wearing a sad expression. "I brought a horse along for you to ride in case you needed it," he said. (I had sprained my ankle in a ski accident the week before.) "But unfortunately the horse has died on the way to the hotel." I did not know if I should laugh or cry; if this horse could not make it to the hotel, how would it have fared on the trek? Nestor explained that they had brought the horse in a truck and had done some wild driving through the streets of Huaraz. The horse had been knocked around; its head had smashed against the paneling. Nestor also explained that we had to make a quick getaway because they wanted to dump the horse somewhere before the police found out. I agreed to leave at once on condition that they would drive moderately. They all laughed and agreed to my request, and we took off at full speed.

After driving north along the Río Santa Valley to the village of Marcara (the horse having been dumped into a ravine) the driver turned off on a dirt track leading toward Baños de Chanchos ("Pig's Hot Springs"). Nestor told me these baths were very good for sciatica and popular with the locals; he offered to stop for a session. I politely declined and we continued to the next village, Vicos, whose inhabitants, I was told, *own* the Honda Valley, the start of our trek. I wondered how the locals could own the high mountain valleys here, so Nestor explained. "All land below four thousand meters is privately held; everything above is national park." Before leaving Vicos we had to pay a levy (about eight dollars) to drive into the lower Honda Valley. Eventually we reached the ramparts of the Cordillera, the huge granite walls looming over us on both sides. It reminded me a bit of entering Yosemite Valley, except that high above these towering rocks I saw the glaciers of Nevado de Copa (20,300 feet), the first of the Andean giants we were to trek around. Soon we were driving along a narrow dirt road inside the *quebrada*, the floor of which was covered with green grasses, wildflowers, and the beautiful quenual tree. The truck stopped at a rustic-looking wooden fence. We unloaded our gear and, shouldering packs, enjoyed three hours of leisurely walking along the flat Quebrada de Honda to Tayapampa, where we made our first camp, at 10,800 feet.

Continuing along the valley floor the following morning, we reached a junction called Rinconada, turned north, and headed up a steep trail toward the pass known locally as Portachuelo de Honda. Many quenual trees lined the trail. Nestor told us that the beautiful tawny-brown bark was once made into shoes. As we climbed higher the valley opened up and snow-capped peaks became visible above. Before the road across the mountains was built this path was a popular foot trail, the shortest route from Vicos to the eastern side of the Cordillera. Now this trail is used only by local cattle herders who graze their animals on the floor and slopes of the Honda Valley. The park—which we had now entered—comprises ninety-three thousand square miles and

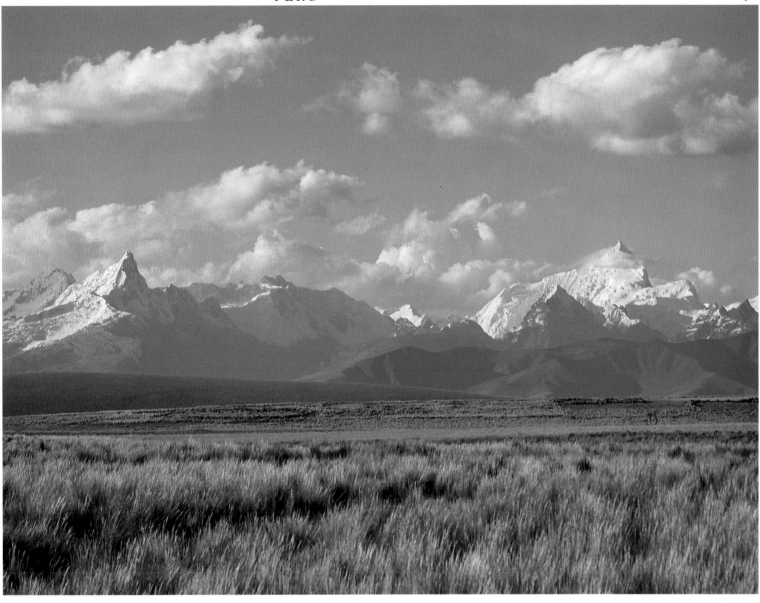

contains two hundred forty lakes.

Near the pass Nestor disappeared down a steep grassy slope and came back with extraordinary flowers called *rima-rima* ("speak a lot"); it is said that they make mute people speak when held in front of them. Nearby we saw evidence of Inca activity—parts of a well-laid trail and the foundations of a watchtower. Most high passes in the Blanca contain similar evidence; the passes guarded the valleys from surprise attack.

At the Portachuelo de Honda (15,580 feet) an overwhelming view awaited us. All the big peaks to the south were visible, and Nestor pointed them out to me: Ocshapalca (19,295 feet), Ranrapalca (20,217 feet), Tocllaraju (19,790 feet), Palcaraju (20,584 feet), and Nevado Chinchey (20,413 feet). We quickly descended from the cold and windy pass to the north side of the ridge and ate lunch there.

Below the pass, which was suitable for animals as well as humans, we reached the lovely high valley of Ismaypampa and the small hamlet of Huitush (12,600 feet). Then, after turning a ridge to the left, we descended the colorful Illauro Valley, where, at 12,100 feet, agriculture once again flourished. Farmers still plow here with the old wooden plow, without metal tip. The soil looked bleak and worn out; harvest from these fields is meager. We found a flat spot and set up camp. Later that night Roberto sang several melodious Indian folk songs about the mountains.

We were up at six and on our way by eight. After walking several more miles down the valley we came to the village of Pompei at the confluence of the Illauro and Potaca rivers. Pompei was once a thriving mining town, but the gold and silver veins ran out and the village soon became forgotten. Now it is a carless town of five hundred. We found a small bakery—a crudely made earthen oven about

*View, looking east, of the peaks of the Cordillera Blanca from the upper reaches of the Santa Valley.*

*Entering the village of Pompei in the Quebrada Kankaraka.*

*(Page 99, Top) Belów the first pass, Portachuelo de Honda (15,580 feet). (Bottom) Porters and trekkers on the Ulta Pass, highest of the trek (16,000 feet), during a mild snowstorm. Author in front.*

four feet in diameter. The kind young Indian couple who tended the business offered us some of their bread, which we ate with delight. Máximo, who served as expedition cook, bought an ample supply. Nothing tastes quite as delicious as freshly baked bread, especially in the mountains.

The town receded as we climbed the right fork of the Potaca. The closing of the mine had ended plans to build a road up this valley, presumably to carry gold and silver across the mountains to Huaraz, and now only traces of an old dirt road remained. We followed this track, here and there swept away by rockslides, until we reached 14,800 feet and two large turquoise lakes, Laguna Yanaraju and Laguna Kankaraka. We stopped for the night, amid snow flurries. One thousand feet above, but unseen because of the gathering storm, was our next objective, Pasaje de Ulta (16,000 feet), the highest elevation of the trek.

As we started off the next morning the weather was cold and overcast and snow was falling gently, but the major storm I had feared all night did not materialize. A good

thing, as the pass was known to be fairly steep and difficult, and impassable for horses or mules. As it turned out, the trail was wide though steep, and the rocky gash that constituted the actual pass had been widened. Animals, even heavily laden mules or horses, can now easily cross the Ulta Pass.

The snowfall ended just as we crossed the pass, and we soon found ourselves once again on the west side of the Andean crest. Because of the clouds we could not see much, but, according to Jim Bartle, who wrote a fine guide to the Blanca trails, "there are beautiful views of Nevado Chopicalci, Huascarán, and Chacraraju to the north, while to the south Nevados Ulta and Contrahierbas hang over the trail as it descends to Potaca." I glissaded on several patches of snow. Lower we came to grassy slopes and some fine stands of quenual trees. At 13,100 feet we arrived at a trail junction.

To the left the Ulta Valley dropped toward the town of Carhuaz, and to the right a little-traveled route led back across the crest at Punta Yanayacu (15,900 feet) and then descended to the village of Yanama. We took this

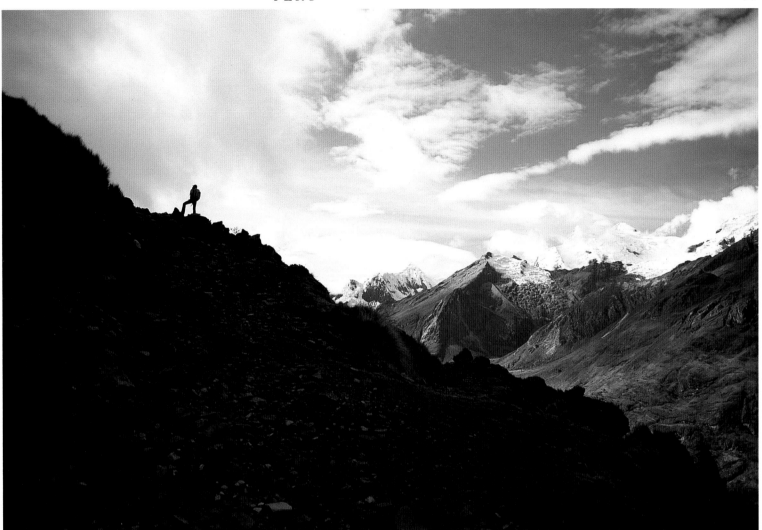

path and stopped early in the afternoon in order to camp below the pass. From all accounts this area—the upper Ulta Valley—was one of the most scenic of the trek, but, alas, the overcast blotted out all views.

The next day we topped the pass—the third of the trek. It was still shrouded in mist as we descended toward Yanama. It quickly became warmer as we dropped down the mountain, and we soon came to a grassy meadow. As the sun finally broke through, we stopped for the day while Jorge and Máximo spread our tents and sleeping bags out to dry.

The next morning we descended the Quebrada Qeshu. Before reaching Yanama, however, we turned north again and took the trail for Huaripampa, which veered sharply to the left and traversed a ridge before dropping to the village of Chaullua. We enjoyed good views of the peaks along this trail. At Chaullua we joined the Llanganuco–Yanama Road, the only vehicular road traversing the very heart of the Cordillera Blanca. The road is merely a one-lane, unpaved dirt strip, and traffic is light.

We walked up the Quebrada Morococha

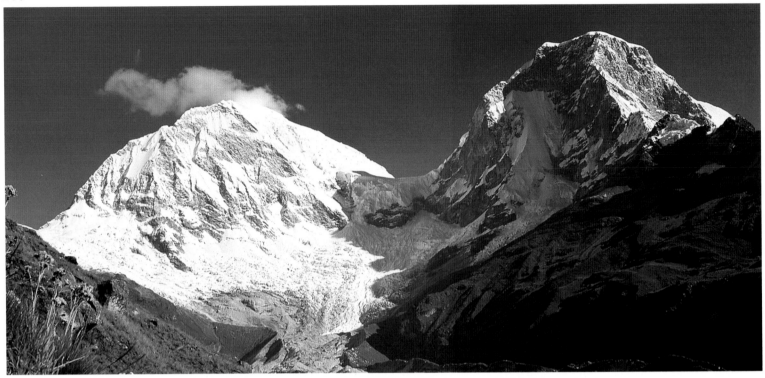

*The twin peaks of Nevado Huascarán. The south peak, to the left, is the highest point in Peru. The north peak was climbed first by Annie Peck.*

past Chaullua toward Vaqueria to a broad open valley with a good campsite and, at last, a great view of Huascaran. It is essential to visit the pass at the head of the valley, perhaps the most famous pass in Peru. Nestor and I made a day trip out of it while the rest of the crew took the day off. The pass, Portachuelo de Llanganuco, is 15,500 feet high and affords views of an incredible array of peaks, from triple-summited Huandoy to Chacraraju (whose name in the Quechua language means "the glacier-covered peak above the cultivated fields"). Chacraraju, which was believed impossible to climb, was eventually climbed by Lionel Terray in 1956.

The pass itself is a large defile blasted into the rock to allow for vehicles. "Expect to see a few tourist buses today," said Nestor. "They come up from Huaraz for the day and the view." Most traffic, however, returns down the Llanganuco Valley, so by staying on the far side one has relative calm and peace of mind. (The few vehicles I had seen during three previous trips were jalopies driven by local Indians at about ten miles per hour.)

The next day, from our camp above Vaqueria, we descended toward Colcabamba (11,300 feet), a fairly large village. We avoided the town by a detour around its north side and soon were in the scenic long, broad valley of Huaripampa, which was humming with human activity. Farming, cultivation, and animal husbandry were evident everywhere. We encountered many hamlets, talked to people,

played with children, and took lots of photographs.

Halfway up this valley Nestor proudly pointed to a sharp, ice-fluted peak jutting steeply into the cobalt-blue sky and said, "Pyramide de Garsilaso." It had been named after the Peruvian writer Inca Garsilaso de la Vega, who in 1824 wrote the first Inca history of Peru. Nestor explained that when he and his four brothers decided to open a small trekking agency in Huaraz, the five of them climbed Pyramide and named their business Pyramid Adventures.

Taulliraju, another mountain that towers over the Huaripampa Valley, is truly one of the most savage-looking peaks of the Blanca. It became even more impressive as we walked up the valley toward the 19,127-foot giant. Under its very base we would cross the last pass of our journey, the Punta Unión (15,600 feet). We camped below the pass and enjoyed a magnificent sunset.

On the ninth day we awoke to a brilliantly clear sunrise. The strong reflection of the sun's rays on Pyramide made it impossible to look at the peak for more than a few seconds. Later we passed several ice-blue lakes below Unión Pass, among them Laguna Morococha, one of the prettiest lakes of the trek. Steep switchbacks led for a thousand feet up and over the pass, a narrow slash cut into the rock by Peru's earliest inhabitants, and possibly improved by the Incas. At least four preColumbian civilizations have left their artifacts

and abandoned canals among the peaks of the Cordillera Blanca, and even now the inhabitants of these enchanting mountains and valleys display a culture that echoes the past. Although life for these Quechua-speaking Indians has begun to change with increasing contact with the outside world, the old traditions remain, at least for now. Many people in these arid valleys still wear colorful hand-loomed clothing while tending their staple crops of corn and potatoes.

Beyond Union Pass an easy descent led into the long Quebrada Santa Cruz, another valley that transects the Blanca from east to west. We camped at Tayapampa, at the junction of the Quebrada Arhuaycocha. From here we first saw Alpamayo (19,495 feet), which, because of its striking ice fluting, many people consider to be the most beautiful peak in the world. Unfortunately, from our camp only the very tip of the peak showed above an intervening ridge; a day's side trip up the Quebrada Arhuaycocha is necessary for a full view.

Now, on the final leg of our trip, we descended the Quebrada Santa Cruz, a lush place filled with alpine flowers of every description. We saw herds of what seemed to me wild horses, but Nestor said they were not wild; they belonged to the villagers of Cashapampa, where our trek would end. This valley, an access to the National Park of Huascarán, belonged to the park system, but the villagers apparently retain grazing rights. Among the horses were several large black bulls. I gave them a *very* wide berth, much to Nestor's amusement.

We walked along the large Laguna Jatun, then tackled the last four downhill miles, hiking through the narrow canyon that typically marks the western entrance of these *quebradas*. Bordered by thousand-foot rock walls, the trail abruptly exited into the huge Río Santa Valley. Our journey came to an end at the small farming village of Cashapampa. Nestor's brother Eudes was waiting for us with his truck for the ride down to the village of Caras (7,400 feet), where the temperature hovered in the high nineties. (No public transport is available in these remote villages high up on the flanks of the Río Santa Valley, so it is wise to arrange for transportation well in advance

with a reputable person or firm.)

For the four-hour ride back to Huaraz Eudes invited me to ride inside the cab, but I much preferred to savor the great open spaces of these magnificent mountains, to look up at the towering peaks, to feel the warm sun, and to smell the peculiar aroma of these Andean valleys—something like a mix of eucalyptus and freshly baked bread. So I rode in the back with my new friends, feeling happy and content at having shared such a fine experience with simple and honest people. As we shook hands in farewell Nestor said, "You are a man who loves only the mountains."

*Hiking along the trail toward Pompei village.*

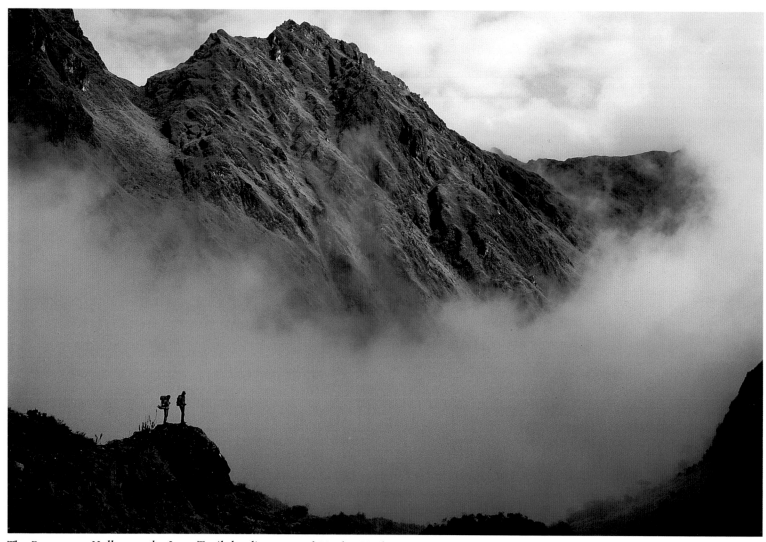

*The Pacamayo Valley on the Inca Trail, leading toward Machu Picchu, at sunrise.*

# The Inca Highlands Trail

*Then the little boy urged us to climb up a steep hill over what seemed to be a flight of stone steps. Surprise followed surprise in bewildering succession. We came to a great stairway of large granite blocks. Then we walked along a path to a clearing where the Indians had planted a small vegetable garden. Suddenly we found ourselves standing in front of the ruins of two of the finest and most interesting structures in ancient America. Made of beautiful white granite, the walls contained blocks of Cyclopean size, higher than a man. The sight held me spellbound.* —Hiram Bingham

LEAVING Cuzco, the ancient capital of the Inca empire, by truck early one morning, our four-man trekking group headed northwest along the Cuzco–Lima Highway toward Limatambo, a small village nestled at 8,600 feet in the Peruvian Andes. We were embarking on a dream trek: a five-day walk across the Cordillera de Vilcabamba—the highlands of the Incas—to the fabled ruins of Machu Picchu.

Arriving at Limatambo around noon, we picnicked near the well-preserved Inca Tarawasi ruins, part of the tambo from which the town's name derives its suffix. The tambos, of which there are four, are Inca garrisons strategically located equidistant from Cuzco; their function was to protect the empire from outside attacks.

We ate our sandwiches in the subtropical sun while watching a gathering of farmers seated on the tambo's magnificent walls, heatedly discussing the Peruvian government's new agrarian reforms.

After lunch we climbed back aboard the Ford truck of adventurer Alfredo Ferreyros and headed up a steep dirt track for seven miles to the remote village of Mollepata. As the truck ground its way up the steep hillside the high Andes unfolded before us for the first time, revealing a striking panorama of deep-blue canyons and snow-clad mountains. To the distant northwest we could just see the dark canyon of the Río Apurimac, a tributary of the Amazon, which forms the western boundary of the Cordillera de Vilcabamba, the range we had come to traverse.

The Cordillera de Vilcabamba is bounded by two powerful mountain rivers—the Río Urubamba to the north, and the Río Apurimac. The range contains such mighty peaks as the Nevado Huayanay (17,927 feet) and Salcantay (20,574 feet), the highest mountain of the Cordillera. Other icy peaks reach skyward farther northwest, including the daunting Pumasillo ("The Puma's Claw") (20,492 feet) and the largely unknown massifs of Sacsarayoc and Panta. To the east of all this mountain grandeur, on a steep and remote mountainside, lay our goal, the grand Inca masterpiece of Machu Picchu.

I intended to trek along ancient Inca trails from the Mollepata trailhead toward Salcantay.

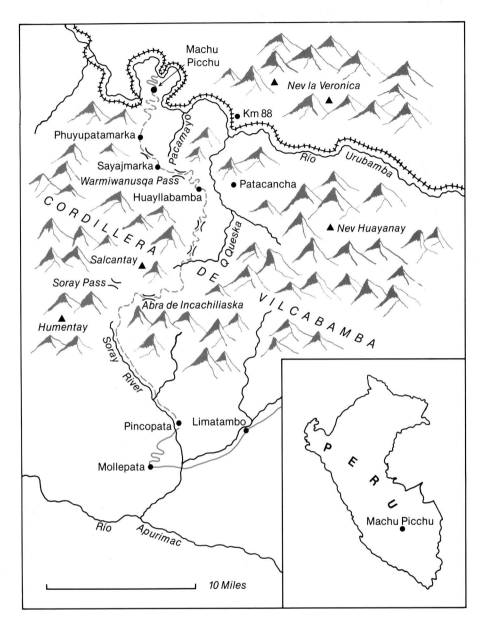

We would cross the spine of the range near this peak, then descend the eastern slope toward the Río Urubamba, eventually arriving at Machu Picchu. The dream of retracing the travels of the Incas across these highlands had obsessed me for years. Whenever I visited friends in Lima and Cuzco we talked of mysterious mountain highways with their precisely laid stone slabs traversing deep valleys and high mountain passes, of trails overgrown with ferns and orchids. But until recently few people knew where these trails were and even fewer had any personal knowledge of the terrain. The Incas did have a complete network of trails, and all evidence pointed to the Cordillera de Vilcabamba as one of the most in-

*The Urubamba Valley,*
*sacred river valley of the*
*Incas.*

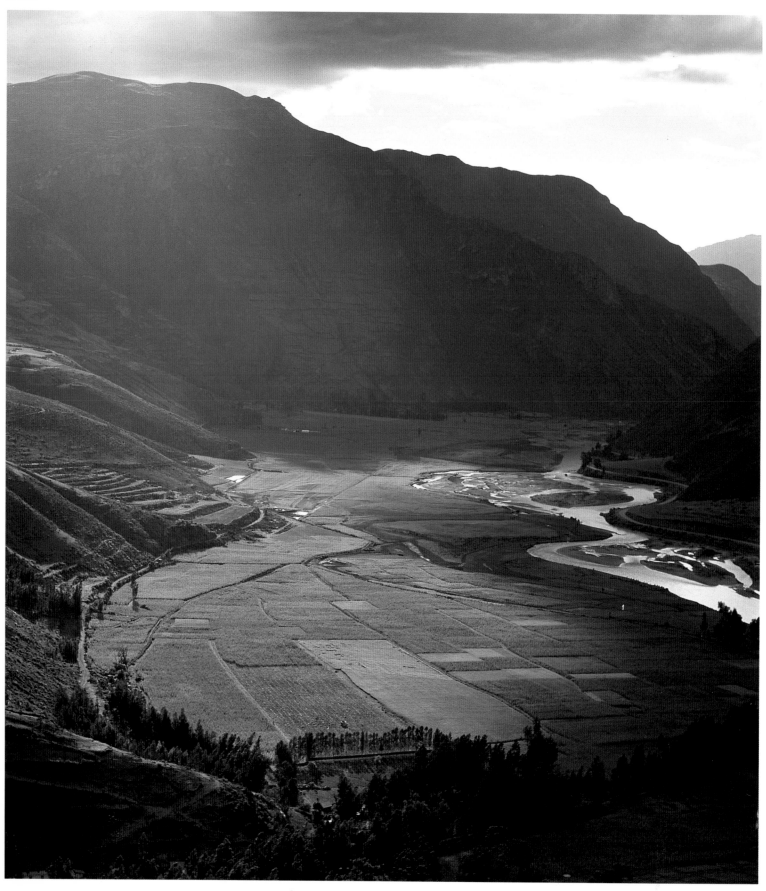

tensively used areas. The Incas mined for gold, built watchtowers and way stations, and engineered irrigation systems to drain swamps and turn them into agricultural fields. It was also in this area that they eluded the Spanish conquerors the longest—for more than forty years after the initial conquest in the sixteenth century.

By traversing the Vilcabamba Range we hoped to follow the Inca trails, find ruins, locate ancient irrigation canals, see the great peaks up close, and enjoy superlative trekking with new insight into the lives of these amazing forefathers of modern Peru.

The idea of our trip was not new. I first heard about a possible route across the Cordillera from Tom de Booy, a Dutch mountaineer and geologist who visited this area in 1950 with a small party of scientific explorers and climbers. He carried out a geological survey of the Andes, and with the French guide Lionel Terray made the first ascent of Nevado Humantay Soray. De Booy told me in the late 1960s that it would be possible to cross from Limatambo into the Urubamba Valley by traversing Abra Soray, a high pass just west of their peak. "From this pass descend into the jungles of the Santa Teresa Valley," said the geologist, "and you end up at the train station at the village on the Urubamba River." In 1973 I planned this trip for Mountain Travel, but the route veered away from the Inca highlands and into jungles devoid of any historical remnants.

It was Alfredo Ferreyros, a Cornell-educated Peruvian, who found the key to the central Inca highlands, not by attempting the Soray Pass, as proposed by De Booy, but by looking eastward and locating the 16,250-foot Abra de Incachiliaska—"The Pass Where the Inca Is Cold." Traveling and exploring by himself, Ferreyros descended the Quebrada Pampacahuana ("Long Valley"), where he discovered remnants of irrigation canals and beautiful carved-stone trail fragments that offered clues to the Inca presence. Descending toward the Río Urubamba he found more ruins at Paucarcancha, a site then connected with the Inca Trail, a route—followed by an increasing number of tourists and backpackers—that starts from a stop known as Kilometro 88 on

the railroad from Cuzco to Machu Picchu. This popular route (now jocularly known as the Gringo Trail) was pioneered in 1972 by Cesar Morales, a well-known figure in Peruvian climbing circles; he connected a trail from the railroad stop, used by local farmers, into the "Long Valley" and then followed a route that led onto an Inca trail to Machu Picchu.

We arrived in Mollepata in midafternoon. This dismal, sprawling pueblo of eight thousand people contained a large, mud-filled square surrounded by bare, dirty adobe houses. The village had no pavement, no electricity, and no running water. Alfredo did not even slow down but continued along a steep dirt track that led eastward toward the Pincopata Ranch, the home of Señora Margherita Montes. Although situated at an elevation of 9,200 feet, the ranch—built more than thirty years ago by Señor Montes—produces citrus, yucca, peaches, avocados, corn, beans, and sugar cane; the trekker can load up here with fresh produce. After enjoying dinner with Señora Montes we said good-bye to Alfredo, who was driving back to Cuzco, and met the two muleteers who would accompany us on our trek.

We started up at 8 A.M. from the ranch, driving along a dirt track that wandered among scenic farmlands to a minor pass, Abra Marcocasa. At this point the actual walking began, and we climbed up and right into the uncultivated higher hills, following a narrowing wooded ridge our mule drivers (*arrieros*) called Cruzcunca. From the top of this ridge we traversed westward, high above steep valleys of dense woods and bushes called *ratama* (similar to Scotch broom) until we emerged into the broad and mountain-ringed Soray Valley. Then, along a gentle sand track on the west side of the valley, we came across some Inca stoneworks: a ruined footbridge and remnants of a small irrigation canal. Eventually, after a good day's march, we arrived at Pampa Soray, an idyllic alpine meadow at the foot of a great ice peak, Humantay Soray (20,397 feet).

My altimeter read 12,800 feet. As evening came, dark clouds covered the peaks and light snow began to fall. Several families of poor Quechua Indians were living at Pampa Soray

*Native porters preparing their evening meal.*

with their cows, carving out a meager existence. Slightly above the meadow we found a good campsite with views of Humantay Soray and Salcantay. In addition to our two muleteers, Pío and Visitacion, stoic yet attractive mountain Indians from the village of Santa Teresa, our party included Maxi Aparicio and his eighteen-year-old son, who went by the improbable name of Wilbur. Maxi, our guide as well as cook, was an indefatigable and kind middle-aged Peruvian from Cuzco who worked for Alfredo on his various expeditions. Both he and Wilbur had agreed to join my son, Bill, and me on our trek as guides and companions.

During the night the skies cleared, and morning dawned with a clear blue sky; a fresh dusting of powdery snow lay on the mountains around us. I arose before six and walked up a rocky ridge to the east of our camp for a thousand feet or so and enjoyed an extensive panorama of snowy ridges and peaks, including a close-up view of Salcantay.

After a fairly early start from Pampa Soray we moved in the direction of Salcantay, first following a small stream that descended from Humantay Soray. Salcantay Pampa (13,600 feet) was reached an hour later; here we watched a fox chase away several large nesting birds. He undoubtedly wanted to eat the eggs, Maxi said. Mules carried our gear and our packs were

light, yet we felt the altitude as we climbed steadily toward a glacial moraine. Around noon we reached a junction of several old moraines. This is where De Booy had turned westward, I thought—to Soray Pass and Santa Teresa—and where Alfredo Ferreyros more than twenty years later had found a route east across the Abra de Incachiliaska. We followed suit and veered east, climbing up steep grassy slopes, then even steeper rocky terrain that challenged the mules.

We reached a promontory now known as Rinconada de Salcantay (14,600 feet), below the awesome south face of the mountain, and stopped for lunch, gazing in wonderment at the play of clouds and sun on the six-thousand-foot ice-covered face of Salcantay. Continuing upward—lungs straining in the thin air—we reached the pass at 1 P.M. It was cold and windy at 16,250 feet, but what a great spot! To the west I could see Humantay Soray, as well as De Booy's route, the Soray Pass. Beyond these, other peaks in endless multitudes extended toward the distant Amazon jungle.

The cold drove us off the pass. Because of the steep descent on narrow scree trails on the eastern side, the muleteers had packed the mules professionally, wrapping all loads in nets made of leather strapping. After descending alongside the East Glacier (no ice, however, must be crossed on this pass) and diagonally traversing the width of an emerging valley, we came to a small shelf named Sisaypampa (15,700 feet). Here, near a section of Inca pavement, we spent a cold night below mighty Salcantay's east face rising across the canyon.

My son Bill, an athletic-looking youth of eighteen, who until now had managed very well, woke me in the night complaining of a nosebleed. At first I worried that we might have to pack up and go down, but we eventually got the bleeding under control, and by morning he was ready to continue, although weak. It was clear and crisp. All the peaks stood out, catching a mellow pink from the first rays of the sun. On mornings like this I always feel a great upwelling of joy. The clean air, the cold, and the dawn combine to produce a brand-new day in a natural and inimitable way. For me nothing quite equals sunrise

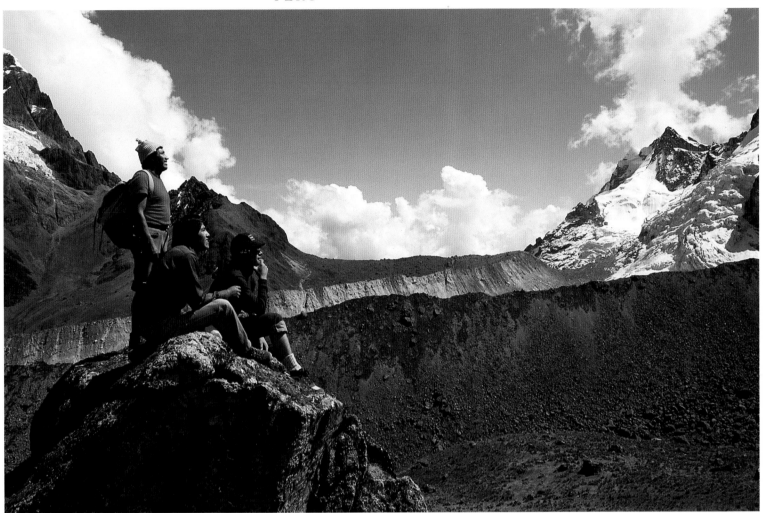

in the mountains. Once the sun is up and warms the air this feeling seems to recede and the day becomes like any other. Bill was by now feeling better, and Maxi fixed him a hearty breakfast of poached eggs, bacon, and potatoes.

From our campsite it was now possible to descend into the long Quebrada Pampacahuana by heading straight down toward it, but Maxi suggested we detour over a small pass that rose a mere one hundred fifty vertical feet above us. By taking that route—Maxi pointed to a long saddleback ridge—we would be able to stay high all morning, see the peaks of the Vilcabamba Range (which until now had eluded us) to the east, and at the same time obtain a more level view of other mountains to the north and west. After a short climb we reached Choquetera Pass and descended east into an isolated hanging valley with a large lake dense with high Andean tussock grass. As we walked along the shores of Laguna Chilietera a flock of white Andean geese landed nearby; our cameras came out immediately.

Continuing north we reached another

small valley and yet another minor pass, Abra Cruzcunca (14,900 feet). Since leaving Limatambo we had not seen a single traveler going in either direction, but now, while we were having lunch on this pass, I saw two Indian riders slowly coming up the steep Milpo Valley to the west, leading a mule train heavily laden with sacks. The woman rider, wearing the black bowler typical of the region, and her young son stopped their horses at the pass to talk to Maxi and our *arrieros*. Wilbur explained to us that she came from Pampacahuana with potatoes grown there and was on her way to Limatambo, where she planned to sell or exchange them for kerosene, salt, and sugar. The steep valley from which the riders had emerged was our route of descent, said Maxi. After lunch we descended into the Quebrada Milpo. Here and there we would see a *paskana*, a small shelter made of loam and puna grass in which a shepherd would sleep when away from his village. At the bottom of the Milpo Valley we now joined the Río Pampacahuana, where we placed our fourth camp of the trek at 12,800 feet. We were, at last, in the enchanting "Long Valley,"

*Maxi (in red shirt) and Wilbur Aparicio and author's son Bill below Soray Pass. To the left rises Nevado Huayanay, while to the right the ramparts of Nevado Salcantay can be seen.*

*The famous flower stone, intricate art of an Inca stonemason, at the Limatambo ruins.*

where Alfredo Ferreyros had spotted the Inca irrigation system—a half-mile-long viaduct—and a fortified Inca lookout station.

I decided to find out what the Incas had in mind with these canals, so early the next morning I climbed alone toward a high ridge, hoping to reach a vantage point for my observations. After a thousand-foot climb I obtained a clear view of the entire valley; it was quickly evident why the Incas had found it expedient to build these canals. The canals drained the pampa, rather than providing water. Without them the pampa floods, making it unsuitable for cultivation. I noticed that where the Inca canal was still in use the fields around were dry and cultivated. (Potatoes had just been harvested, and some were at this moment on their way to Limatambo on the backs of the mules we had met on the pass.) Where the canals had been allowed to deteriorate and collapse the pampa had turned into a swamp. It was pleasing to realize that people today in remote settlements of Peru live off the fruits of the labor of the ingenious Incas of five hundred years ago.

On day five we visited some of the scattered settlements, the most rudimentary and dismal clusters of hovels I have ever seen. The people in this valley are among the poorest and most backward hill dwellers I have encountered, even worse off than the wretched animistic Hindus of western Nepal. One barefoot, reeking woman we met had lost the fire in her kitchen corner; she was too poor to afford matches. She had walked for several miles to the next settlement to borrow a small piece of burning dung, which she was taking back to her dwelling, keeping it alight in a large piece of dried cow dung.

From the lower end of the pampa the trail now descended a narrow canyon. Here and there we saw small plots of farmed land, most of them lying fallow. After several hours we reached the Paucarcancha Ruins, which I photographed extensively. The ruins are strategically situated at the junction of the Queska and Llullucha valleys. They were in poor condition and neglected, and the site was overgrown with weeds, sharp thorny plants, and cactus. Nevertheless, this way station is well worth a visit—it comprises several houses, fortifications, and walls in fair condition (though not of outstanding quality). Seeing these and other Inca ruins in remote areas makes one realize that the Incas devoted more time and attention to the well-polished and smoothly fitting stones in urban areas and sacred places of high traffic than to the stonework in the mountains.

Continuing now toward the Llullucha Valley, I was nearly hit by a female condor that either missed seeing me or was just plain fearless. Soon thereafter we reached Huayllabamba, where the regular Inca Trail connects. Unbelievable amounts of trash lay everywhere: toilet paper, empty bottles, matches, cans, and even empty pill containers. Several stone huts and a small school building made up all of Huayllabamba. It was the day after Independence Day—July 28—and everyone was drunk with *chicha*, a local alcoholic brew made from cornmeal and wheat flour. Looking into one of the dark huts, all I saw were three pairs of bloodshot eyes of local Indians who lay sprawled against the wall, awake but totally wretched.

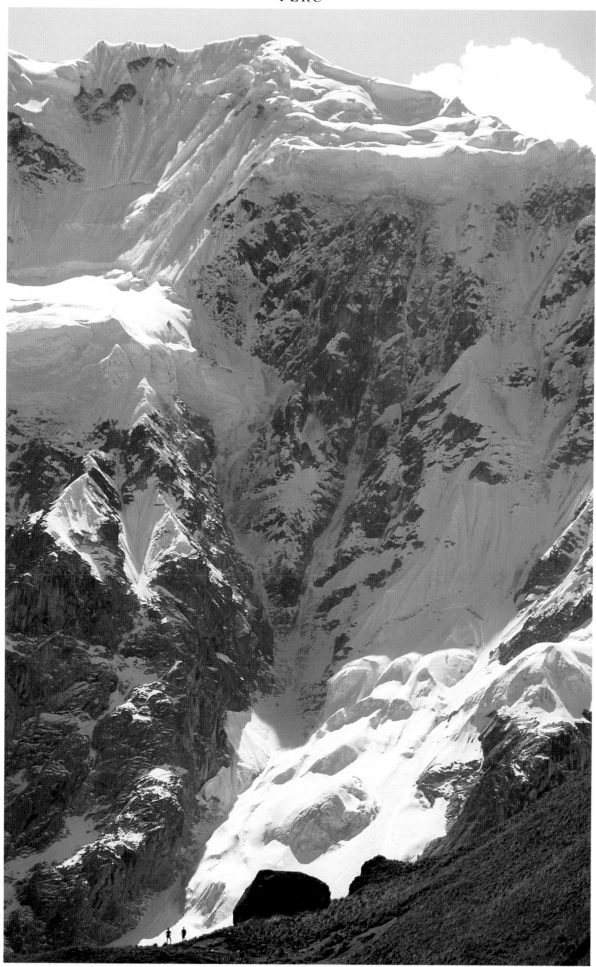

*Hikers below the 6,000-foot south face of Nevado Salcantay, highest peak of the region at 20,574 feet.*

We were now set to take on the Inca Trail. In order to save at least a modicum of aesthetic quality on this trail the local government has banned the use of horses or mules, limiting the number of travelers to those who can make it on foot. Besides, animals would have a difficult time getting across narrow places on the trail, especially with large loads. So we arranged with Alfredo Ferreyros for four Indian porters to carry our gear. To their credit, it must be said that they showed up at Huayllabamba on the appointed day—sober. They had come from the small village of Patacancha, above the well-known Inca fortress Ollantaytambo, and were named Gregorio Guispe, Mariano Yapu, Celso Monarca, and Venancio Monarca, who at seventeen was the youngest.

There is an enormous difference in ecology between the high traverse we had just completed and the Inca Trail. Until Pampacahuana we had been trekking in dry terrain well above thirteen thousand feet, but now we were down to 9,700 feet and in a semitropical environment. From here on, except for a few passes, we would be traveling in cloud forest, or what the Peruvians call montaña. The climatic conditions east of the high peaks are different from the drier western altiplano, or high plateau, from where we came. Moisture-laden air from the Amazon and frequent fog have provided the length of the Inca Trail with a rich flora. Fern forests abound, as do many varieties of bromeliads as well as Spanish moss. In the trees fluttered countless species of birds. And even though man's disgraceful treatment of this delicate natural habitat was evident everywhere—especially on the walk from Huayllabamba to Lluluchapampa, where we planned to camp that night—the Inca Trail is an experience I would not want to have missed.

We finally threw on our packs—now a bit heavier because we were sharing some of the load left behind by the animals—and headed up the Llullucha Valley toward our campsite far above. The trail is steep, climbing 4,300 feet in three miles from the village to the pass. Few unacclimatized tourists who get off the train at Kilometro 88 are able to handle this walk in a day. The trail wanders through dense forests of Andean hardwoods, gigantic roots often barring the way. Vines and creepers hang in festoons from the canopy above. As we arrived at Lluluchapampa heavy mists crept up from below; they had followed us up the mountain all afternoon. Maxi, with his usual alacrity, cooked up a big meal in his small kitchen tent, where we huddled for warmth, comfort, and good conversation.

A light rain fell in the morning as we started up for our last day and Warmiwañusqa Pass (13,940 feet), the highest point on the Inca Trail. Donning rain gear, we soon were walking above the tree line, where only the wet Andean bunchgrass grows. The pass was heavily fogged in (as is often the case), with no views whatever. Maxi insisted on pulling out his kerosene stove and preparing some hot soup. From the pass Bill, Wilbur, and I descended on the run to the warmer climes of the lush Pacamayo Valley. Several tents stood there in a small clearing, and their occupants were just about to get up when we came striding through—racing, it must have seemed to them. We had been traveling rather fast, as we planned to do the trail in a day and a half, which meant we had no time to waste. Normally people who walk the Inca Trail from the railroad take anywhere from three to six days. Being well acclimatized and in good shape, and having our loads carried by our porters, we figured that we could manage the fifteen miles in far less time.

It was at the low point of this valley traverse, after crossing a small stream, the Pacamayo, that we encountered the first Inca stoneworks. Up to now all our walking had been on ordinary dirt trails, but here appeared a series of flat, well-laid stone steps two or three feet wide that led up the east side of the valley to the small picturesque Inca fortress—actually a permanent watchtower complex—of Runkuraquay. We found several Frenchmen encamped amid the trash left inside the ruins. The site comprises a round-walled court with rooms to the outside and a detached watchtower. At the time of our visit no efforts had been made by the authorities to clean, restore, and preserve this unique mirador structure.

Leaving the Runkuraquay ruins, we

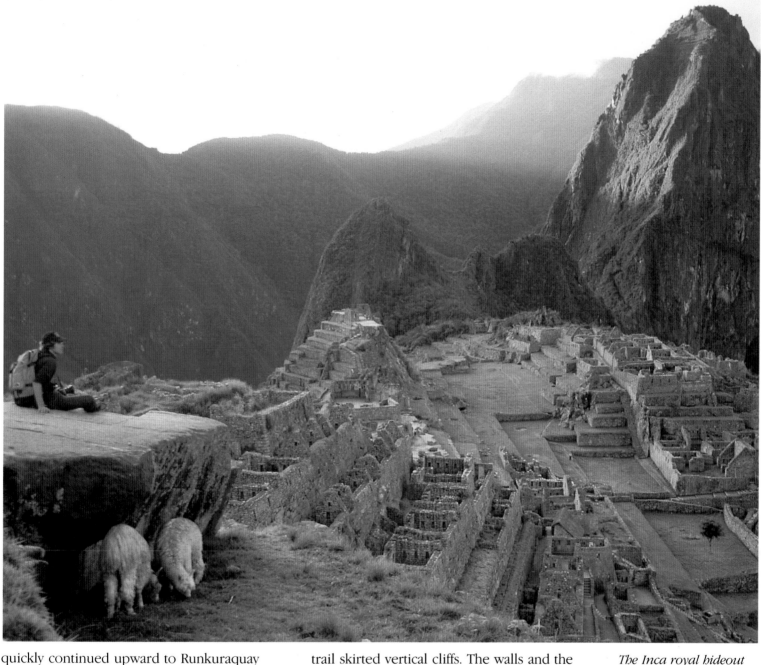

quickly continued upward to Runkuraquay Pass (13,120 feet), then descended into what must rank as one of the finest high-montane jungles in the world. The section between the pass and Phuyupatamarka is a veritable botanical garden. Huge sword ferns competed with gnarled trees, brown mosses hung from high limbs in long streamers, and blue lupine, spiny agave, and red aloe vera intermixed with delicate yellow orchids. A light fog drifted through the dripping-wet vegetation, hiding the tops of the tallest trees. The whole scene was otherworldly.

The magic continued. Underfoot was a beautifully built stone path, often three feet wide, sometimes consisting of white slabs weighing hundreds of pounds. At places the trail skirted vertical cliffs. The walls and the space below were often invisible because of thick vegetation, and the buildup of stonework in some places was nearly twenty feet high. Several small lakes covered with green algae added to the charm.

Ahead of us, on a ridge to the left, appeared Sayajmarka, another ruined *castello* complete with Inca baths, turrets, and lookout towers; it was discovered by Yale scholar Hiram Bingham in 1915. From the observation platform on top of the ruin I could see the stone slabs of the Inca Trail rising into the clouds beyond toward the last pass of the trek. When, an hour later, we reached this obstacle, Abra Phuyupatamarka (11,900 feet), a stupendous view of the Urubamba Valley awaited us.

*The Inca royal hideout of Machu Picchu.*

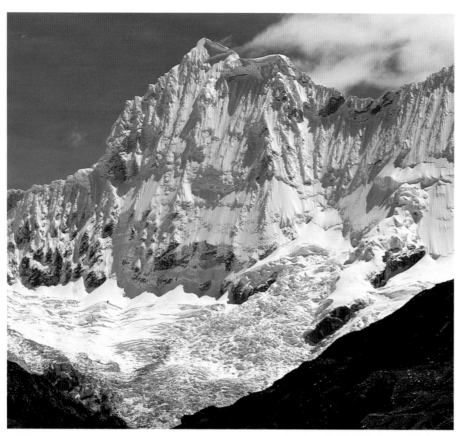

*The formidable Chacra-raju, one of the most beautiful peaks of the Cordillera Blanca.*

bridges had been laid into place. Then a wide, seemingly endless staircase cut into the rock led to a corner on a knife-edge ridge, and turning this we found ourselves at last below the famous Gate of the Sun—Intipunku, the Inca entrance to Machu Picchu. One more step and we were inside the sanctuary, as the last rays of the setting sun illuminated it. A marvel of design, the white granite terraces, walls, and buildings, divided by a series of cascading plazas, seemed to float in the twilight, giving the entire complex a mysterious, unearthly appearance.

Machu Picchu was a royal hideout, as well as a temple to the Sun God. (A local guide told us that the bones of three hundred young women have been excavated from the ruins.) Hiram Bingham discovered Machu Picchu in 1911. A tremendous amount of excavation and restoration has since been carried out by Peruvian archaeologists, and at least a full day should be devoted to the ruins and to the ascent of the two hilltops of Machu Picchu and Huayna Picchu ("Little Peak") that straddle the site.

The views of the surrounding region are striking. Two thousand feet below the Río Urubamba, a foaming mountain torrent, twists and gnarls around steep rock walls, tracing a nearly circular arc around the magical Inca stronghold. Once past the National Historical Sanctuary of Machu Picchu the river calms down and gently flows northward, out of the mountains and beyond, to an eventual confluence with the Amazon, the largest river of the South American continent.

If one books well in advance (up to a year) it is possible to spend the night at the tourist hotel near the ruins. (Camping is no longer allowed at the ruins.) Something had gone haywire with our reservations: we were told, *"Mañana, Señores, mañana."* So Bill, Maxi, Wilbur, and I, along with our four porters, squeezed into the last bus of the day for the bumpy ride two thousand feet down a series of switchbacks to the Río Urubamba; we reached the bridge after dark.

We camped in a field near the railway station, and the next morning we said good-bye to our new friends before catching the train for the five-hour ride to Cuzco.

To the left of the pass lay another fine site. Phuyupatamarka (12,000 feet) is perhaps the most interesting of all the major ruins encountered along the way; it is certainly my favorite. Baths were connected to each other by a carved-stone waterway; after hundreds of years of abandonment and decay water was still flowing from bath to bath to bath. After a quick look at an impressive massive gateway on top of the ruins we were off again, wanting to arrive at Machu Picchu before sunset.

The trail beyond Phuyupatamarka was flat for about two miles; then, suddenly, it tumbled four thousand feet in chaotic twists and steep steps toward the river and Machu Picchu. Here and there we had a glimpse of the complex, but it was not until later, on a small promontory, that we had our first real view of "the lost city of the Incas." Above the ruins rose a large pyramidal peak also named Machu Picchu (the words actually mean "big peak"), which we traversed around to the east. Dense vegetation overhung the trail, which was cut into the solid rock in places. Sometimes the path vanished altogether along the vertical walls, and here makeshift bamboo

# TREKKING IN PERU
## Expedition Planners

### General Information

*Visas:* No visa is required. A tourist card is issued on the airplane en route to Peru.

*Vaccinations:* The following are recommended: yellow fever, diptheria-tetanus booster, typhoid, and a gamma globulin shot as protection against hepatitis. Regulations change frequently, so please consult your physician or the local U.S. Public Health Service.

*Nearest Airport:* Lima International for the Cordillera Blanca Traverse—flights are available from most major cities in South and North America; Cuzco airport for the Inca Highlands Trail.

*Water Purification:* Water should always be boiled or treated with water purification pills or iodine crystals. Avoid drinking tap water in hotels.

*Source of Official Information:* Peru Tourist Offices in New York and Los Angeles.

*Further Reading:* See Bibliography, Chapters 9 and 10.

### The Cordillera Blanca Traverse (Chapter Nine)

*Access:* From Lima an excellent road now runs to Huaraz, the chief town of Ancash Province, where the Blanca is located. There are local bus services, *collectivos* (share-cost taxis), and private cars for hire. Count on one full day of driving. In Huaraz, where one can make trekking arrangements as well, it is possible to hire a truck to take you to any roadhead in the mountains. Be sure to prearrange for someone to pick you up at the end of your journey. Transportation to the trailhead can be arranged by local hotels and/or guides.

*Logistics:* Plenty of manpower (trek guides, climbing porters) is now readily available in Huaraz, as well as in the other mountain villages of the Santa Valley, such as Carhuaz and Yungay. Animal handlers *(arrieros)* and donkeys are the way to trek. Many experienced trekking and mountaineering guides can be found among the local *campesino* and Indian populations. It pays to inquire and obtain references beforehand. Backpacking is also possible.

*Travel Tips:*

*Best season:* May–September.

*Trekking days:* 10 days, including side trip to Portachuelo Llanganuco.

*Distance:* About 130 miles.

*Difficulty:* A fairly arduous trek with many passes, none of which has permanent snow. Weather generally quite warm because of tropical location. Light hiking boots or running shoes are satisfactory, but be prepared for short storms, including snow flurries in the passes.

*People:* The markets of Huaraz and Santa Valley are very colorful and great for people watching. The area visited during the trek is uninhabited. The local Quechua Indians are friendly but shy and avoid foreigners.

*Food:* Most food supplies are available in Huaraz. Buy specialty items in Lima.

### The Inca Highlands Trek (Chapter Ten)

*Access:* It is best to fly to Cuzco (driving is not recommended), the ancient Inca capital. The flight from Lima takes an hour, and service is provided by both Aero Peru and Fawcett Airlines. Flights always leave early in the morning. There is no regular bus service from Cuzco to Limatambo (60 miles), only trucks and *collectivos.* Best and safest is to hire a sturdy truck or get a taxi driver with a sound vehicle and good brakes. Be sure to negotiate all details in advance. The drive takes half a day. Spending the last night at the Machu Picchu Hotel is a great way of ending this trek. Be sure to make reservations as far in advance as possible;

up to a year is not farfetched. At Machu Picchu there is a bus that takes you down to the Urubamba River and to the railroad station. Buy tickets as soon as you can. If the hotel is full, descend with the last bus (usually around 4 p.m.) and camp on a wide meadow past the railroad station, or walk to Aguas Calientes where there are cheap roadside inns. Do not miss the hot springs.

*Logistics:* Arrangements should be made in advance for guide, food, and equipment, unless you come prepared to backpack the entire trip on your own, which is possible. Equipment can be rented or bought in Cuzco. There is nothing to be purchased along the trail, even along the Inca Trail section proper. Mules and *arrieros* can be found at Mollepata, with advance notice.

*Travel Tips:*

*Best season:* May–August (crowded during school holidays).

*Trekking days:* 5–6, depending on side trips.

*Distance:* About 40 miles.

*Difficulty:* Moderate trek. There may be seasons when the high pass is temporarily snowed in and impassable for animals (up to the end of May). In that case, take the Soray Pass to Santa Teresa. Expect some rain and/or fog. Light hiking boots are sufficient for this trek.

*Cautionary Notes:* Beware of thieves on the Machu Picchu to Cuzco train and in places such as train stations, airports, and congested areas.

Conditions of overcrowding along the Inca Trail and scarce firewood make use of stove and water purification mandatory.

*People:* Quechua Indians living in this area are very shy, suspicious of foreigners, and difficult to approach. Their life-style is very primitive and the contacts with them are limited.

*Food:* All supplies should be purchased in Cuzco. Some vegetables and fruits are available at Pincopata Ranch at the start of the trek.

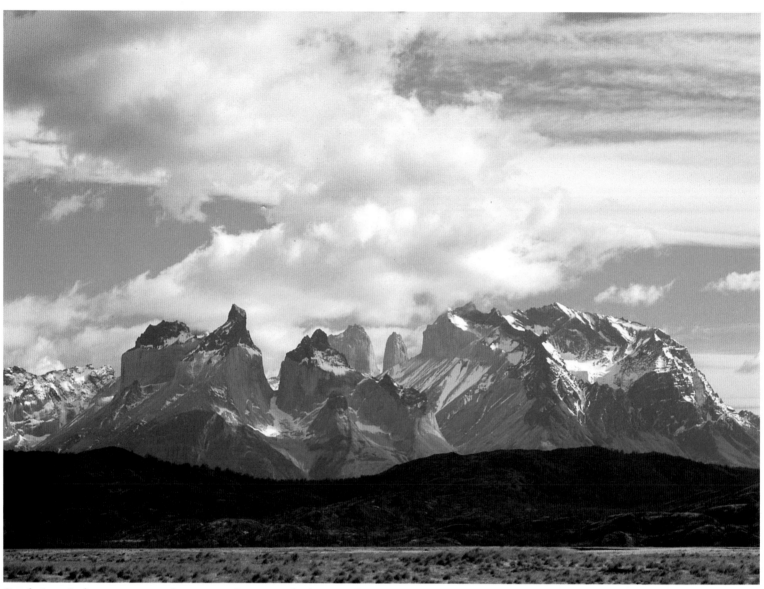

*South America's most spectacular mountain range, the Torres of Paine; the prominent peak, left, is the Cuerno, or Horn.*

# CHILE AND ARGENTINA
## Trekking in Patagonia

*There are no words that can tell of the hidden spirit of*

*the wilderness, that can reveal its mystery, its melancholy*

*and its charm. There is delight in the hardy life of the*

*open . . . the silent places . . . the wide wastes of the earth,*

*unworn of man and changed only by the slow change of the ages*

*through time everlasting.*

*—Theodore Roosevelt*

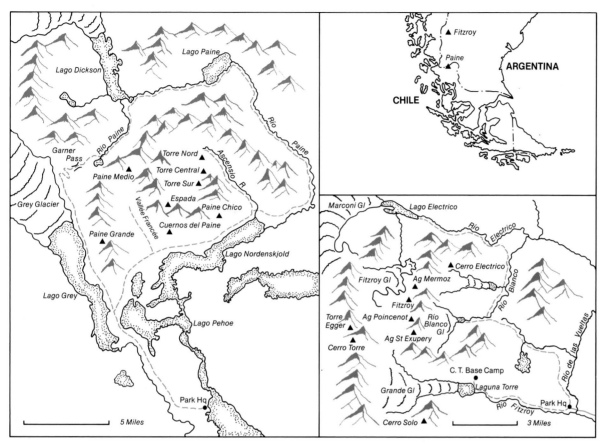

THE SOUTHERNMOST thousand miles of the South American continent constitute a dramatic and tempestuous geographical region called Patagonia, a magnificent wilderness with scenery ranging from the stunning towers of Paine and Fitzroy, whose massive spires of pink-and-white granite thrust six thousand feet skyward, to large mountain lakes and Alaskan-size glaciers. Patagonia is dominated by the Andes, the longest mountain range on earth, running the length of South America from Colombia to the Strait of Magellan and across to Tierra del Fuego. These mountains divide Patagonia into three distinct environments: a stormbound Pacific coast with deep fjords, a huge icecap (actually two icecaps separated by a few fjords) held in the teeth of the Andean peaks, and the endless golden plains of the Argentine pampa.

The Portuguese navigator Fernão de Magalhães—known to us as Ferdinand Magellan—then in the service of Spain, landed along the strait that now bears his name in 1520. The great explorer and his crew encountered native hunters who, according to Magellan's diarist Antonio Pigafetta, "were giants so tall that the tallest of us only came up to their waist." Magellan took a liking to these people. He named them Patagonians (*Pata-gon* meaning "big feet"), and the name Patagonia was eventually adopted for the land north of the strait. The tribes that inhabited Patagonia and neighboring Tierra del Fuego, such as the Tehuelche, the Alacaluf, and the Ona, are now virtually extinct, wiped out by the white man's incursions: disease, alcoholism, forced acculturation, and the loss of their lands.

Following the discovery of the famous passage from the Atlantic to the Pacific—and the magnificent wilderness that bordered it—the Spanish settled three hundred Europeans in the region in 1584, and more immigrants arrived later. But the attempt eventually failed because of lack of supplies and of communication with the motherland. Originally a Spanish dominion, Patagonia was divided in 1881 between Chile and Argentina, the latter obtaining the much larger share. Today the name refers not to a political division but to the whole of the mainland south of the fortieth parallel. The main settlement, the once thriving port of

*Salto Grande, or Great Falls, of the Paine River near Lake Pehoe, Paine National Park.*

Punta Arenas, was founded in 1843 as a frontier outpost of the Chilean government; it grew rapidly, but the boom years came to an end with the opening of the Panama Canal in 1915.

In 1835 Captain Robert Fitzroy, accompanied by Charles Darwin, then only twenty-six, sailed the H.M.S. *Beagle* through these turbulent waters. The *Beagle* anchored near the mouth of a large river at the fiftieth parallel on the Atlantic side. From this river, the Santa Cruz, a three-week expedition by whaleboat was undertaken to explore the interior, of which little was known. Far in the interior the men viewed the 11,072-foot rock spire later named after Fitzroy by the Argentine explorer and geographer Francisco Moreno. The peak had been discovered in 1782 by Antonio Viedma, the first white man to reach the large lake, named after him, below the peak. (The Tehuelche called the mountain Chaltel, "The Hidden God.")

Of all the men who ventured into these Patagonian wilds perhaps the most active explorer was an Italian Salesian priest, Alberto De Agostini, who arrived in Punta Arenas in 1910. He spent the three decades before World War II exploring and photographing when not busy with his missionary work. De Agostini's work was published in a book containing large foldout panoramic photographs of the enormous glaciers and peaks of the southern Andes.

Although De Agostini led an early attempt on Fitzroy in 1937, mountaineering first became serious in 1952, when a group of Argentine climbers made the first ascent of Patagonia's highest peak, Cerro San Valentin (13,310 feet). Fitzroy, perhaps the most spectacular rock spire in the world, was climbed that same year by French mountaineers Lionel Terray and Guido Magnone. While climbers were vying to be first to climb Patagonia's famous spires, others were keen to explore the two icecaps. The first complete traverse of the southern icecap was made by H. W. Tilman in 1956. Because of the stormy weather typical of Patagonia, this fifty-mile journey took six weeks.

Eleven years after Fitzroy was climbed a

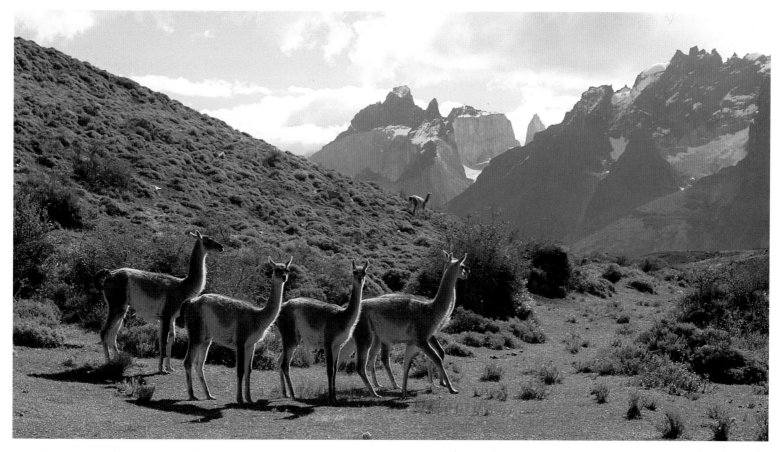

British group led by Don Whillans conquered the central Tower of Paine, an equally savage-looking rock spire in Chile. Both the Paine and the Fitzroy ranges are in areas of superb wilderness that have been set aside by their respective governments as national parks. I found the Patagonian environment to be one of the most invigorating on earth.

From Punta Arenas, which can be reached by air from Santiago, we journeyed to and from the parks of Patagonia by rental truck. Rather than limit ourselves to one particular trek, Miguel Alfonso, Cesar Morales, Pepe Alarcón, and I decided to spend ten days trekking and camping in Paine National Park—a few days in the Lago Argentino area and a week at Fitzroy. We also planned to drive across Tierra del Fuego to Ushuaia.

Our first trek was to be a circular route around the famous Torres del Paine (Towers of Paine), a granite batholith severely eroded during a recent ice age and not connected to the main Andean chain. The Paine mountains are rich in fauna, forests, and lakes. Among the hundred twenty species of birds found in the national park, parrots, geese (*Enicognatus ferruginea*), black-necked swans, caiquen (*Chloe phaga picta*), and flamingos occur abundantly. Enchanting forests of Magellan beech—from dwarfed trees ten inches tall to huge, gnarled specimens—have somehow withstood the elements. Flowers include daisies (introduced), snapdragons, and colorful mosses. Foxes, pumas, and skunks are plentiful, as are eagles, condors, and rheas. In 1985 more than a thousand guanacos, wild cousins of llamas, were estimated to be in the park.

We began our Paine trek from a base camp on the shore of lovely turquoise-green Lago Pehoe (260 feet), which we reached after two days' driving from Punta Arenas along the Chilean coast. The entire western shore of Patagonia is a maze of deep fjords and thousands of mountainous islands, nearly impenetrable and virtually uninhabited, except between Puerto Natales, a small, time-forgotten harbor on Seno Ultima Esperanza, and Paine National Park. Dense rain forests compete for space with the glaciers, which tumble in chaotic masses off the central ice-

*The guanaco, wild cousin of the llama, in Paine National Park.*

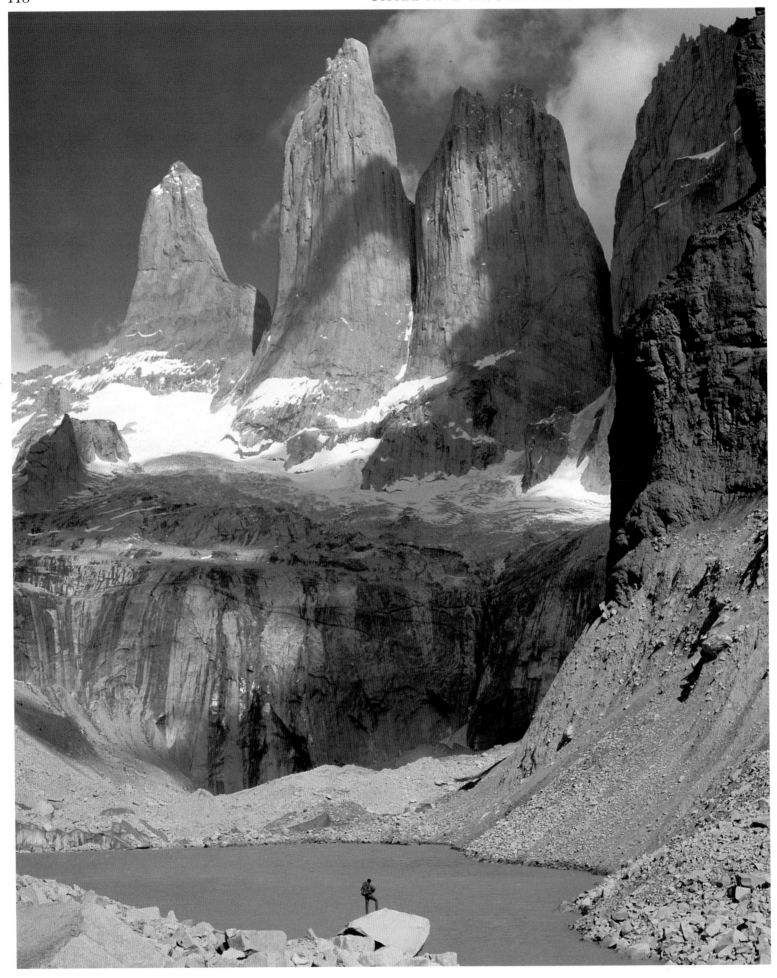

cap, often falling right into the sea. Directly across our lake rose the Towers of Paine, a palatial cluster of ice-clad peaks and granite needles, swept by hurricane winds, shooting straight up for more than six thousand feet out of the rolling green hills and grasslands that surround them. We started our hike westward through a narrow strip of land separating lakes Nordenskjöld and Pehoe and soon reached Valle Francée, an enclosed sanctuary in the very heart of the peaks. From this cirque, one of the world's most majestic places, polished vertical cliffs rise between hanging glaciers to the sharp summits of Paine Grande (10,600 feet), the Fortress (9,400 feet), and Cuernos del Paine, the last a stunning hornlike granite peak topped by a layer of dark metamorphic rock.

We retraced our steps out of the Valle Francée the next day and headed cross country east around the Cuernos and Paine Chico, following the shore of Lago Nordenskjöld past rolling meadows, gnarled Magellan beeches, and crystal-clear streams. At dusk we reached the east side of the Paine Range and the Ascensio River, a stream that descends from a glacier-filled cirque containing the famous tower first climbed by Whillans. A clear but windy morning greeted us as we hiked up the trail along the south side of the Ascensio, striding through dense forests of new birch as well as the remains of ancient woods burned fifty years ago by Huaso settlers to add more pasture to their holdings. A five-hour walk took us into the Torres sanctuary and a small glacial lake, where we had a grandstand view of what certainly rank as some of the most awesome granite spires in the world. As I sat there in utter fascination, the three spires (Torre Nord, 7,400 feet; Torre Sur, 8,200 feet; and Torre Central, 8,100 feet) caught the light of the sun between rents in swift-passing clouds, creating a kaleidoscopic show. That evening we were back on level ground, having crossed the Ascensio by an unbelievable cable contraption—an old bridge left to collapse and rot. We spent the night at the Estancia Paine, a ranch adjacent to the park.

The following day we reached Lago Paine, the northern end of the trek. We could see the Andes in the distance, the southern icecap glistening here and there among the peaks. Eric Shipton once visited this icecap, making an arduous two-hundred-fifty-mile crossing from the Pacific to the eastern pampa. A journey of great hardship, this fifty-two-day trek ranks as one of the greatest exploratory achievements of our time.

We continued west from Lago Paine, then headed through partially forested parkland to Lago Dickson, fed by the large Dickson Glacier, which also tumbled off the nearby icecap. The next day we entered Valle de Perro ("the Valley of the Dogs,") which lies under the summit of Paine Medio. As the small trail wound around fallen trees through avalanche debris, and teetering boulders, route finding became difficult and care had to be taken. The tiny track was often obscured by large fallen trees, a common sight in Patagonia, uprooted by the fierce southern gales originating in the Antarctic. After camping in a small wood near the Perro Glacier we crossed the Paine Pass (approximately 4,000 feet), also known as Garner Pass. Here the scenery changed drastically. Across and two thousand feet below us the immense icecap tumbled into the maze of cracked-ice towers of the eighteen-mile-long Grey Glacier. We descended steeply along the unmaintained trail through the beech forest, keeping between the glacier and the foot of the Paine mountains. After a long and arduous day—the toughest on the journey—we reached a pleasant camp on the shores of Lago Grey. We returned to our base at Lago Nordenskjöld, passing Salto Grande ("Big Falls") on the way. This is now no longer possible because of the collapse of a bridge linking the land bridge between lakes Pehoe and Nordenskjöld with the road and campsite. Trekkers must now walk south along the shore of Lago Pehoe to the park headquarters, where the only bridge across the Río Paine allows exit from the park.

Next we planned to visit the Lago Argentino region of Argentina. Although this large lake was located a mere fifty miles across an Andean spur to our northeast we were obliged on account of border problems to drive back to Puerto Natales and head east across the border to Río Turbio (a dismal mining town), a detour of two hundred fifty

*The three Towers of Paine, after which the park is named.*

miles. (One can now cross at Cerro Castillo, cutting this detour by about a hundred miles.) There we connected with the main artery running from Punta Arenas to Lago Argentino, Fitzroy, and other points to the north. The wide-open skies, the sprawling *estancias*, and the wildlife all added to the enjoyment of our drive across this wild land. Birdlife, as in Chile, was abundant, with flocks of flamingos covering small lakes, and parrots squawking in the beech forests. Many small herds of guanacos roamed the hills, while high overhead the condors circled slowly and effortlessly.

Arriving at Lago Argentino, we checked into a small hotel at Calafate, a frontier town and supply center for the large ranches of the area and a popular spot for Argentine tourists who come from Buenos Aires to fish and sightsee. More exciting to the mountain lover are the long, jumbled glaciers that flow into the lake from the icecap hidden above and beyond the nearby Andean crest. One glacier, the well-known Perito Moreno, advances so rapidly that it seals off an entire arm of Lago Argentino in the winter. The water in the cut-off section then rises until the ice dam breaks in what surely must rank as one of nature's grandest spectacles: blocks of ice the size of boxcars hurtle into the air like popcorn, then crash thunderously into the waters.

A day's hike took us to Brazo Norte, the northern arm of Lago Argentino, and the tongue of the enormous Upsala Glacier, the largest in Patagonia. Grotesquely eroded icebergs floated offshore, framed by gale-twisted beech trees. An easy climb leads from Brazo Norte to the top of Cerro Cervantes (7,800 feet). We made the ascent in one day and got a good taste of what real Patagonian weather is like. The wind was ferocious. Never before had I experienced such violent tugs on my body. We had to hang on to anything in sight, a rock or a friend, or even crawl in the snow on all fours. My climbing partner, Miguel, a mountain guide from Mendoza, Argentina, had the misfortune of wearing a large plastic rain poncho, which almost caused him to become airborne. I struggled to help Miguel out of his poncho; the flapping of the plastic sounded like rifle shots and hurt when the ends hit me on the hand. We lost control of the poncho

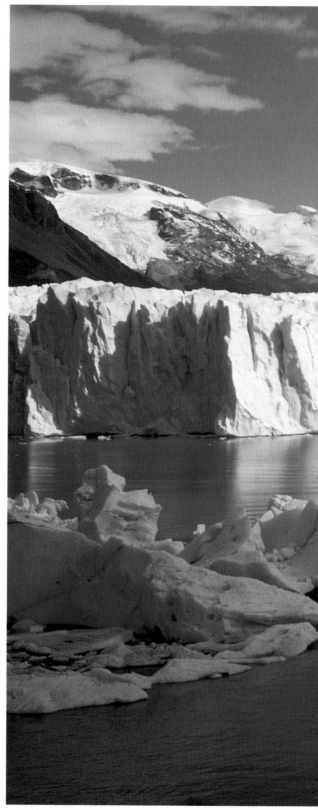

and off it went, disappearing in an instant.

From the foggy summit of Cervantes we enjoyed brief glimpses of the icecap and the vast undulating sea of ice of the Upsala and Moreno glaciers. I reflected on the truly intrepid men, explorers like De Agostini and Shipton, who dared to tread across this impossible mass of glaciers to snowy peaks beyond, unnamed, unclimbed, and often invisible.

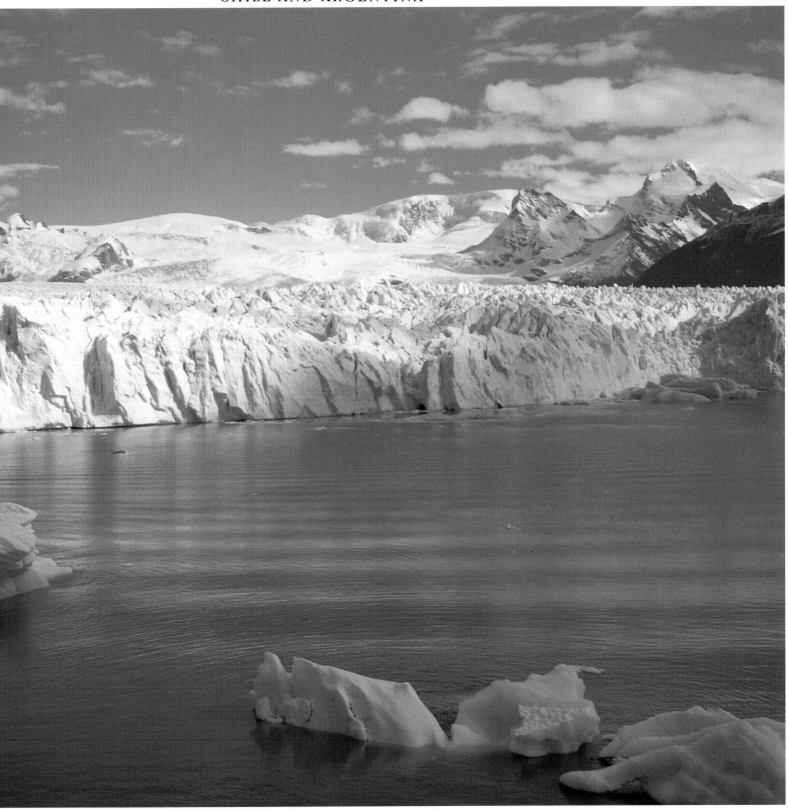

We spent some time in the cafés of Cala-
fate hanging out with the gauchos, enjoying
scenes reminiscent of the classic westerns. Tall,
lean, and mean-looking guys were lined up at
the bar, six-shooters hanging from their hips.

Two days later we headed for Fitzroy, a
hundred-twenty-five-mile drive to the north.
The road ended near the Río de las Vueltas, at
the entrance to the Parque Nacional Los Gla-
ciares (Glacier National Park), where a lonely
park ranger welcomed us as rare visitors.

Besides Fitzroy, this area is famous for its
unique rock spires, granite blades that rise out
of the icecap; some jut six thousand feet into
the full thrust of the Pacific gales, which hurtle
at speeds of more than 120 miles an hour.
Cerro Torre is the most renowned of these
spires, but others such as Torre Egger and

*The Moreno Glacier, de-
scending from the Pata-
gonian ice cap, calving
into Lago Argentino.*

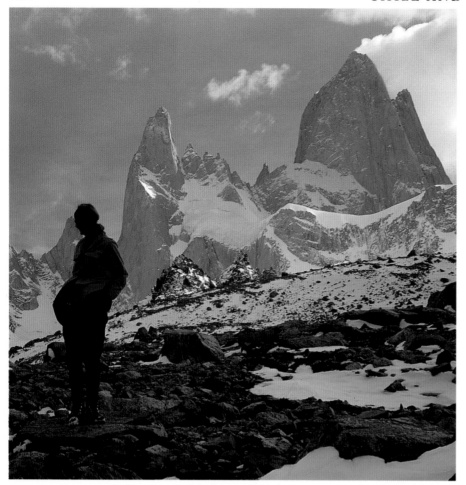

*Fitzroy, in Glacier National Park, Argentina.*

Aiguille Poincenot are also well known to climbers. For trekkers the best plan of action for visiting this area is to set up base camp near the beech forest at the end of the road (1,150 feet), making side trips to places that can be reached in one- and two-day excursions. That way, if the weather gets really rough, one is not too far from safety.

To the west of base camp lies Cerro Solo, the shoulder of which we traversed to the source of the Río Tunel and Windy Pass (5,100 feet). The pass, situated at the edge of the sprawling icecap, can be reached by an overnight hike. On another day we walked up the Río Fitzroy, past beautiful Laguna Torre, encircled by writhing beech trees, and from there reached the Cerro Torre base camp.

One of the finest two-day hikes lies north and west of the main base camp, through a forest of beech filled with parrots and myriad other birds, to the old "French Base Camp" of Terray and Magnone at the foot of the great pyramid of Fitzroy. From this historical spot we hiked up the moraines below the Río Blanco Glacier for stunning views of this mountain of flawless white granite. After making this side trip we continued down to the Río Electrico, which we followed to Lago Elec-

trico, a lovely tarn surrounded by glaciers and eye-popping summits. Not far from here the Marconi Glacier descends from the icecap. Paso Marconi, north of the Marconi Ridge, leads onto the vast expanse of ice that forms the key to a difficult glacier trek circling the entire Fitzroy massif, a journey that takes at least ten days.

Hiking around Fitzroy is dangerous whether one chooses the icecap route or the pass just west of the great peak itself. High and sudden winds, blinding snow, and zero visibility can create conditions that are nearly impossible to survive. Terray was forced to retreat from just such a tempest in 1952. The leader of that expedition, M. Azema, wrote about this incident in his book *The Conquest of Fitzroy*:

> I was worn out and my hands were frozen [after putting up the tent] when I tucked into my sleeping bag. It was barely three o'clock [in the afternoon]. We were in the center of a storm which Lionel said could not have been equaled in the Himalaya. No storm on the highest ridges of the Alps had ever given me such a sense of insecurity. And we were in the hollow of a basin at scarcely more than 3,000 feet! Supposing we had been upon Fitzroy....

For the less intrepid, I suggest that a mere glance at the icecap's edge may suffice for a lifetime's appreciation of the conditions that can occur.

We returned to Punta Arenas, boarded the ferry to Tierra del Fuego, and explored this barren island by car for a week, enjoying the visit to Ushuaia, the southernmost town in the world. Lago Fagnano, the largest on the island, has great birding and is good for camping. It is also possible to drive north from Punta Arenas to the resort town of San Carlos de Bariloche, where one can continue by air or surface transportation to either Santiago or Buenos Aires. The roads are poor and there is often no assurance of fuel. If you wish to drive north, take spare gas, spare tires, and a good repair kit. Decent food and lodging are available everywhere.

# TREKKING IN PATAGONIA
## Expedition Planner

*Grey Glacier and Grey Lake as seen from below Garner Pass.*

*Visas:* An Argentine visa is required for U.S. citizens and is obtained at Consular offices in major U.S. cities. No visa is required for Chile.

*Vaccinations:* None is required for this trek. A tetanus booster is suggested.

*Sources of Official Information:* The Chilean and Argentine Tourist Offices in New York City.

*Nearest Airport:* Punta Arenas, in Chile, for Paine National Park. Rio Gallegos, in Argentina, for Fitzroy.

*Access:* For Fitzroy Glacier National Park (Argentina), fly to Buenos Aires and connect to Rio Gallegos, the southernmost airport on the mainland. From there bus service is available to Calafate, a small ranching town near Lago Argentino. Transport by taxi can be arranged at Calafate to take you to the entrance of Fitzroy Park. Register with the ranger before entering. Check in Calafate for possible bus service going north to Bariloche.

For Paine National Park (Chile), fly to Santiago and continue by air to Punta Arenas, on the Strait of Magellan (regular service). Daily bus service (4 hours, 150 miles) is available to Puerto Natales, on Ultima Esperanza Sound. There is bus service twice a week during December and January (3 hours, 80 miles) from Puerto Natales to the park, otherwise hitch with local tour buses or forestry trucks, or rent a taxi.

*Logistics:* Registration with park rangers is required. Overland trips can be booked through some adventure-travel companies or clubs in the U.S. Arrangements can also be made through local travel agencies in Santiago and Buenos Aires, but these tend toward the more mundane. Traveling on your own is possible using local transportation and backpacking. Porters and/or guides, however, are normally not available and neither is equipment for rent. Bring your own freeze-dried food and a good tent if you wish to hike/trek extensively.

As horses cannot travel between Lago Paine and Lago Grey, hikers must be prepared to backpack this section (3 to 4 days). Paine Park Headquarters has a small and cozy inn, the Posada Rio Serrano, with reasonable rates and good food; it also has a small grocery store.

*Travel Tips:*

*Best season:* November–April (fall is more settled and less windy). Avoid the holiday season (Christmas and New Year) as the region is crowded with locals. High winds and rain in January.

*Trekking days:* 7–9 for the Paine Circuit, including the side trips to Vallée Francée and Ascensio. A week or more around Fitzroy.

*Distance:* About 60 miles (Paine Circuit).

*Difficulty:* Moderate trekking at low altitudes. Beware of sudden storms and high winds. Waterproof rain gear is essential (including a hat such as the Sou'wester). Light hiking boots will suffice for most treks in this region.

*People:* The parks are uninhabited except for the rangers at the headquarters, and staff of small inns that provide lodgings.

*Food:* All food should be purchased in Puerto Natales, Punta Arenas, or Calafate. The Posada (inn) at Paine Park Headquarters was well stocked in 1986. No food is available beyond this point. If you do your own cooking, plenty of firewood available.

*Water:* Water should always be boiled or purified with water purification pills or iodine crystals.

*Further Reading:* See Bibliography, Chapter Eleven.

*Sunset in Amboseli Game Reserve, a large plain from which Kilimanjaro rises dramatically to reach the highest point in Africa.*

# TANZANIA
# *The Kilimanjaro Trek*

*As wide as all the world, great, high, and*

*unbelievably white in the sun, was the square top of Kilimanjaro.*

*—Ernest Hemingway*

KILIMANJARO, the roof of Africa! This magnificent peak, covered by permanent ice and rising out of the dusty Maasai gamelands two hundred miles south of the equator, is one of the world's largest dormant volcanos. At the five-thousand-foot level, the base of Kilimanjaro is more than forty miles wide from east to west, while at 18,500 feet the peak still thrusts over two and a half square miles of surface into the thin Tanzanian air. Its "square top," the cone called Kibo, is crowned with no fewer than fifteen glaciers flowing off three large ice fields.

Kilimanjaro actually consists of three connected volcanic centers: Kibo, the central peak (19,340 feet); Mawenzi (16,893 feet), rising eight miles east of Kibo across a flat, desert-like saddle; and, to the west, Shira (13,140 feet), a moorland plateau that has evolved from the collapsed remains of a caldera.

When I first visited East Africa in 1969 I was eager to climb Kilimanjaro, as well as Kenya's highest point, Mount Kenya (17,058 feet). These two mountains, the two highest in Africa, exert such a magnetic attraction on mountaineers and trekkers (nontechnical walking routes are found on both peaks) that thousands attempt them each year. Although I was successful in climbing one of the two central peaks of Mount Kenya, time ran out for a visit to Kilimanjaro.

Fifteen years passed before I again had the chance to climb Kilimanjaro. In late September of 1984 I joined a Mountain Travel trekking party to traverse the mountain from west to east along the Machame Route, considered to be the finest track along the flanks of the peak. We needed six days to traverse Kilimanjaro, a distance of about forty-five miles, and climb Kibo. The elevation gain was roughly fifteen thousand feet.

Entering Tanzania (formerly Tanganyika and Zanzibar) from Kenya, we crossed the border at Namanga on foot, switched vehicles (tour companies are not allowed to take their vehicles into Tanzania as of this writing), and continued seventy miles to Arusha, a large township where we stopped briefly for lunch. Continuing east along the highway that links Arusha to Dar es Salaam, the capital, we reached Moshi, the closest big town to Kili-

manjaro. Moshi has a small hospital, and one can rent a car and buy food supplies; hotels, however, are primitive. Turning north we then drove to Marangu (5,000 feet), a village at the base of the mountain. In this village, the jumping-off point for the normal tourist route, the Marangu Hotel and the Kibo Hotel cater to Kilimanjaro adventurers; the latter was our choice.

Kilimanjaro lies within a national park officially opened in 1977 by Tanzania's president, Julius Nyerere. It was established to "preserve and protect Kilimanjaro and the surrounding nature and wildlife for future generations, and improve huts, tracks, and other facilities for visitors." The first Western visitors to Kilimanjaro did not enjoy such amenities. The first white men to venture into the then unknown interior of East Africa were Protestant missionaries who overcame danger, disease, and hostile tribes in search of evangelical work. In 1847 the London-based Church Missionary Society sent John Rebmann to visit a remote tribe at a place called Kasigau. He also intended to visit Jagga, where, he was told by a local caravan leader, "the high mountain Kilima N'jaro was visible." Permis-

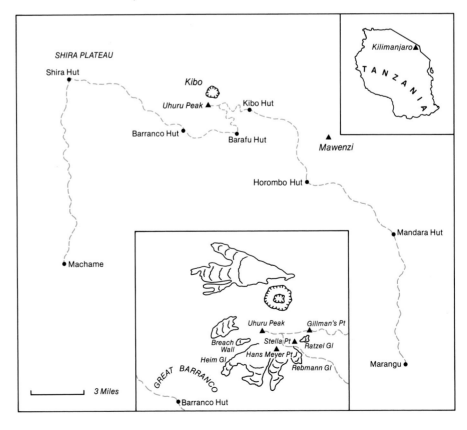

*Freddy, a guide, is a member of the Chagga tribe, which inhabits the southern slopes of Kilimanjaro.*

sion to travel to Jagga was withheld, but Rebmann persisted and returned to the interior the following year. On May 11, 1848, from the plains to the east of Jagga he saw "something remarkably white on the top of a high mountain."

Fourteen years elapsed before Europeans made any attempts to set foot on Kilimanjaro, and another five went by before anyone reached the "something remarkably white," which turned out to be snow covering the saddle between Kibo and Mawenzi. Additional expeditions visited the region during the 1880s. Of interest during this exploratory period were the relations between the missionaries and local inhabitants. Apparently all was not harmonious. According to John Reader, whose eminently readable book *Kilimanjaro* was published in 1982, Charles New, the young missionary who in 1867 was the first to reach the snowy saddle, had a hard time dealing with the natives and in fact was "sorely harassed by Mandara, the chief of the Moshi district. Rapacious, unpredictable, usually hindering, but occasionally helpful, Mandara required more presents than New had intended

to offer before allowing the young man to attempt and ascend the mountain." After his initial success on reaching the saddle, New returned in 1875, but on this occasion, according to Reader, Mandara "took virtually everything the missionary possessed and allowed him nothing in return. Dispirited, New had no alternative but to turn back. He was ill and poorly equipped when he left Mandara's village, and died before he could reach Mombas

The mountain was finally conquered in 1889 by Professor Hans Meyer, a Leipzig geographer, and his guide, Ludwig Purtscheller. After reaching Kibo's mile-wide summit crater on October 3, Meyer returned three days later to climb the highest point on the rim. This he named Kaiser Wilhelm Spitze in honor of the German emperor, for it was the highest point not only in Africa but in the German empire as well. (Germany, at the instigation of its "Iron Chancellor," Otto von Bismarck, had annexed a large area of East Africa, including Kilimanjaro, in the late nineteenth century.) Meyer described the mountain (again quoting from Reader) as "a spectacle of imposing majesty, and unapproachable grandeur." Indeed, only those who have reached Kibo's rim and traveled to the ultimate height of Uhuru (the Swahili name for the rim's highest point) can truly appreciate the magnificence that is Kilimanjaro.

The Kilimanjaro trek described below, a route I have traveled twice, is in my opinion Africa's finest mountain walk. The variety of plants and life zones and the all-encompassing views and changes of scenery combine to form a memorable and exhilarating trek.

The trek covers portions of several routes. The trekker begins on the Machame Route (a trail recently developed by the park) in the village of Machame (about 5,000 feet). The trail rises in a northwesterly direction—angling slightly away from Kibo—toward the Shira Plateau. This plateau is reached on the second day, and after traversing the upper section of the plateau one reaches the Shira Hut, situated on a ridge. From this hut the trek now heads directly toward Kibo, shortly reaching another junction. To the left is the Northern Circuit Route; to the right is the start of the Southern Circuit Trail.

*Dense, dark, and primeval forest of giant fig trees near the start of the trek.*

One then proceeds as follows: Continue on this route until intersecting the Mweka Track. Here turn north, ascending the Mweka directly up to Barafu Hut. Then follow the valley lying between the Rebmann and Ratzel glaciers to the crater rim, arriving between Stella and Hans Meyer points. From here traverse Uhuru, then head back past Stella Point to Gillman Point. After descending the steep scree slopes of the tourist route to the Kibo Hut, descend to Marangu Gate via Horombo and the Mandara Hut.

The route that we took, combining the best features of several different trails, is truly magnificent: The montane forest above Machame is one of the finest rain forests on Kilimanjaro; the Southern Circuit Trail winds under the great glaciers and the Breach Wall; and the climb up to Kibo is nontechnical, straightforward, and free of ice. Finally, one

need not carry a heavy pack over the summit, which any other traverse requires. Porters can carry all the equipment up to the Barafu Hut, spend the night there, take down camp, and carry tents and duffels directly to Horombo Hut, where they await you with your gear the evening after the climb.

The Kibo Hotel in Marangu, a rambling, slightly run-down turn-of-the-century structure resembling some old German hotel you would find in the Black Forest, was once the fashionable address for the German elite who came up to the cool Kilimanjaro foothills to escape the oppressive heat and humidity of Dar es Salaam. It is said that the hotel is bewitched, that at night one can hear German generals click their heels in the attic. One of our trekkers swears he heard the generals stride around for a good part of the night.

As our vehicles pulled up at the hotel's

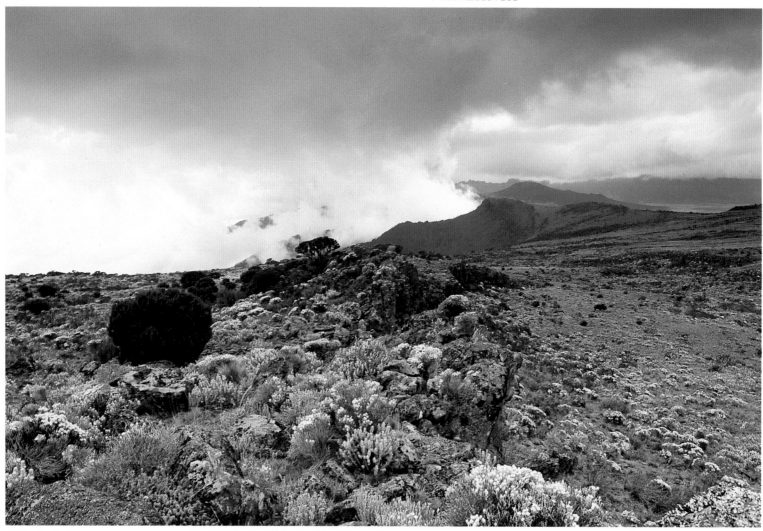

*On the edge of the Shira Plateau, the rim of the caldera can clearly be seen. This is also the beginning of the Alpine zone of vegetation.*

entrance we were immediately surrounded by a large number of Chagga tribespeople, all black as chimneys, who cheerfully helped us unload our packs. These men would be our porters on the expedition and had assembled here after having been recruited by the hotel. Once checked in, we were introduced to Winifred, our Chagga guide, and his assistant guides and cook. Winifred would make all the arrangements with the park authorities, oversee the smooth running of our trip, and look after the porters. A serious and powerfully built man in his late thirties, he exuded the confidence and nonchalance that more than four hundred ascents had instilled.

Later, over dinner in the rustic dining room, talk turned to the days ahead. Most guests shared a common bond: they were either about to climb Kilimanjaro or had just returned from it. Those who had returned successfully were festive and loud. Those who were ready to start were subdued, apprehensive—perhaps a bit scared. After all, climbing a 19,300-foot mountain is not something one does every day, and who can know for sure if he or she will reach the top? What all prospective climbers share is the knowledge that a rather extraordinary physical effort will be required. In this respect our group felt quite secure, as we had come to climb a mountain for which we had prepared ourselves well. In addition, our ascent would be tempered by the longer approach—the normal route takes one day less—enabling us to better acclimatize to the higher altitude.

After dinner we lingered in the glass-enclosed lounge, looking at old wall maps, mountain memorabilia, and photographs of early expeditions. One picture especially fascinated me: a faded black-and-white photograph of a distinguished-looking older gentleman. On closer examination it turned out to be Herr Professor Meyer, who made the first ascent of the highest pinnacle in Africa.

All parties wishing to climb the mountain must check in with the park service at the Marangu Gate. From the Kibo Hotel this is a good five miles up the road, so early the next morning we drove up to the station, accompanied by a truckload of joyous porters. After

the necessary formalities were completed and the registration fees paid, we were cleared for the Machame Route and ready to go.

Instead of starting the long trek at the Marangu Gate we returned to the highway at Moshi and drove ten miles west toward Arusha (the way we had come) to a junction where a dirt road led to the village of Machame. During the first part of this drive rolling grasslands alternated with corn and potato fields; here and there freshly turned plots of red soil were revealed. Above the fields the dark outline of the thick forest belt that surrounds Kilimanjaro became visible, but of the mountain itself there was no trace—thick gray clouds covered everything above the ten-thousand-foot level. We soon arrived at Machame, a Chagga village of ramshackle wooden houses and corrugated sheds. After a brief stop in the town square to allow our porters to buy cigarettes and food we proceeded along a four-wheel-drive track, passing small Chagga farms left and right. In dense fog we chugged up the forest track for another four miles to a small clearing at 6,300 feet. Here our great adventure was about to begin.

Dense, dark, primeval tropical forest. Giant sword ferns. Vines of all sizes and thicknesses hang from huge fig trees whose canopies reach as much as a hundred feet into the air. The humidity is high. The trail is barely visible, overgrown with long sharp grasses. Begonias cascade off tree trunks in clusters; impatiens (among them tiny *Impatiens kilimanjari*, indigenous to the mountain) grow profusely under shrubs and ferns. A climax of vegetation; a biomass of incredible proportions. This southwestern side of the mountain receives the most water, the most rain, and the most moisture. The water comes from the melting snows, the rains from the westerly storms, and the moisture from the dense mists created by the intense solar radiation at high altitude.

After several hours of enchanted wading through this lush tropical greenery, climbing over fallen logs and moss-covered trees, we begin to zigzag up an ever narrowing forested ridge. The change in vegetation is imperceptible at first, then gradually becomes obvious. The impatiens have given way to dry grasses,

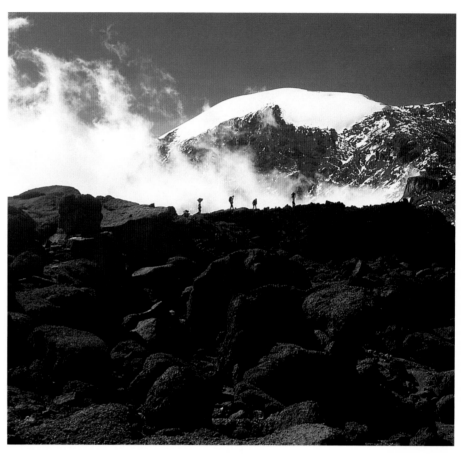

the figs are gone, and now giant-heather forests are replacing the deciduous plants of the tropical forest. Then, suddenly, a small clearing appears, an open ridge with a view toward the Maasai Plains five thousand feet below. Fifty yards beyond stand two round metal prefab huts called Uniports. It is the Machame campsite (10,000 feet), our first stop. Slightly less than six hours has elapsed since we left the road. Here, amid swirls of long mosses, profuse ferns, and tall grasses, we set up our tents. The huts are without floor or furniture and are occupied by the porters, the cook, and the guides. These huts soon turn into smoke-filled dens none of us would dream of entering.

By late morning our group reaches a rock wall that bars further progress. We detour to the left and, after crossing a steep ravine that contains a wondrously delicate waterfall, emerge onto the upper edge of the immense Shira Plateau and a new region of vegetation: the Alpine Zone. We stop for lunch here, enjoying tremendous views south and west out to Meru, a finely shaped fifteen-thousand-foot

*Traversing below the great ramparts of Kibo along the Machame route. The central peak is 19,340 feet.*

*(Overleaf) In Amboseli Game Reserve. The Machame route traverses the mountain on the far side.*

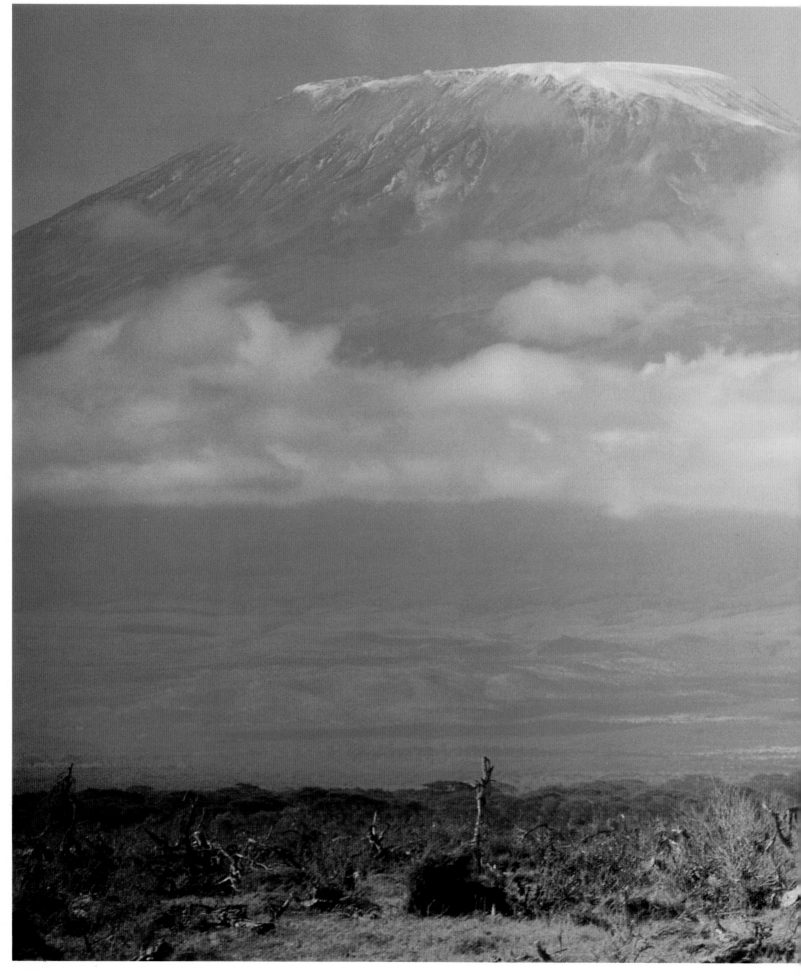

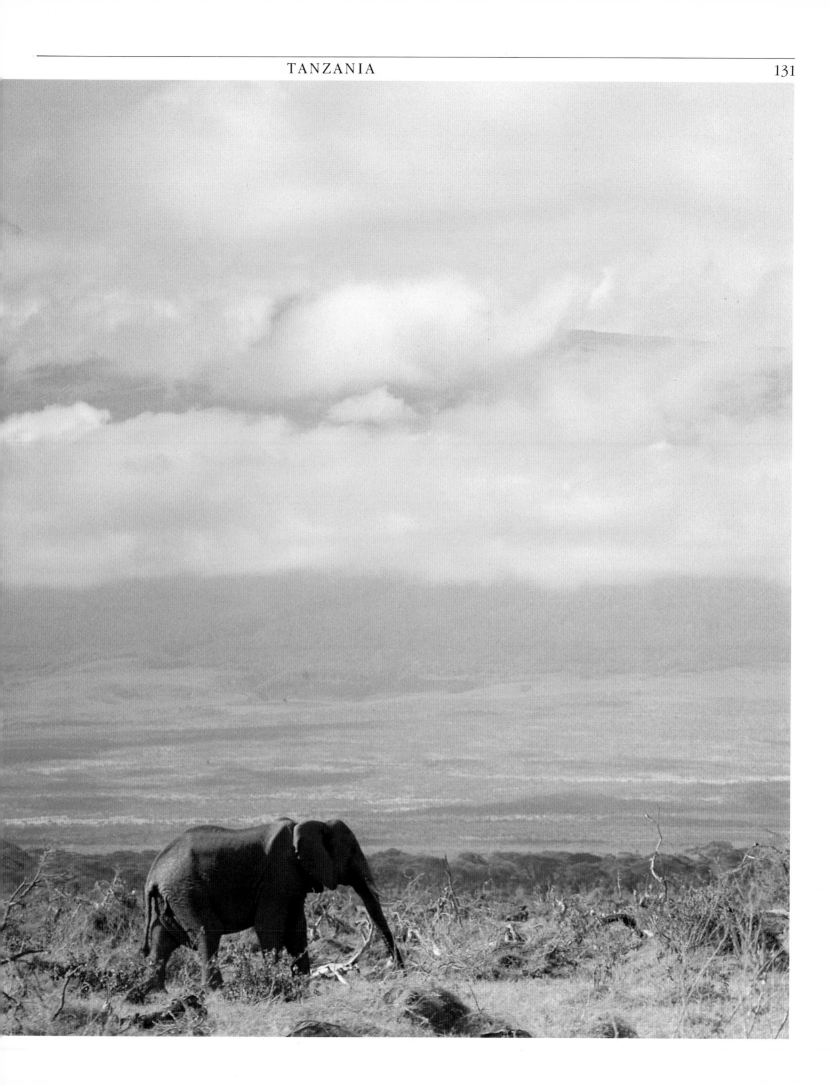

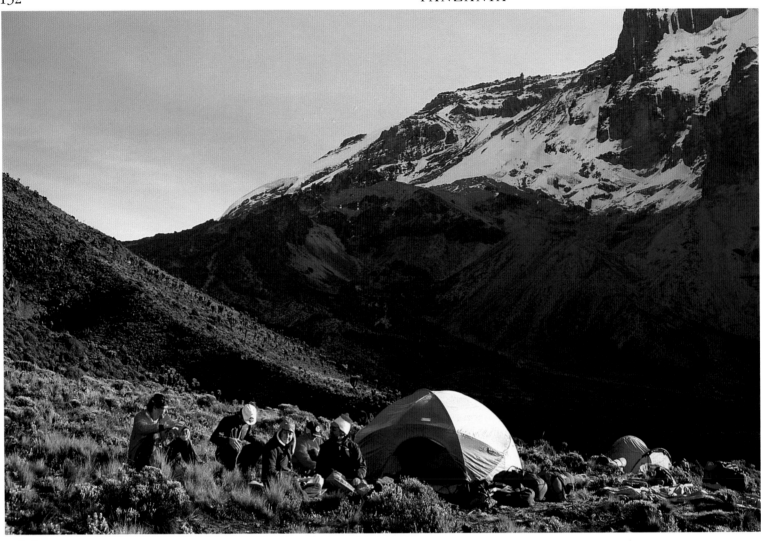

*Campsite in the Barranco Valley. Ahead is the famous Breach Wall of Kilimanjaro, with its famous 250-foot icicle.*

volcano forty miles away. The plateau itself lies slightly below us to the north. Once a mountain estimated to be 16,500 feet high, Shira collapsed to form a caldera two miles in diameter. After considerable erosion only the southern and the higher western rims remain.

After a short traverse we sight a narrow rib of rock on which stand the two Uniports of Shira Hut (12,600 feet). Our elapsed time: slightly more than five hours. According to Winifred the Machame Trail was first established by one Professor Balletto, who needed six months to trace its outline. Winifred started climbing on Kili as a porter in 1964 but did not travel the Machame Route until 1971, when he helped build the trail. All the porters belong to the Chagga tribe, says Winifred; no one but the Chagga are allowed to work on the mountain. We also learn that "Kibo," the name for the summit cone of Kilimanjaro, simply but tellingly means "white" in Chagga.

I am awakened by noisy mountain chats, tiny gray birds that flutter around camp looking for morsels of food. The sun has risen be-

hind Kibo, illuminating the Shira crater to the west, but our hut and tents remain in the cold shadow of the mountain for another hour. Ice clogs my water bottle. Below, a sea of clouds extends to the horizon. My tent companion is a bit groggy from the altitude and the cold, and so are the tiny chats—puffed-up little balls of furry gray feathers. All thirty-four of our porters have been gossiping since dawn, packed into the tiny metal huts head to toe like sardines. We're off early to fight against the cold. We are now embarking on the Southern Circuit Trail, which starts from Shira Hut and traverses the southern side of the mountain toward Horombo. Facing Kibo, we climb up barren fields of lava for most of the morning, now and then surmounting a ridge, hoping it will be the last one, only to spot another ridge farther up. The only vegetation remaining is a strange ocher-and-red spongy moss growing on boulders. Our trail is marked by cairns placed at regular intervals. By eleven o'clock thick fog swirls into the upper corries of Kibo, and soon the mountain disappears.

The campsite is empty, for which I am grateful, for just enough level sites exist for our four tents. During August—high season for Kilimanjaro—as many as eighteen hundred people attempt the mountain; most ascend the tourist route. The Machame Route, with its fragile ecology and delicate campsites, would be hard-pressed to accommodate more than the handful of adventure seekers who now use it.

The morning at Machame is brilliantly clear. The mountain is fully visible; Uhuru rises straight over our heads. We are up at six-thirty. Slight frost blankets the ground, an ominous sign of things to come. After a solid breakfast we're off at eight-thirty. Climbing the steep trail behind the hut, I see the four-thousand-foot Breach Wall, the most significant feature of Kilimanjaro. This rampart of steep ice and crumbling rock, nearly a mile and a half wide, is perhaps the most imposing wall in Africa. Tumbling down from the face are several fingers of ice, great hanging glaciers flowing from the summit ice field. Visible are the Heim Glacier, longest and most beautiful

ribbon of ice on Kilimanjaro; the round Diamond Glacier; and the enormous icicle that connects this ice mass to the Balletto Glacier underneath. The two-hundred-fifty-foot vertical icicle was first climbed in 1978 by the world's premier mountaineer, Reinhold Messner, who considered the route more difficult than the notorious north face of the Eiger in Switzerland.

The heather thins, and after clambering over a few easy rocky steps here and there we approach what is known as the Moorland Zone. Huge lobelias appear, their delicate blue flowers hidden behind rosettes of tightly clustered leaves. We traverse small gorges of volcanic rock, some containing pools of clear water. We fill the water bottles, not forgetting to purify with iodine, as we have spotted eland droppings nearby. Long stringy moss is present everywhere: on the heather, on dead trees once scorched by fire, and on the grotesquely eroded volcanic-rock walls and isolated boulders lying about in wild disarray. Farther on we come upon the first of the giant groundsels that thrive here in sheltered nooks

*The Great Barranco, a jaggedly carved valley two thousand feet deep. The trail descends into the gorge visible behind the hut, then climbs the wall in the background.*

at the upper limit of the Moorland Zone. These isolated, treelike plants are a startling sight indeed.

We reach yet another ridge; this one proves to be the highest point of the day: fifteen thousand feet. Although the summit can be reached from here, we are committed to the Southern Circuit Trail and continue toward Barranco Hut, a mile and a half farther and twelve hundred feet lower. As we descend the mountain suddenly clears. The entire Breach Wall unfolds above our heads; it's truly a superb view of the imposing southwest face of Kilimanjaro. Lower down we encounter the familiar giant groundsels again, in abundant forested stands. On one such tree I count more than thirty separate flowering rosettes. We descend to Barranco Hut along a gently sloped ridge to the 13,800-foot level; then the path cuts sharply to the left and drops steeply into one of the finest natural features of the entire mountain: the Great Barranco.

From a distance the Great Barranco looks like a huge gouge from the top of Kibo down the southern face of the peak. Geologists are not sure what caused this breach but speculate that some geological upheaval once caused an enormous landslide or slippage, leaving a jaggedly carved valley about a thousand feet deep. The walls of the gorge are festooned with waterfalls; its floor is a maze of small streams descending from the glaciers of the Breach Wall. Dense stands of giant groundsels adorn the chasm, making it one of the most picturesque high valleys of Kilimanjaro. It is scenery straight out of Sir Arthur Conan Doyle's *The Lost World*, unlike anything I have ever seen. We descend to a wooded overlook on the west rim, where the park service has established Barranco Hut, in actuality two unfurnished Uniports. Of the nine huts built by the park, Barranco surely occupies the finest site. We set up our tents on a bit of level ground, while the porters immediately make for the dubious comforts of the metal huts. The third day's walk has taken six hours.

I am awakened at dawn by a loud explosion. Quickly looking out of the tent, I see a large avalanche tumbling off the south face below the Heim Glacier. The sky is again clear— a seemingly standard feature of Kilimanjaro;

clear mornings are followed by foggy afternoons caused by the buildup of clouds from below. Having dried out the tents for an hour (the condensation is extreme) we set off, descending to the floor of the Barranco. Crossing several streams near some large caves, I slip momentarily on a thin ice glaze covering some boulders. The trail soon disappears into a solid-looking wall of volcanic rock perhaps six hundred feet high. But a distinct trail lies hidden between and behind the jumbled mass of lava and honeycombed rock formations. Here and there we must scramble (without much exposure), but the top is soon reached. We gaze back into the Barranco, with an unsurpassed view of a triple waterfall plunging hundreds of feet into the jungles of the lower canyon. We are now on a shelflike formation, bare of any vegetation, as high and as close under the great hanging walls of ice as one can possibly get by trail. The Heim Glacier glistens in the brilliant morning sun, a crooked finger of ice two hundred feet thick cascading from five thousand feet above, the sides of the glacier tumbling over dark red rock in twisted contortions. Off we move, descending again toward a ravine with overhanging lava walls dripping water and long streamers of moss—a vertical bog. At the bottom we stop for a hot lunch.

We must now decide what equipment, clothing, and food stays with us for the summit day, because a number of porters are descending this afternoon toward Horombo. These men are not needed at Barafu Hut, where we will spend the night. There is hasty repacking of duffles as unwanted items are sent down. Soon we are off again. Fog keeps its appointed hour and we are soon engulfed with cold tendrils of upward-drifting clouds. Temperatures on Kilimanjaro are so extreme that an axiom has evolved: "It is summer on Kili every day, and winter every night." Although cold can be the most serious problem encountered in climbing this huge mountain, the deep chill needs to be endured but for several hours in the early morning of the actual summit climb. We still have one more day before we encounter the big chill.

Around two o'clock we reach a long rocky ridge standing out of the fog and rising

steeply and ominously toward Kibo, invisible somewhere above. This is the junction of the Mweka Route with the Southern Circuit Trail, and the ridge forms the next section of our route. We have finished our trek around the mountain; now it is straight up toward our campsite for the night, and the summit tomorrow.

We move upward slowly, for all are feeling the altitude more strongly. The ridge is a rising expanse of volcanic rock littered by large boulders. This is the Alpine Zone of Kilimanjaro, better described by Iain Allen in his *Guide to Kenya and Kilimanjaro* as the Alpine Desert. At 14,500 feet the volcanic scree is perfectly barren except for a few tiny flowers. Higher we go, until our ridge converges with a larger, steeper ridge of solid rock. We no longer walk together, and progress becomes a ten-minute stumble alternating with a two-minute standing rest. The smarter ones sit down, or sprawl over their daypacks. Finally, reaching a rocky corner, we are rewarded with a spectacular view of Mawenzi, its dark rock ridges sharply contrasting with the long snow gullies separating them.

Toward four in the afternoon the roof of Barafu Hut finally peeks above an outcrop of red boulders. We're there! It has taken us six and a half hours from Barranco Hut; the altitude is just over fifteen thousand feet. There is no water at Barafu, no wood. But our porters have brought up loads of firewood, and soon the hut is filled with thick smoke. As the sun slowly sets we catch the last rays before donning down jackets and returning to our tents and sleeping bags.

Winifred wakes me at 1 A.M. with a mug of hot tea and a cheerful "Time to go, Papa Chief." Outside, the full moon, which I had hoped would aid us during the first hours of the ascent, has just slipped behind Kibo. A bit of reflected light remains, but this will be of little help. Even though the stars are out, it is quite dark by the time we are ready to leave. The night is cold but calm. Since we had agreed to pack before going to bed, all I have to do is dress, stuff my sleeping bag, zip my duffle, wait for the cook to bring hot water, drink hot cocoa, and down a bowl of instant oatmeal. The tents will be taken down by our

*Climbing out of the Great Barranco requires scrambling along a jumbled mass of lava and honeycombed rock formation. The Breach Wall is visible.*

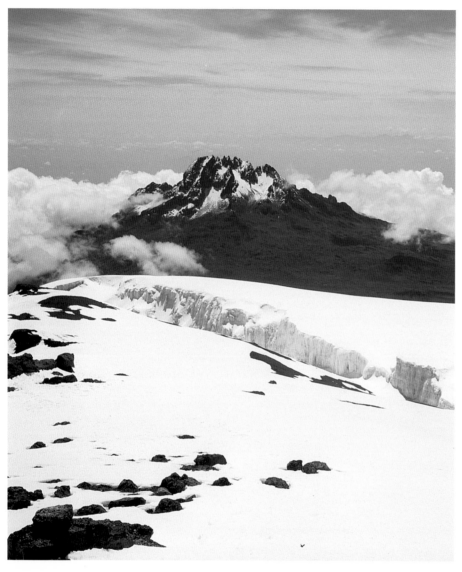

*Mawenzi rises 16,893 feet eight miles to the east of Kibo, as seen from near the summit of Kilimanjaro.*

era, a supply of snack food, and some spare clothing. I wear my down jacket, expedition down mitts, Goretex windpants over soft cotton/nylon warm-up pants, and a pair of light hiking boots with full-length gaiters. A short ice axe comes in handy for balance but is otherwise unnecessary.

I decide to call a stop every hour for a short rest. Around three o'clock the cold becomes intolerable, forcing me to wiggle my toes continuously to keep them from losing all feeling. We are now topped out above the steep slope, and the going becomes easier. Nevertheless the pace slows, and soon people are calling for more frequent stops whenever the need for additional oxygen is felt. Far below, in the ink-black darkness, glint the lights of a small town. "Moshi," says Freddy, our assistant guide. He is carrying a good-size pack without a hint of fatigue. "Soon the sun will be up," I say. "Then we can take a rest and sleep a bit in the sun." This seems to infuse much-needed resolve in our little band. Soon a thin line of light appears in the east, just to the left of Mawenzi. Minutes later we are treated to a pale but magnificent sunrise; the headlamps are turned off. It's a great feeling to finally see everything in front of us.

We have our promised nap in the sunshine. On we struggle: ten paces, three breaths; twenty paces, six breaths; whichever suits the individual better. Whatever the technique, I find I can proceed upward only after having absorbed a sufficient amount of oxygen. After a certain distance is covered the muscles are depleted, the lungs scream for air, and stop one must, until once again fresh oxygen brings another tiny amount of energy for one more set of paces.

We are now reaching the eighteen-thousand-foot mark, higher than most of our trekkers have ever been. Some people are slowly beginning to pull away from the group; others fall farther behind and make frequent stops, gasping for air. The lower wings of the Rebmann and Ratzel glaciers are starting to encompass us as our route passes between these two tongues of ice. Soon I am level with the lower reaches of the Rebmann, and I know I have only five hundred feet to go. After one last stop for water and snacks I set off

porters and carried, together with all other expedition gear, to Horombo, where we will meet after descending from the summit.

The climb begins in a slow crawl, with everyone trying to concentrate on placing one stumbling foot in front of the other, paying attention only to the boots of the person ahead by the light of the headlamps. The first thousand feet above Barafu is a difficult incline covered with large boulders, loose-scree gullies, and short rocky walls demanding a bit of scrambling. Mercifully, due to the darkness, we can only guess at the obstacles; our concentration centers on those few lighted square feet in front of us. Winifred goes first, guiding the way, looking for the cairns visible every twenty feet or so. Most of us carry only a daypack containing a full bottle of water, a cam-

for the final stretch. Then I spot tiny figures above, walking along the rim; soon we all begin to top out. Within half an hour everyone is gathered on the small saddle between Stella and Hans Meyer points. Below us lies the wide expanse of the great crater of Kilimanjaro. Looking up to the left, we spot Uhuru, the summit of Africa. The scene is of such compelling grandeur that the available air is promptly sucked out of me. To the right we can see the terraces of the Eastern Ice Field, its gigantic steps cut into fluted towers and pinnacles of blue-white ice. Gasping for air, I collapse on the rim, my eyes riveting on a scene of utter magnificence. High above the mountain stark white clouds race in billowing formation across the deep-blue, almost blackened sky.

I look at my watch: 8 A.M. As the group gets under way for the final stretch to Uhuru—an hour away across the rim of the caldera—I feel my pulse beating at an alarming rate. I decide to remain near Stella Point and wait for matters to improve, but after half an hour there is no letup of the pounding. I decide to go down. Meanwhile the others, having left their packs behind, continue to Uhuru. Winifred stays with me, as does another Chagga guide, who is posted to stay with the packs. I am terribly disappointed at not being able to continue to the summit but console myself with the thought that I can always come back and try again.

For six months afterward I could think of nothing but Kilimanjaro, and when a business meeting in Kenya planned for March 1985 came through I suddenly saw an opportunity to try Kili once again, this time with several friends and business partners. The trek unfolded exactly as the earlier one had, and at 8:30 A.M. on March 3 I again stood on the rim of Kibo's caldera. This time I felt stronger and fitter, and I eagerly looked forward to those last steps along the rim to that magical point, the summit of the continent. Although our route itself was identical with that of the previous expedition, one major difference stood out: there was much more snow on Kilimanjaro—more snow than at any time in the past five years, I was told. Indeed, when I had earlier looked at Kilimanjaro from the Maasai lands of Amboseli, the mountain was covered in a huge white blanket extending to well below the fifteen-thousand-foot level. The rains, which normally come in April, had started six weeks early, wiping out the two years' drought in Kenya, and at this altitude had decked the mountain with an early mantle of snow. On reaching the rim I found the entire caldera, the glacier terraces, and the summit peak under a two-foot layer of hard-packed snow. It felt like a special gift, a magical occurrence. As we slowly walked toward the top I was overcome by emotion and could not speak. Then a plaque, a few stakes, and some flags fluttering in the wind indicated the summit. We shook hands, hugged, and took pictures.

Our descent was quite fast. We were back at Stella Point in twenty minutes, and at Gillman Point a short time later. I took great care coming down several icy steps where a slip would have meant a hundred-fifty-foot fall into the crater—I was glad to have my ice axe along. We traversed around Gillman without looking or stopping and immediately climbed down the narrow scree chute that drops in a straight line three thousand feet to the base of Kibo's cone. Later a wide, sandy trail led eastward to a large rock outcrop, behind which we found Kibo Hut. We had reached the summit at ten o'clock and were at Kibo Hut at noon. From 15,000 feet to 19,340 feet and back to 15,400 feet in less than twelve hours! Kibo Hut is unlike those found on the Machame side. Solidly built of stone and wood, it accommodates mainly those who come up the tourist route.

We found Kibo Hut conveniently empty and soon were occupying the comfortable bunks (with thick foam mattresses) for a two-hour nap. Freddy, my guide on the second trek, managed to find some fresh water, normally unavailable at this hut. By two o'clock we were off again, descending into the lunar desertscape of the great saddle between Kibo and Mawenzi. Nothing much grows there save for a few hardy plants and grasses. It is the bleakest and most desolate terrain on the entire route. The earth is gray, dusty, and lifeless. Apparently covered by huge converging glaciers in a previous ice age, the saddle was scoured clean of numerous small volcanic

*Uhuru ("freedom" in Swahili) Peak, Africa's highest pinnacle. Plaques, a stake, and flags mark the spot.*

from the barren heights where no man can long survive.

After picking my way across a swamp a track appeared, which I followed around a ridge to Horombo Hut (12,200 feet), a large Norwegian-built A-frame surrounded by a number of smaller ones. Freddy was there to greet us and showed us to our previously reserved hut. After a well-earned bottle of *pombe baridi* (Swahili for "cold beer"), we turned in at 5 P.M.

From Horombo the next morning we had a last view of Kilimanjaro, now seemingly far away, a small white bump peeking across a grassy ridge descending from Mawenzi. We were off by 8 A.M. The scenery between Horombo and the upper forest belt is especially attractive and parklike, with wide-open vistas of the grasslands below. Underfoot the cover is green and wildflowers abound. Aloe, violets, and other flowering plants grow along the trail. Then, suddenly, one enters the giant-heather woodland, tall groves of gnarled woods; branches are draped with long streamers of what looks like Spanish moss.

For the traveler who comes up the tourist route Horombo is the second night's stop. For those descending from Horombo the distance to the Marangu Gate is usually covered in a single day, with lunch taken at Mandara Hut (8,900 feet), a walk of about three hours. Situated on top of the forest belt, Mandara Hut enjoys a lovely setting amid dense foliage and tall leafy trees. The descent from Horombo to Marangu Gate is one of my favorite walks, though excessive use has left the trail in a horrible state of erosion, a fact to which the park authorities seem to pay little attention.

Freddy served our last lunch on the deck of the lovely central chalet at Mandara, and after a short but well-deserved nap on the lawn we headed down into the tropical rain forest for the three-hour walk to the road. There is a sign-out procedure at park headquarters, after which certificates are handed out to those who have reached Gillman or Uhuru points. Our vehicles met us at the gate, and half an hour later we were back at the Kibo Hotel in Marangu enjoying the trappings of a civilized world: a hot shower, clean clothes, and a fine meal.

cones and other features. I enjoyed the walk, though, as cold and eerie mists from the plains below were spilling over the saddle, giving it a Wagnerian character. Then, not far below the saddle, the land began to live again. Soon we were back in the moorland, where giant groundsels with their now familiar candelabra shapes greeted those who had come

# THE KILIMANJARO TREK

## Expedition Planner

*Access:* Kilimanjaro International Airport is conveniently located near Arusha for those who wish to fly directly into Tanzania. Flights are only once or twice a week, however, so it is wise to plan your trip around the air schedules. Local bus service is available to Moshi and taxi service from Moshi to hotels and Marangu Gate. There is also an International Airport at Dar Es Salaam, with daily train service to Moshi.

*Visas:* A Tanzanian visa should be obtained before departure through a visa service agency or by applying directly at the Tanzania Embassy in Washington, D.C. If Tanzania is reached by road via Kenya, a Kenyan visa is also required.

*Vaccinations:* A cholera inoculation may be required when traveling to Kenya and Tanzania. Have your inoculations recorded on an International Health Certificate ("yellow card") and plan to carry it with you while traveling. The following inoculations are recommended: typhoid, tetanus, gamma globulin, polio, yellow fever (only if coming from infected areas such as West Africa and South America). Malaria suppressant pills are essential. Chloroquine should be taken according to instructions. A more recent drug called Fansidar has proved very controversial and the latest recommendation from health officials is not to use it for prevention—because of its many adverse side effects—but only for actual treatment of malaria once the disease has been contracted.

*Source Of Official Information:* Tanzania Tourist Corporation, New York City.

*Nearest Airport:* Kilimanjaro International Airport, approximately 18 miles outside Arusha, for flights from Amsterdam, Brussels, Nairobi, and Addis Ababa.

*Logistics:* Trips to Kilimanjaro can be booked through adventure travel agencies such as Mountain Travel in the U.S. (on a group basis with experienced leaders as guides or on a private, per person basis) or directly via the local hotels. Treks can also be arranged on your own after arrival (allow at least one extra day to get things organized). Guides (native Chaggas), porters, equipment rental, and food can be arranged through the local hotels. Those wishing to backpack must still hire a guide from the Park Service and pay camp and usage fees before being allowed on the mountain.

*Travel Tips:*

*Best season:* Avoid rainy seasons of April–June and November.

*Trekking days:* 6 days.
*Distance:* About 45 miles.

*Difficulty:* Technically easy, no climbing. To hike to 19,000 feet is strenuous, especially the last six hours of the ascent. Snow on the rim is possible. Sturdy mountain boots and warm clothes are essential (bring a heavy down parka).

*Preparing for the climb:* The greatest obstacles to climbing Kilimanjaro (Kibo) by non-technical routes, i.e., the tourist Mweka and Arrow Routes, are the altitude and the cold. The physical effort required to reach 19,000 feet is considerable, and it follows that all prospective ascensionists should be fit and healthy. A conditioning program at home before the trip is essential if success is to be assured. In addition, the basic rule on the mountain is *acclimatize!* Do not attempt to climb Kibo in less than four days. And climb slowly. Lastly, be prepared for the cold, which can be fierce, especially if camping out along the trek route. Temperatures of −20°F are not uncommon at night and during the early morning hours near the top of Kibo.

*Cautionary Notes:* New 1986 Tanzania national park regulations require fees to be paid at the gate in U.S. dollars or travelers checks, as follows: $240 per person/one trekker; $230 per person/2–3 trekkers; $211 per person/4 or more people.

*People:* Local people as well as porters on Kili belong to the Chagga tribe. Some guides speak broken English and German. Once you leave Marangu, no other people, except for tourists, are to be met on the trail. Substantial tips are expected if the summit is reached.

*Food:* For independent travelers, all food should be purchased in the town of Moshi. The hotels in Marangu can sometimes provide food and a cook if arrangements are made ahead of time. No food is available at or beyond Marangu Gate, with the exception of beer and soft drinks at the lower huts.

*Water Purification:* Water collected on the mountain should always be boiled or purified with iodine pills or crystals. Never drink tap water in hotels.

# Photography Notes
## Guidelines on Adventure Travel Photography

Taking good pictures on a trek, sometimes at high altitude, often in cold or windy weather, is not always an easy task. Before embarking on an outdoor adventure, consider the basic choices regarding photographic equipment: weight and size; types of cameras and lenses; amount and type of film; tripod; accessories; and the proper case to carry them all safely and comfortably. Here are some basic guidelines.

*Camera Body:* 35mm SLR (single lens reflex) cameras are the tools of the trade for most serious amateurs, semi-pros, and well-known outdoor professionals. Most camera bodies of the 35mm SLR category are of about equal weight. Choose your SLR for its ruggedness, strength, functional design, and simplicity of operation. Avoid complex electronic "auto-everything" cameras, which can easily go haywire under adverse outdoor conditions (cold, moisture, dust and sand), and are impossible to adjust or repair.

Essential features on an SLR are a depth-of-field-preview button, a back-up mechanical shutter release, shutter speed to 1/2000 second, and a self-timer. Other features I look for are a center-weighted light meter for automatic exposure and a memory lock which allows you to compensate for under- or overexposures, a multiple exposure lever, and an eyepiece shutter to eliminate stray light from entering the eyepiece when using a tripod. A mirror lock-up lever is also useful. Mechanical breakdown in the field can occur (from such conditions as long vehicle rides over dirt roads, moisture-laden tents, etc.), so it is wise, perhaps even mandatory on some trips, to take along a back-up camera. For this I recommend a manual camera with mechanical shutter (such as the Nikon FM). This should be of the same make as your principal camera so that your lenses will be interchangeable between the camera bodies.

*Lenses:* Lenses must be chosen with regard to bulk and weight and also for the specific trek or adventure that is being planned and the type of photographs you want to obtain. Many trekkers prefer zoom lenses, as they allow wide focal ranges. However, there are negative aspects which must be considered. For instance, a 35—300mm zoom lens means a slower lens, i.e. a smaller aperture, loss of overall sharpness, and less accurate color balance. In other words, the smaller the zoom range, the better the lens. When selecting a zoom lens, try to stay within moderate ranges for optimum clarity and focus. The following approximate ranges give the maximum results:

Wide angle to normal: 25 to 50mm
Normal to telephoto: 50 to 105mm
Telephoto: 80 to 200mm

Wide angle lenses are often overlooked by amateur photographers, but it is important to note that most dramatic photos of the outdoors are either taken with 20mm and 24mm lenses, or with telephotos which bring out strong moods. A standard 50mm lens is the least useful, since it sees the image as the eye does and may fail to give a dramatic impact to the picture.

For the serious beginner, I recommend taking the following lenses:

1. 24mm
2. 50mm
3. 75-to-150mm zoom

For the intermediate amateur:

1. 24mm
2. 50mm, or 35-to-75mm zoom
3. 75mm-to-150mm zoom

For the advanced amateur:

1. 20mm
2. 24mm
3. 28-to-50mm zoom, or 35-to-75mm
4. 80-to-200mm zoom
5. 300mm (for special situations)

I use the following lenses as my basic kit:

1. 20mm
2. 24mm
3. 28mm
4. 85mm (for portraits)
5. 35-to-75mm zoom
6. 80-to-200mm zoom

For a superlight combination, use lightweight lenses such as the Nikon Series E.

*Sunrise in Amboseli
Game Reserve.*

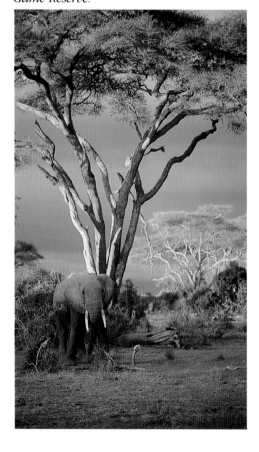

Longer focal lenses can be added as required for particular trips such as animal safaris in Africa where a 300mm (or longer) lens is indispensable. An easier, cheaper, and lighter way to enlarge your focal length is with a teleconverter, which doubles the lens's focal length.

**Accessories:**

*Tripods:* If you want to obtain good, sharp photos with plenty of depth of field, bring a sturdy tripod, preferably one with a quick-release attachment, weighing about four or five pounds (heavier if you like); avoid monopods or skinny lightweight tripods.

*Camera bag:* A sturdy, well-padded soft camera bag with both a shoulder strap and a hip belt is an essential item. It's the surest way to avoid camera breakdown, because the heavy padding will protect gear from airplane and vehicle vibrations. To minimize vibration damage even further, don't place your camera bag on the floor of cars, buses or airplanes.

*Batteries:* Take two sets of extra silver oxide batteries for each camera body. Loss of power can occur in very cold weather, and power switches are often left on for hours on end during busy periods of picture taking.

*Filters:* Color photography does not lend itself to the extensive use of filters, but I never go anywhere without a neutral density X2 filter for bright snow, a polarizing filter to cut glare, and a graduated filter to compensate for bright skies above dark foregrounds. A light tobacco-colored graduated filter is useful to accentuate flat sunsets.

*Flash photography:* If you plan to use a flash, take the smallest and lightest attachment you can find. Chances are you will take very few pictures after dark when on a trek but you might on a special occasion, such as a visit to someone's hut or tent. For these instances, you can compensate for not having a flash by doing the following: take along a couple of rolls of fast 20-exposure film, use a tripod, and set the camera and self-timer on automatic. This will probably give you as

good a result as a flash.

*Film:* I recommend Kodachrome 64 transparency film. It is an excellent well-balanced color film suitable for most outdoor situations. It is about 1.3 stops faster that Kodachrome 25. How many rolls of film to take? That depends on individual choice, of course, but a good guide is one 36-exposure roll per day of travel.

*Motor drive:* Because of the added weight of the motor drive as well as the many batteries needed, I do not recommend carrying a motor drive on a long trek.

*Miscellaneous Tips:* When to photograph: The best light of day for outdoor photography is in the early morning and in the late afternoon; try to look for good photographs then. Some of my best pictures were taken while my trekking companions were either asleep or eating breakfast or dinner—"magic hours" for the photographer. Avoid mid-day hours and their corresponding stark shadows (unfortunately, that is usually when most trekkers are active!).

*Ethnic portraits:* When taking pictures of local people, always be courteous and ask for permission first. Find out if they have any objections or if there are local taboos against photography. For instance, photographing the Sherpas of Nepal is no problem, but the Masai in East Africa will demand to be paid. Muslim women are not to be photographed under any circumstances, especially by men! Often people, especially older people, object to having their photos taken, but they are thrilled if you take shots of their children and grandchildren. Once you have broken the ice with the kids, it is easier to photograph the elders.

*Other suggestions:* Do not be afraid to "move in" on your subject. Look for interesting details that make your exotic location special. Do include your fellow trekkers in your pictures; seeing others like yourself "in action" will add to the interest and give dimension to the landscape as well. If possible, ask your companions to wear bright clothes, to add an

extra touch of color to what may otherwise be a colorless photograph. Good opportunities often come unannounced, so have your camera prefocused and preset; that way you are ready to react instantly, with a greater likelihood of a good result.

*General Maintenance:* Keep your gear clean, well-stowed and always check the settings before shooting. Light meters go out due to cold, lenses get fogged up during wet mornings or coated with dust in windy areas, and the camera setting often gets accidentally changed during stowing and rough handling in tight corners (my ASA setting has a habit of changing by itself at times!).

Although I still try other equipment from time to time, Nikon gear has been my first choice for the past twenty years, for three reasons: the lenses are nearly perfect, the equipment is extremely rugged, and field breakdown is rare. My camera of choice? The F–3.

# *Acknowledgments*

WORK on this book began in 1976 with a feasibility study for a book on one hundred treks. At that time I was thinking of describing mostly those trips pioneered at Mountain Travel.

My hundred-treks idea got nowhere because of the scope of the undertaking. Later Gordon Wiltsie helped me select and edit a smaller number of treks, but even fifty trips was more than we could handle. I decided to start over and do it alone, describing only those trips I had done that had given me the most joy and satisfaction.

During the long, drawn-out process of writing, I benefited greatly from the guidance, advice, and support of many friends and associates. I would first like to thank all those friends who helped me plan, organize, and guide the journeys described in these pages: Wu Ming, liaison officer on our Kangshung trek; Zhen Suchen, liaison officer on the Minya Konka trek; Sun Jian Zhang and Guo Jin Wei, enthusiastic travelers from Urumchi who guided us on the K2 trek; the Nepalese Sherpas Ang Phu (tragically killed on Everest while descending from his second ascent) and Pasang Kami, who joined us on the Kanjiroba and Around Annapurna treks, and Nima Dorje, our trek guide in 1967; "Bull" Kumar, my good Indian friend, who grappled with the logistics in Kashmir and Ladakh; and Nim, our phlegmatic Bhutanese guide on Chomolhari. In South America I fondly remember Maxi and Wilbur Aparicio, who looked after my son Bill and me in Cuzco and on the Inca Trail; dear Nestor Morales from Huaraz, one of the truly genuine mountain men I have met; José Alarcón, *huaso* of the Chilean Andes, who guided us at Torres del Paine; and Miguel Alfonso from Mendosa, with whom we visited Fitzroy. And I won't forget Winifred and Freddy, head guides on Kilimanjaro, who did an excellent job of getting us all to the top.

I must also credit those individuals and organizations that helped with field logistics: the Chinese Mountaineering Association of Beijing and its vice-chairman, Shi Zhanchun; Stan Armington of Himalayan Journeys in Kathmandu; Alfredo Ferreyros of Explorandes in Lima; Gautham Khanna of Mercury Travel in Delhi; Saradindu Malla of Malla Hotel in Kathmandu; Thad Peterson of Dorobo Safaris in Arusha; the Bhutanese Department of Tourism in Thimphu; Brigitte Buhofer, who helped with

my logistics in Patagonia; Iain Allen of Tropical Ice of Nairobi; and the staff of Turavion in Santiago.

Equally important to a successful adventure are one's companions. I fondly remember trekking with Murray Alcosser and Susan Fairclough, Sara Jacobson, Barry Bishop, Sandy Bryson, Ray Jewell, John Martinek, Nigel Dabby, Greg Thompson and Leila Kessler, Jean Hoerni, the always cheerful Clarence and Flo Richmond, Jack Turner and Rick Ridgeway from Minya Konka, Dick Irvin, Cesar Morales Arnao, Jim Gerstley, Jim Jenner, Barney Rosenthal, Jeff Nadler, and many others too numerous to list. To all, my heartfelt thanks.

For editorial assistance in writing this book I wish to thank especially Kitty Horn for her early encouragement and coaching, Ginny Schmitz, Pam Shandrick, Dr. Harka Gurung, and Allen Steck. Steve Roper offered much critical evaluation and reworked the manuscript. Michael Hoffman of Aperture was strongly supportive of the project and Donald Young was the skillful editor.

Special gratitude is due Hugh Swift for his excellent maps and to Ken Scott for assistance with the photo selection. I also owe a great deal of thanks to John Thune for his help with the Kangshung Trek chapter, and Dena Bartolome for help with research, bibliography, editing, and word processing. Thanks to Ruth Bandera of Lan Chile, Rick Laylin of Pan American, and Tom Hackett of Thai International for their generous support. And thanks to my partner, Dick McGowan, and his wife, Louise, for their companionship on the Annapurna Trek as well as their unswerving support for the project during the past eight years of our association.

Mike Banks and Warwick Deacock added valuable input, as did Smoke Blanchard and many others who have been closely associated with Mountain Travel.

Last, thanks to my children, Suzanne and William, for putting up with endless weeks on the trail following Dad around instead of enjoying normal vacations with their school friends, and to my wife, Nadia Billia, for her ultimate trust in the project, her encouragement, her long hours on the word processor, and, above all, her love.

Without the help of these many friends, *Where Mountains Live* would not now exist.

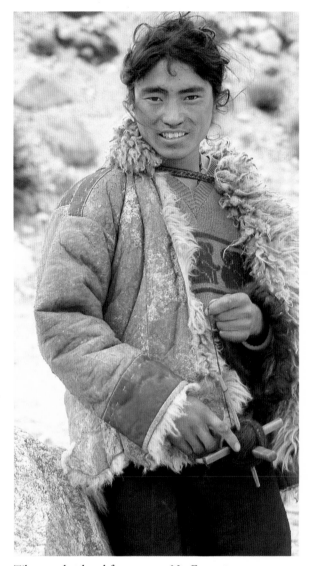

*Tibetan shepherd from near Mt. Everest.*

# Bibliography

## Chapter One

Hopkirk, Peter. *Foreign Devils on the Silk Road*. London: John Murray, 1980.

Shipton, Eric. *Blank on the Map*. London: Hodder & Stoughton, 1938. (Also included in the anthology *The Six Mountain-Travel Books*. London/Seattle: Diadem/Mountaineers, 1985).

Younghusband, Francis. *The Heart of a Continent*. London: John Murray, 1896.

## Chapter Two

Gansser, August, and Heim, Arnold. *The Throne of Gods*. New York: Macmillan, 1939.

Leigh Mallory, George H. *Mount Everest, The Reconnaissance 1921*. New York: Longmans, Green & Co., 1922, London: Edward Arnold & Co., 1922.

Landor, A. Henry Savage. *In the Forbidden Land*. London: Heinemann, 1898.

Tilman, Harold W. *Everest 1938*. Cambridge: Cambridge University Press, 1942. (Also included in the anthology *The Seven Mountain/Travel Books*. London/Seattle: Diadem/Mountaineers, 1983).

Various authors. *High Mountain Peaks in China*. Beijing/Tokyo: People's Sports Publishing House of China/Tokyo Shimbun Publishing Bureau, 1981.

## Chapter Three

Burdsall, Richard L. and Emmons, Arthur B. *Men Against the Clouds: The Conquest of Minya Konka*. New York: Harper & Bros., 1935. Reprinted by The Mountaineers, Seattle, 1980.

Kreitner, Gustav. *In Fernen Osten*. Wien: A. Holder, 1881.

Rock, Joseph F. "The Glories of Minya Konka," *National Geographic Magazine*, October 1930.

Sutton, Stephanne Barry. *In China's Border Provinces: the Turbulent Career of Joseph Rock, Botanist-Explorer*. New York: Hastings House, 1974.

## Chapter Four

Chapman, Frederick S. *Helvellyn to Himalaya*. London: Chatto & Windus, 1940.

## Chapter Five

Armington, Stan. *Trekking in the Nepal Himalaya*. Victoria, Australia: Lonely Planet, 1985.

Bezruchka, Stephen. *A Guide to Trekking in Nepal*. Seattle: The Mountaineers, 1985.

Herzog, Maurice. *Annapurna*. New York: E. P. Dutton, 1952.

Tilman, Harold W. *Nepal Himalaya*. London: Cambridge 1952. (Also included in the anthology *The Seven Mountain-Travel Books*. London/Seattle: Diadem/Mountaineers, 1983).

## Chapter Six

Kawaguchi, the Shramana Ekai. *Three Years in Tibet*. Benares and London: The Theosophical Publishing Society, 1909.

Kleinert, Christian. *Nepal Trekking*. Munich: Bergverlag Rudolf Rother GmbH, n.d.

## Chapters Seven and Eight

Filippi, Filippo de *An Account of Tibet: Travels of Ippolito Desideri*. London: Routledge & Sons, 1932.

Douglas, William O. *Beyond the High Himalayas*. Garden City: Doubleday, 1953.

Harrer, Heinrich. *Ladakh, Gods and Mortals Behind the Himalayas*. Innsbruck: Pinguin Verlag, 1978.

Schettler, Rolf and Margaret. *Kashmir, Ladakh & Zanskar*. Victoria, Australia: Lonely Planet, 1985.

Snellgrove, David, and Skorupski, Tadeusz. *The Cultural Heritage of Ladakh*. New Delhi: Vikas, 1977.

Weare, Gary. *Trekking in the Indian Himalaya*. Victoria, Australia: Lonely Planet, 1986

## Chapter Nine

Bartle, Jim. *Trails of the Cordillera Blanca and Huayhuash of Peru*. Lima: by the author, 1981.

Frazier, Charles, with Donald Secreast. *Adventuring in the Andes*. San Francisco: Sierra Club Books, 1985.

Kinzl, Hans, and Schneider, Ervin. *Cordillera Blanca*. Innsbruck: Universitatsverlag Wagner, 1950.

Peck, Annie Smith. *A Search for the Apex in America: High Mountain Climbing in Peru and Bolivia, Including the Conquest of Huascarán*. New York: Dodd, Mead & Co., 1911.

Ricker, John F. *Yurak Janka: Cordillera Blanca and Rosko*. Banff, Alberta: The Alpine Club of Canada; New York: The American Alpine Club, 1977.

## Chapter Ten

Bingham, Hiram. *Lost City of the Incas*. Lima: Librerias A.B.C. S.A., 1948, paperback edition, 1975.

Frost, Peter. *Exploring Cuzco*. Lima: Lima 2000, 1979.

## Chapter Eleven

Azema, Marc. *The Conquest of Fitzroy*. London: Deutsch, 1957.

Agostini, Alberto M. De. *Ande Patagoniche*. Milano: De Agostini, 1948.

Shipton, Eric. *Land of Tempest*. New York: E.P. Dutton, 1963. (Also included in the anthology *The Six Mountain-Travel Books*. London/Seattle: Diadem/Mountaineers, 1985).

## Chapter Twelve

Allan, Iain, ed. *Guide to Mount Kenya and Kilimanjaro*. Nairobi: The Mountain Club of Kenya, 1981.

Hemingway, Ernest. *The Snows of Kilimanjaro* (various editions).

Reader, John. *Kilimanjaro*. London: Elm Tree Books, 1982.

Taylor, Rob. *The Breach: Kilimanjaro and the Conquest of Self*. New York: Coward, McCann & Geoghegan, 1981.

## General References

Baume, Louis. *Sivalaya*. Seattle: the Mountaineers, 1979.

Peters, Ed. *Mountaineering: Freedom of the Hills*. Seattle: The Mountaineers, 1982.

Hackett, Peter H. *Mountain Sickness: Prevention, Recognition & Treatment*. New York: American Alpine Club, 1980.

Houston, Charles S. *Going Higher: The Story of Man and Altitude*. Burlington, Vermont: by the author, 1983.

Le Bon, Leo. *The Adventurous Traveler's Guide*. New York: Simon and Schuster, 1985. Mountain Travel's 1986/87 catalog of more than 180 treks, outings, and expeditions with descriptions of the various types of adventure-travel activities and essays by trek members.

Newby, Eric. *Great Ascents: A Narrative History of Mountaineering*. New York: Viking, 1977.

Swift, Hugh. *Trekker's Guide to the Himalayas & Karakoram*. San Francisco: Sierra Club Books, 1982.